Art Market Guide

Contemporary American Art

Richard Polsky

The Marlit Press
San Francisco

Designed by Klaus Ottmann/white.room productions, New York.

Printed and bound in the United States of America.

Published by The Marlit Press, San Francisco.

Available through D.A.P./Distributed Art Publishers
155 Sixth Avenue, 2nd Floor, New York, New York 10013
Tel.: (212) 627–1999
Fax: (212) 627–9484

ISBN 1–881616–76–2

Disclaimer

The opinions expressed in the *Art Market Guide* are those of the author. While they are informed opinions, they are ultimately just that. The information provided here is not specific investment advice to buy or sell any particular artist or particular work of art. The *Art Market Guide* should be used as a catalyst for discussion and analysis of one's own collecting goals. The author bears no responsibility for errors, omissions, or buy/sell decisions made by the reader based on information provided in the *Art Market Guide*.

Acknowledgments

The author wishes to thank Barbara Hogenson (Agent), Lorrie Goldin (Editor), Jonathan Marshall (Editor), Lee Kaplan (Arcana Books on the Arts), Alan Porter (Attorney), Rick Dirickson (Patron), Mark Magowan (Abbeville Press), Jonathan Novak (Jonathan Novak Contemporary Art), Joe Wachs (Computer Consultant), Sandy Smith (Sanford Smith & Associates), Gunter Stern (Artist), and Mr. and Mrs. Bernie Polsky (Parents). He would also like to thank Bill James, author of *The Baseball Abstract*, for inspiration.

Contents

Introduction 8

Definitions 9

1994–1995 Market Outlook 11

1995–1996 Market Outlook 15

Richard Artschwager 18

Jennifer Bartlett 22

Jean-Michel Basquiat 25

Ross Bleckner 29

Louise Bourgeois 32

Alexander Calder 35

John Chamberlain 38

Joseph Cornell 42

Willem de Kooning 46

Richard Diebenkorn 51

Jim Dine 55

Richard Estes 59

Dan Flavin 63

Sam Francis 66

Helen Frankenthaler 70

Arshile Gorky 73

Philip Guston 76

Duane Hanson 79

Keith Haring 82

David Hockney 85

Jasper Johns 89

Donald Judd 92

Alex Katz 96

Franz Kline 99

Jeff Koons 102

Roy Lichtenstein 105

Brice Marden 110

Agnes Martin 114

Joan Mitchell 118

Elizabeth Murray 121

Bruce Nauman 124

Louise Nevelson 127

Claes Oldenburg 130

Jackson Pollock 134

Robert Rauschenberg 137

James Rosenquist 141

Susan Rothenberg 145

Mark Rothko 148

Edward Ruscha 151

Robert Ryman 155

David Salle 158

Julian Schnabel 161

Joel Shapiro 164

Cindy Sherman 169

Kiki Smith 173

Frank Stella 176

Wayne Thiebaud 180

Cy Twombly 184

Andy Warhol 189

Tom Wesselmann 198

Introduction to Galleries 202

Galleries 203

Introduction

When you get the art collecting bug, the first piece of advice you are given is to buy what you love; never buy for investment. Spiritually this is sound advice. Realistically, if you are spending $3,500 or more (which means at least $5,000 in income before taxes), it becomes an investment unless you are truly wealthy. You have to feel that the purchased work of art will at least hold and maybe increase its value with inflation and other market factors.

The purpose of this guide is not to tout art as a good investment or a bad investment. That is up to the purchaser and his or her motivation for buying. Instead, the *Art Market Guide* attempts to make determinations about which art is likely to stand the test of time and thus hold its value and possibly appreciate.

The most important consideration when it comes to investing in art is a long-term outlook. You need to ask questions. Which artists are the innovators? Which artists influenced their peers? Which artists produce work that is visually seductive with intellectually challenging content? The answers to these questions go a long way toward determining an artist's investment potential.

The 1995–96 *Art Market Guide* featured 40 artists. The 1997 *Art Market Guide* features a total of 50 artists: 35 artists from last year's *Guide*, plus 15 new ones. All 50 artists are among the most widely collected. The 1997 *Art Market Guide* also evaluates 50 contemporary galleries. Future *Guides* will continue with the format of 50 artists and 50 galleries, but will rotate the list to reflect whoever is the most relevant in the market at the time.

Last year's *Art Market Guide* looked at an artist's past and present markets and used this information to determine a possible future market direction. This year's *Guide* still utilizes the "Past," "Present," and "Future" categories. However, for the 35 artists originally rated in last year's *Guide*, the "Past" section remains the same. The "Present" category consists of all new information. The "Future" augments the previous year's material with new information and analysis. This year's *Guide* also features all new material on the 15 artists that were added.

The 1997 *Art Market Guide's* analysis comes strictly from auction results (from November 1995 to May 1996). This is because auction results can be verified. There are several record prices listed for individual artists that no doubt were exceeded by private gallery transactions. The problem, of course, is that most dealers will not go on the record with these deals (showing invoices, canceled checks, etc.). Readers should therefore be aware that auction prices, while a strong indicator of an artist's market, are not the only indicator.

Definitions

Buy
This artist's best works from his or her best periods are likely to appreciate over time.

Sell
This artist's works are unlikely to appreciate over time.

Hold
For now, whether this artist's works are likely to appreciate or depreciate is unclear.

Past
Commentary on the artist's past market with an emphasis on the boom years of 1987–89.

Present
Commentary on the artist's current market during the 1995–96 auction season.

Future
Commentary on the artist's future market potential.

Abbreviations

S	Sotheby's	a/c	Acrylic on canvas
C	Christie's	g/p	Gouache on paper
o/c	Oil on canvas	a/p	Acrylic on paper

Auction Terms

Note: All prices discussed in the *Guide* include the buyer's premium.

Buyer's Premium The amount of money the buyer pays the auction house that is added on to the winning bid (15 percent on the first $50,000, 10 percent on amount above that).

Seller's Premium The amount of money the seller pays the auction house that is deducted from the winning bid (can range from 0 percent to 10 percent).

Hammer Price The winning bid without the buyer's premium added on.

Bought-In An work at auction that passed.

Estimate A price range that the auction house expects the winning bid to fall within (not including the buyer's premium).

Evening Sale Generally, a small (50–70 lots), tight sale of the most important and expensive works the auction house has to offer.

Day Sale Generally, a large (200–300 lots), diverse sale of medium to less expensive works of varying quality.

1995–1996 Market Overview

The Auctions

The 1995–1996 season's auctions were for the most part uneventful and flat. Yet, the overall perception was that the art market was stronger than the previous season and that things were gradually improving. The key, of course, is that the American economy continues to stay healthy (which it has since 1994). Since the art world was one of the last sectors of the economy to recover from the recession of the early 1990s, it is only now starting to enjoy the recovery in consumer confidence.

A brief look at the numbers from the season's contemporary art auctions reveals how tenuous the recovery in the art market really is. During the November 1995 sales, the dollar volume of works sold by Sotheby's and Christie's had a combined total of $34.4 million. Christie's sales accounted for $14.5 million of the above total. The sale was estimated to bring $19.8 million to $26 million. A total of 60 works came up with 46 selling and 14 passing. A record price was set for a painting by Barnett Newman ($3 million for *The World II*). The next morning, the *New York Times* headlines for the sale were: "Contemporary Art Lags at Auction."

Over at Sotheby's, its sale totaled $19.9 million against expectations of $18.4 million to $25.2 million. A total of 57 works appeared with 47 selling and 10 passing. A record was set for a painting by Arshile Gorky ($3.9 million for *Scent of Apricots on the Fields*). On the day following the sale, the *New York Times* headlines read: "Low-Risk Auction Ends Fall Sales."

As we shift to the May 1996 sales, we find the sales for the two houses totaled $28.6 million. Christie's went first with what observers thought was the weaker material of the two houses. But Christie's sale turned out quite well, as it totaled $15.2 million, nicely within its pre-sale estimate of $13.2 million to $17 million. A total of 46 works came up with 37 selling and 9 passing. A record was set by a Joel Shapiro ($404,000 for *Untitled*). The *New York Times* ran the encouraging headline "Contemporary Art Bounces Back."

Why did Christie's do so well? Observers sighted the usual reasons: fresh, good quality material that was reasonably estimated. In a touch of typical art world hypocrisy, these were the same people who when they received their auction catalogs before the sale said the work had been shopped and the estimates were high. You can't win.

The last sale of the season was held at Sotheby's. This sale totaled $13.4

million, well below the expected $23 million to $31 million. A total of 59 works came up with 45 selling and 14 passing. The reason for the low dollar volume was the failure of three of the million dollar lots to sell (works by de Kooning, Johns, and Kline that carried total estimates of $10 million to $14 million). However, as this book went to press, Sotheby's was holding private negotiations to sell all three lots. On the positive side, new price records were set for works by Eva Hesse ($662,500 for *Sans II*) and Agnes Martin ($525,000 for *The Tree*). The next morning, the *New York Times* ran the deflating headline "Stars Fail to Shine at Contemporary Art Auction."

Despite the sales ending on a down note, a total of $63 million worth of art was sold. That's a lot of contemporary art. Last year's total was $50.8 million. Also, shed no tears for the auction houses. Both houses reported that their new policy of no longer waiving fees for favored sellers helped boost their profits.

Both houses' new department heads, Robert Monk and Neal Meltzer, seemed to adjust well to their leadership responsibilities. Both were enthusiastic and offered knowledgeable answers when asked questions about the art being offered. Christie's chairman, Christopher Burge, continues to be the best auctioneer in America. Sotheby's president and CEO, Diana Brooks, tried her hand at auctioneering and found out how difficult it is to orchestrate an evening sale. To be a top flight auctioneer is an art form. It takes a certain panache and at least five years' experience.

One disturbing incident occurred at Sotheby's. It was an issue of integrity. At the evening sale of November 1995, Sotheby's offered four lots from the collection of Asher Edelman. All the lots were of obvious high quality. The highlight of the group was Jasper Johns's painting from the *Four Seasons* series, *Winter*. Sotheby's catalog featured a short essay that fawned over the merits of Mr. Edelman's holdings. For that I don't blame Sotheby's. Hype is part of the game.

What was disturbing was that Sotheby's catalog declared: "*Winter*, from Jasper Johns's *Seasons* series, is a testament to Mr. Edelman's discerning eye. At the time of Johns's exhibition at the Leo Castelli Gallery, one would have perhaps been seduced by one of the other *Seasons* paintings, which are lighter in hue and subject matter. Rather, Mr. Edelman selected *Winter*."

The problem with this statement is that it goes beyond hype. It's simply not true. The catalog statement made it sound like Mr. Edelman had first pick of the paintings. It's highly probable that Mr. Edelman had last pick. Supposedly, Philip Johnson (the architect) had first pick followed by Robert and Jane Meyerhoff (major collectors), and then Jasper Johns made his own selection. Leo Castelli is known for his loyalty to his longtime supporters (such as Mr. Johnson and the Meyerhoffs) and would certainly have given them the first choices. Even if this "picking order" is off, one thing is for certain; no sophisticated collector would

have selected *Winter* before *Summer* (universally recognized as the most beautiful of the four paintings).

Regardless, *Winter* didn't need any propaganda. It stands on its own merits as a first-rate, historically important painting. Apparently the market thought so too as it went over estimate to sell for $3 million.

It's one thing when Christopher Burge and Diana Brooks try to put a positive spin on each and every sale. That's their job and their responsibility to their shareholders. But Sotheby's lost credibility with knowledgeable collectors when they went beyond mere hype. The art market continues to struggle with buyer confidence in the art buying process. This sort of thing doesn't help.

The Galleries

The upheaval in the gallery world during the 1995–1996 season was profound in its implications. One change was symbolic more than substantive: Mary Boone's move uptown. A second change was more substantive than symbolic: Chelsea becoming a new art neighborhood. A third new development was a little of both: the opening of Pace Wildenstein and Gagosian in Beverly Hills.

As anyone who participated in the art world in the 1980s will tell you, the Mary Boone Gallery was the pivotal point of the SoHo gallery scene. Her decision to relocate uptown caused the rest of SoHo to pause for a moment and reflect on where the scene was going. However, the demise of SoHo has been greatly exaggerated by the press.

Mary Boone, as well as other galleries that were moving, said they were leaving because SoHo has been taken over by the boutiques and is no longer a serious place to view art. That's a lot of nonsense. The reason some galleries are leaving is because of rising rents. It's as simple as that. Even Mary Boone left because of a rent dispute. There is nothing wrong with the fact that SoHo offers great shopping and good restaurants. These factors are positive. Still, her leaving SoHo to move uptown is symbolic because the uptown gallery scene is about established artists. SoHo is more about emerging talent.

An uptown address is prestigious for a gallery and its artists. If you can afford it, there's no better place to be. Galleries like Pace Wildenstein, C&M, Gagosian, and Robert Miller presumably can afford to locate where they want. They chose to locate where they and their clientele live and work (in many cases). Don't forget the auction houses are uptown as well.

The relocation of galleries such as Matthew Marks, Metro Pictures, Paula Cooper, and Barbara Gladstone to Chelsea is a long time coming. The art world is a living, breathing organism. It needs to go through changes from time to time to rejuvenate itself. This is one of those changes. It's very much like nature.

When lightning storms set off a fire that burns hundreds of acres of forest, it clears out old growth scrub and allows new growth to take place.

There has been a lot of talk about whether Chelsea will make it. Doubters speak of how difficult it is to get to, how forbidding the area is at night let alone during the day, and how there aren't any decent restaurants or bars. Just wait. Of course Chelsea is going to make it.

No, it will never have SoHo's charm. SoHo is one of those special things, a place inhabited by artists and businesses that serve artists. The whole scene came together in the late 1960s under a happy confluence of circumstances that are unlikely ever to be duplicated (cheap Manhattan rents, a place where artists lived and worked, and incredible architecture).

The point is there is plenty of room for a new art neighborhood. Within a year and a half there will be at least half a dozen restaurants, clothing boutiques, and loft living. It will just have a different flavor than SoHo.

The last big story of the season is the opening of Beverly Hills branches of Pace Wildenstein and Larry Gagosian. The Gagosian Gallery opened with a Frank Stella sculpture show and a dinner at Mr. Chow. Its space, designed by Richard Meier, is certainly impressive and a more beautiful space for viewing art than Pace is. However, Pace's opening exhibition (new paintings by Chuck Close, shown for the first time) as well as its grand opening party made a statement that captured the excitement of a major Hollywood premier.

And that was the point. In one glorious evening, Pace Wildenstein announced to the city of Los Angeles that this was it; Pace is in town and the art scene is going to be elevated to the next level. The opening party was amazing. Pace managed to persuade the city of Beverly Hills to close off part of Rodeo Drive and had it covered in white carpet. The gallery also erected a giant tent that had large hanging banners with photos of all its artists (you could look up and see Mark Rothko). Pace even flew in all the gallery artists and put them up at the exclusive Peninsula Hotel.

This made for some very unlikely scenes (unlikely anywhere other than Los Angeles, that is) such as Pace co-owner Arne Glimcher walking around holding hands with Julian Schnabel, who was wearing sunglasses and the requisite paint-spattered khakis. Naturally, there was a 12-piece orchestra and fabulous food stations. What was so special was that the party was inclusive and not the usual art world "exclusive" affair. Pace invited art dealers (which is highly unusual for a gallery), local artists, Hollywood celebrities, assorted curators and critics, and, of course, collectors.

Will Pace and Gagosian affect the Los Angeles art scene? They will and they won't. These two galleries are in a league of their own as far as exhibitions (apologies to the Margo Leavin Gallery) and offering resale material. Symboli-

cally, their presence makes the L.A. scene big time overnight. However, as far as helping the community's galleries do more business or the local artists get into more shows, their effect is virtually nil.

In the case of Gagosian, the move is mostly a tactical move to keep up with Pace (and the opportunity Pace perceives in developing buyers from the entertainment industry). For Pace Wildenstein, the Los Angeles gallery is part of a master expansion plan to locate galleries in key cities around the world (Pace has a lot of high-powered artists that need to show and make sales on a year-round basis, not just when their slot comes up every year and a half).

All in all, Pace Wildenstein will do quite well in Los Angeles and so will Gagosian (assuming it's as well financed as it appears to be).

1996–1997 Market Outlook

The Auctions

The story of the past season was Sotheby's June 1996 announcement that it had purchased the Andre Emmerich Gallery, one of the industry's senior galleries.

There has been relatively little reaction in the press, considering the potential ramifications of the deal. The reason (as this book goes to press) is that Sotheby's and Andre Emmerich probably don't know themselves what their game plan is going to be. In an article by Alexandra Peers in the *Wall Street Journal*, Sotheby's president and CEO, Diana Brooks, was quoted as lauding Mr. Emmerich's "expertise, scholarship, and relationships." There is some truth to this statement. Andre Emmerich is certainly a dignified presence in the art world.

However, this is the same dealer who testified at the Andy Warhol estate trial (which sought to set a value on the paintings remaining in the estate) and was quoted as saying that Warhol's work would go down in value. His reasoning was that some of Warhol's primary subjects, such as Marilyn Monroe and Elvis Presley, would be forgotten about in twenty years; therefore the paintings would be of less interest. That's absurd. Marilyn and Elvis are icons of twentieth century popular culture and are hardly in danger of being forgotten (even the U.S. government recently honored both entertainers with postage stamps). It would seem Mr. Warhol's market is safe for now.

At any rate, what was Sotheby's motivation for buying the Emmerich Gallery and how does it affect the art market?

Let's go with the possible assumption that Sotheby's is concerned with a recent new development in the gallery business. The largest galleries like Pace Wildenstein are starting to tread on auction house territory by doing exhibitions and sales of entire estates. As everyone who follows the market knows,

great estate collections are prized because the material is fresh to the market. By luring away some of this business, Pace has in effect issued a challenge to the auction houses. Business will no longer be divided along traditional lines.

Logically, Sotheby's might be thinking about ways it can pursue business traditionally handled within the gallery domain. One possibility is the estates of artists. This has been a lucrative source of income for some of the bigger galleries for years. By acquiring Andre Emmerich, Sotheby's now controls the estates (or part of the estates) of Sam Francis, Morris Louis, Milton Avery, Hans Hofmann, and Keith Haring.

In theory, this means Sotheby's will be able to derive income both from exhibiting works from these estates or auctioning off works. That's a nice position to be in. With Sotheby's vast international marketing clout, it should now be able to use the Emmerich Gallery estates as a magnet for attracting additional estates.

Which brings us to the other half of the equation, the living Emmerich Gallery artists. The great experiment is how they will now be marketed. What will happen with artists like David Hockney and Al Held? One of two things. Either Sotheby's will reorganize the gallery's stable and use its marketing prowess to promote the artists. Or it will get out of representing artists and just use the space to show estate material.

A third possibility is that the gallery will be used as an exhibition annex to sell material that Sotheby's guaranteed (to consignors) but got stuck with when the material didn't sell. Now Sotheby's has another outlet.

One thing you can count on. Christie's is certainly following this development closely and is already looking into galleries that are ripe for purchase.

The Galleries

Let's face it, there hasn't been an interesting gallery season in years, maybe not since the late 1980s. But this may be the season. Why? What's currently happening in the National Basketball Association (NBA) offers an analogy.

As anyone who follows professional sports will tell you, the NBA is stirring up all sorts of excitement. Not only does it have the most exciting athlete alive in Michael Jordan but it now has the most exciting sport around. One reason is the excitement provided by "free agency". Players with expired contracts can now sell themselves to the highest bidder. This has led the NBA into a version of musical chairs. However, the shuffling of players is healthy because it creates new competitive team match-ups, that excite the fans.

Teams in the highest television revenue markets, such as New York and Los Angeles, have as a result bid the most money for these great ballplayers' ser-

vices. These teams can afford to do so because they derive a large chunk of their income from television contracts (the bigger the city's population, the bigger the TV audience and thus the bigger the TV contract). You now have basketball star, rapper, and Pepsi pitchman Shaquile O'Neal moving to Los Angeles. You also have exciting new players who have signed to play for New York and Miami. Basketball fans can't wait for the next season to get started.

Now what does the NBA have to do with the gallery scene? Everything. It's called change and the excitement it can generate among art world "fans." Not in years has there been a season alive with so many possibilities. Will Mary Boone's move uptown accelerate the competition for collectors among blue chip galleries? Will Chelsea be a "happening scene" and energize the art world the way the East Village did in the 1980s? Will the auction houses start acquiring more galleries? Will the Jasper Johns retrospective lead to a secondary market boom in artists from his era? Will the long-rumored takeover at Sotheby's finally occur?

Any or all of the above could easily happen during the 1996–1997 season. As long as the American economy stays strong (and at this point indications are that it will), this season will provide the galleries and the auction houses with plenty of opportunities to take substantial risks.

It should also be a good time for artists to follow suit and take big risks with their work. A lot of the political battles have been fought and won. There's been a big improvement in galleries showing more women and minority artists. Artists have also gained a greater freedom to use a wider range of mediums that collectors are willing to buy and museums are willing to show (such as the art of Matthew Barney, which is derived from the body). The hope is that this greater acceptance of less traditional media than painting and sculpture will lead to either a new movement, like the so called "Neo-Expressionists" of the 1980s (Fischl, Schnabel, Salle, Clemente, etc.), or at least the emergence of some great individual talents in painting and sculpture.

A seismic shift in the art world is overdue. This may be the season that things get shaken up.

RICHARD ARTSCHWAGER (b. 1924)

Prime Representation: Mary Boone Gallery, New York

Record Prices at Auction:

Sculpture: $308,000. *Piano*, formica on wood, 32" x 48" x 19", 1965 (C. May 90).

Painting: $990,000. *Triptych V (Interior)*, liquitex on celotex, 81 1/2" x 140 1/4", 1972 (C. Nov. 89, The Robert Mayer Collection).

Top Prices at Auction (Nov. 1994–May 1996):

Sculpture: $46,000. *Trunk*, formica on wood, 35" x 18" x 12", 1964 (C. Nov, 94)

Painting: $88,300. *Untitled (Building)*, liquitex on celotex, 53 1/2" x 79 1/2", 1974 (C. Nov. 95).

MARKET ANALYSIS

Past

The 1980s boom market worked greatly to Richard Artschwager's advantage.

Artschwager, always a strong talent known for originality, superb craftsmanship, and a dry sense of humor, had largely been overlooked by the art market.

Enterprising art dealers realized that there was plenty of material around, especially paintings, at low prices. They began buying up his work and trading in it, often at auction.

Artschwager's sculpture got a major price boost in May 1989 at Sotheby's when a "double" chair soared above its $60,000–$80,000 estimate to sell for $198,000. It was a milestone in the Artschwager market. This was his first piece of sculpture to break $100,000. In retrospect, it's amazing that it took until 1989 for an Artschwager to sell for six figures. This sale finally pointed out how undervalued his sculpture had been.

It took the magic of the Andy Warhol sale (S. May 88) to boost Artschwager's painting prices past $100,000. A three-panel vertical interior scene eclipsed its "disrespectful" estimate of $35,000–$50,000 to sell for $176,000. The estimate

was not a teaser. It was typical of what had been the art market's lack of interest.

The Artschwager market reached its peak in November 1989 at the sale of Chicago collector Robert Mayer's collection. Perhaps the biggest picture ever created by Artschwager (81 1/2" x 140 1/4") came up with a $250,000–$350,000 estimate. It brought an eye-opening $990,000, nearly giving Artschwager membership in the exclusive "million dollar club." Artschwager said afterward that he wasn't fazed by the price but his mother-in-law was duly impressed. The art market was also impressed. If collectors weren't previously aware of the market potential of Artschwager paintings, they were now.

Present

It was a pretty dull season for Artschwager at auction. The only point of interest was the opportunity to view a great 1960s sculpture, *Chair/Chair* (42" x 44" x 18", 1965). This work is best described as a pair of solid forms that resemble chairs placed back to back. The sculpture is made out of Artschwager's "patented" colored and woodgrained Formica. *Chair/Chair* came up once before in 1989 at Sotheby's. At the time, it did very well, selling for $198,000. Alas, the story this time around was not so happy. *Chair/Chair* came up again at Sotheby's in May 1996. This time it passed. The estimate had been $125,000–$175,000.

Artschwager's 1995-1996 season boxscore saw a total of twelve works appear with ten selling. This represented a big improvement over the previous season, when sixteen works came up and only seven sold. The dollar volume of Artschwagers sold totaled $306,800 during the 1995–1996 season. A total of $171,825 worth of Artschwagers were sold the previous season.

If you only read the above numbers, you'd conclude that things are looking up for Richard Artschwager. However, these statistics are misleading. Even though the current season yielded a greater percentage of works that sold as well as a greater dollar volume, the quality of the works that sold were superior last season. This only goes to show you that in the art market there's no substitute for seeing the actual work (or at least good transparencies) before you rely on the statistics you read about.

Future

Richard Artschwager was certainly the quirkiest major talent to emerge from the 1960s. His main contribution was creating work that blurred the line between furniture and sculpture (he started out as a furniture maker, then became an artist).

Artschwager's sculpture was constructed primarily out of colored formica. In the early 1960s this must have looked quite radical, since sculptors were just beginning to explore materials beyond bronze, steel, and wood. Artschwager took a simple object like a chair and transformed it into unmistakable sculpture. He did this by reducing it to a solid simple geometric form. He fabricated the chair with formica of a single color and indicated the negative space under the chair with another color.

Although Artschwager got an occasional outrageous price in the late 1980s, the work has never gotten its economic due. Artschwager's representational sculptures, including tables, dressers, and mirrors, currently bring $50,000–$150,000 when they sell. He's also done some nonrepresentational sculptures. These are to be avoided. Since it's difficult enough to sell his best sculpture (representational), the abstract pieces will be unsalable in the future.

Despite the fact that his sculpture is more historically important, his paintings have the most potential for appreciation. This is due to the usual reasons: more variety in size, price, and a far larger audience for painting than sculpture. Artschwager's imagery offers great variety. Past subject matter has included images as disparate as the interior of an IRS office, a train wreck, and a group of sailors. Good paintings have been bringing approximately the same prices as his sculpture ($50,000–$150,000).

Ironically, what holds back Artschwager's prices is his versatility. He is one of the few major artists to make important paintings and important sculpture. The art market has trouble dealing with an artist whom it can't categorize as either a painter or a sculptor. If he exclusively made paintings, his prices for paintings would undoubtedly be higher. Maybe much higher. Ditto for his sculpture.

Try as I might, I cannot come up with a single artist who has produced significant work in both mediums. Claes Oldenburg and Joel Shapiro come to mind, but they make drawings rather than paintings. Jim Dine comes close, but his sculpture isn't the equal of his painting.

Last year's *Art Market Guide* rated Artschwager a "Buy." However, at this point, he's been downgraded from a "Buy" to a "Hold." What's changed is that the current market seems to view him more as a curiosity, rather than as an essential artist to be collected.

In the art market of the 1980s, the emphasis was on speculating on those artists who were overlooked and therefore undervalued. The current art market places greater emphasis on artists that people want to live with. In most cases, that means artists who make work that is colorful and more decorative (not said in a derogatory sense) than intellectual.

This doesn't mean collectors no longer want work by big names. Of course

they do. Naturally, there are collectors who want to buy artists that make work which emphasizes content. But for every collector who buys an artist like Richard Artschwager, there are at least 50 collectors who want to buy a late Sam Francis. The bottom line is that Artschwager's audience seems to have shrunk.

JENNIFER BARTLETT (b. 1941)

Estate Representation: Paula Cooper Gallery, New York

Record Prices at Auction

Painting: $176,000. *At the Lake*, combination of o/c and baked enamel and ink on 45 steel plates, 77″ x 188″, 1978 (C. April 91).

Enameled Steel Plates: $99,000. *17 White Street*, baked enamel and silkscreen ink on 81 steel plates, 116″ x 116″, 1977 (S. April 91), 1981 (S. Nov. 89).

Print: $55,000. *At Sea, Japan*, woodcut and silkscreen on 6 sheets, 22″ x 100″, edition of 58, 1980 (S. May 89).

Top Prices at Auction (Nov. 1994–May 1996):

Painting: $16,100. *At Sands Point 23*, o/c, 48″ x 24″, 1985-86 (S. May 95).

Pastel: $34,500. *Old House Lane #34*, pastel on paper in five parts, 44″ x 150″, 1987 (S. May 96)

Enameled Steel Plates: $13,800. "9 Plate Series," baked enamel and silkscreen ink on 9 steel plates, 108″ x 12″, 1972 (C. Nov 95).

Print: $34,000, *At Sea, Japan*, woodcut and silkscreen on 6 sheets, 22″ x 100″, edition of 58, 1980 (S. Nov, 94).

MARKET ANALYSIS

Past

Jennifer Bartlett had a strong market during the late 1980s but actually had a stronger market in 1991 when everything appeared to be collapsing. In April 1991, her multipanel painting, *At the Lake*, sold for a record $176,000 at Sotheby's. That same sale yielded another strong result as the painting 17 *White Street* sold for $99,000, setting a record for an enamel painting. Finally, she set another record in 1991 for a single canvas when *The Island* (o/c, 108″ x 157″) brought $132,000.

What was particularly interesting about Bartlett's pre-1991 market was that

virtually every painting that came up for sale found a buyer. Her audience showed especially strong support for her baked enamel on steel paintings (Bartlett began these paintings in 1968). These works consist of individual 12" x 12" steel tiles that are covered with white enamel and silkscreened with a tiny grid pattern. The artist usually then paints a single color dot within each tiny box that forms the grid (almost like a Pointillist painting). The individual tiles are then installed on the wall in various configurations. Sometimes the individual tiles joined together to create an abstract picture. Other times these works depicted an image such as a house. Regardless, they always seemed to sell.

Present

The 1995-1996 season was a marked contrast to 1991. The interest was minimal for all Bartlett's work except for one major pastel, *Old House Lane #34*, which sold for $34,500. But even that result is a bit misleading because it went below its estimate of $40,000 to $60,000.

Another observation of the season was the failure of one of her three-dimensional mixed media works to sell. The work, *Fire/Fallen Table*, was a combination of a canvas depicting a red table turned on its side (a fire blazed in the background) and an actual three- dimensional version of that same red table. The canvas was hung on the wall and the table was placed on the floor in a position that mimicked the table's placement in the painting. If this sounds a little too obvious that's because it is.

The two other Bartlett works (with 3-D objects) that came up to auction in the past also failed to sell. In 1993, an installation called *White House* (a painting of a white house, an actual white house, and an actual white picket fence) failed to sell for its $100,000 to $150,000 estimate. The next year a huge installation titled *Luxembourg Gardens* (a large painting of a garden along with an actual house, a rowboat, and a sailboat with a tartan sail) also remained unsold, failing to meet its same $100,000 to $150,000 expectations.

Future

With the exception of Jennifer Bartlett's first-rate pastels, her future market doesn't look very promising. Basically, she has become the Martha Stewart of the art world. All of her paintings have that correct "town and country image" that would look right at home in a house decorated by Stewart.

Bartlett's paintings range from the "never should have left the studio" small sketch-like canvases to the mediocre full-scale pictures. The best thing that can be said about them is they are an improvement over her earlier baked

enamel on steel paintings.

If all this sounds cruel, it's because the pricing of her work is cruel. Up until only a few years ago, it was not uncommon to see $100,000-plus estimates for Bartlett's large paintings. Whoever paid any of those prices must be regretting it now (even if they are madly in love with the works; nobody likes to lose money). There hasn't been a Bartlett to sell for over $35,000 in five years. The odds are there won't be a sale above $60,000 for quite some time in the future, if ever. The work is of no importance historically, which is why her future prices are limited.

One of Bartlett's more recent gallery exhibitions centered around the theme of "24 Hours." The artist created 24 paintings that were supposed to reflect an activity from a different hour of the day. In the past, Bartlett has also tackled familiar themes such as "The Seasons" and "The Elements." In each case she created a series of paintings and pastels. Typical for Bartlett, the pastels were the superior works. Bartlett is a gifted artist with a pastel in her hand. Unfortunately, the same cannot be said about her with a brush in her hand. If you must buy Bartlett, stick with her pastels.

JEAN-MICHEL BASQUIAT (1960–1988)

Hold

Estate Representation: Gerard Basquiat, New York

Record Prices at Auction:

Painting: $440,000. *Arroz con Pollo*, mixed media/c, 68" x 48 1/2", 1981 (C. Nov. 89).

Drawing: $63,250. *Untitled* (colorful single figure), oil stick/p, 24" x 17 3/4", 1981 (S. Nov. 89).

Top Prices at Auction (Nov. 1994–May 1996):

Painting: $294,000. *Undiscovered Genius of the Mississippi Delta*, a/c, 48" x 184", 1983 (S. Nov. 94).

Drawing: $31,500. *Untitled*, crayon, graphite/p, 33" x 25 1/2", 1985 (C. Nov. 95).

MARKET ANALYSIS

Past

Jean-Michel Basquiat's death in 1988 dovetailed with the art market boom to produce a dramatic upsurge in his prices.

As late as November 1987, a major Basquiat canvas could be had for as little as $15,000 (the range was basically $20,000–$30,000). Believe it or not, these were good prices that showed his market was gathering momentum. Then Basquiat died. "It was a great career move" was the black-humored remark making the rounds. The comment almost made sense given Basquiat's constant search for attention.

The market's reaction was swift. Dealers began talking about prices tripling to as much as $75,000. They were wrong. The market sped to $200,000–$400,000 in 1989. These prices were driven largely by the Europeans. As with their early recognition of the Pop artists in the 1960s, the Europeans were quick to see Basquiat's potential.

Although Basquiat worked steadily for only around six years, he produced a large body of work, especially on paper. Works on paper had been selling for $2,500–$5,000. By 1989, a first-rate drawing was $25,000–$50,000.

So many Basquiats were being traded at auction that 16 works came up in a single day (S. Nov. 89). This total was exceeded only by one artist, his mentor Andy Warhol (Warhol had an incredible 35 works in the same sale). In fact, during the October 1989 to May 1990 season, a grand total of 111 Basquiats came up for sale.

Present

Basquiat's 1995-1996 season started out strong and gathered momentum. In fact, Basquiat's current market is starting to approach the record-breaking highs of the late 1980s.

The sale of the painting *Danny Rosen* is a case in point. This large-scale painting (87" x 47 1/2", 1983) first appeared at a day sale at Sotheby's in May 1989. The imagery is a combination of faces painted in shades of chartreuse and sky blue and scrawled words such as "Pure" and "All Beef." The background is predominantly white with patches of black. On a scale of 1 to 10 it would rate an 8. It had been estimated at $50,000–$70,000 and sold for an impressive $181,500.

The same painting was on the block again in November 1995. This time *Danny Rosen* was offered at the more prestigious evening sale (a sure sign of the rising market for Basquiat). Sotheby's estimated it at $150,000–$200,000 and it sold for $156,000. This is only $25,500 less (or approximately 15 percent less) than what it sold for in the art market's golden age.

Including *Danny Rosen*, a total of 23 works by Basquiat came up for sale, and a remarkable 22 sold. There were 11 paintings that sold for an average price of $87,850 (the highest price for an individual painting was $233,500) and 11 drawings that sold for an average price of $15,400.

Future

Jean-Michel Basquiat is an artist whose career has already taken on mythic proportions. He's the next Jackson Pollock. He's had a *New York Times Sunday Magazine* (1985) cover, a full dress Whitney retrospective, and Julian Schnabel recently made a movie about his short and tragic but intensely productive life.

Then there was *Time* magazine critic Robert Hughes's infamous disparaging article, "Requiem for a Featherweight." Stir into this brew that the artist was African-American, promoted by Andy Warhol, showed at top international galleries, and died at age 27 of a heroin overdose, and you've got a hell of a story. And a hell of a market.

Yes, the Basquiat market is happening but it currently shows signs of strain.

It rose like a meteor during the boom, went down during the bust, but didn't crash. During the 1995–1996 season, it quickly rose again. What's driving this market? What are the factors at work?

It all goes back to the Whitney retrospective. A retrospective for a young artist is always risky (just ask Terry Winters). A retrospective for an artist with only six years of mature production is downright dangerous. Many went to view this show with suspicion and serious doubt. The majority seemed to emerge as believers. The show was also well received by the press. Even the jaded had to admit that Basquiat's best pictures, generally from 1983–84, held up.

After the close scrutiny of the Whitney show it seemed safe to buy Basquiat. He had passed the test. The work's strength lies in the tension of the childlike scrawls that play off the sophisticated use of repetitious images and words. Basquiat also knew how to move paint around and possessed a strong intuitive feel for composition. In this respect, comparisons to the great Cy Twombly are not overstated.

There's a genuine authority to Basquiat's best works. They have heavy "street credibility" without being threatening. Collectors enjoy living with them. Hanging a Basquiat in a room energizes the rest of the collection. This is ultimately why the work has value and potential to appreciate.

However, this does not mean Basquiat is universally accepted by the high-end collecting world. Many wealthy collectors with serious collections tend to be conservative, especially when it comes to Basquiat. (The exception is Californian Eli Broad, who has major Basquiat holdings, yet Charles Saatchi, the biggest collector in the 1980s, never hoarded Basquiat). As time goes on, Basquiat's work will look more conservative.

There's currently a wide range of prices for Basquiat's work at auction. Colorful oilstick drawings trade in the $15,000–$35,000 range. Small paintings on objects are $25,000–$75,000. Canvases generally jump from $75,000–$250,000.

In the spring of 1996, the Basquiat market received a jolt that can be compared to a corporate takeover. The artist's father, Gerard Basquiat, decided to take over representation of his son's estate. He also put the sale of work on indefinite hold. The estate had been represented by the Robert Miller Gallery. It's hard to get to the bottom of why Mr. Basquiat decided to make his move. A safe assumption is that it was done to increase demand for the work by shrinking its supply. Sounds prudent, right? Wrong.

The Robert Miller Gallery had done a textbook job of handling the Basquiat estate. It organized several shows that treated the work with the utmost dignity. The Miller Gallery's first Basquiat exhibition concentrated on never-before-shown drawings. The gallery produced a beautiful book to commemorate

the occasion and also managed to get Basquiat's prices up. Perhaps most important, the gallery helped organize an authentication committee that's considered highly professional (a rarity in the art world). In short, the Robert Miller Gallery handled the Basquiat estate with professionalism and increased the credibility of the work.

Mr. Basquiat may think he already has enough money, so what's the point of selling off his finite supply of estate material? After all, it's only going to be worth more in the future. Well, running an estate is not so simple. As mentioned previously, representation by a respected gallery is the only way to handle work and disseminate information. Mr. Basquiat, an accountant by profession, does not have the necessary art world experience to do the best possible job in representing his son's estate.

The art market's reaction to the Basquiat "takeover" was swift. Several European speculators (a term not used in the art world since the 1980s) put the word out that they were buying up Basquiats. Predictably, prices started to rise. Dealers got on the phones, frantically calling their contacts for "that drawing so and so had available six months ago." Much of the available Basquiat material was bought up before the May 1996 auctions. At the actual auctions, prices were up and virtually all the Basquiat material was absorbed.

But in June 1996, the world's most important art fair opened in Basel, Switzerland. The Basel Art Fair was flooded with high-priced Basquiats. Apparently few sold.

Last year's *Art Market Guide* rated Basquiat as a "Buy." This year, his rating has been lowered to a "Hold." At this point, if you already own a Basquiat, hang onto it. He's still a solid artist and a good long-term call. But if you're thinking of acquiring your first Basquiat, hold off. The market is overheated. Better to wait a bit and see if the next round of auction sales will confirm the new price levels (which in many cases are within 10 to 20 percent of their 1989 levels).

ROSS BLECKNER (b. 1949)

Estate Representation: Mary Boone, New York

Record Prices at Auction:

 Painting: $187,000. *One Wish*, o/c, 48" x 40", 1986 (C. May 88).

 Watercolor: $14,300. *Untitled*, w/p, 16" x 12", 1988 (Nov. 89).

Top Prices at Auction (Nov. 1994–May 1996):

 Painting: $92,700. *Second Gold Count*, o/c, 96" x 72", 1990 (C. Nov 95).

 Watercolor: $11,500. *Untitled*, w/p, 30" x 22", 1989 (S. May 95).

MARKET ANALYSIS

Past

Ross Bleckner was an infrequent visitor to auction during the market's boom years and when he did appear, he made just a fair impression. Bleckner's big auction moment took place at Christie's evening sale on May 3, 1988. The painting *One Wish* (48" x 40", 1986) appeared carrying a $45,000–$55,000 estimate. The image was an "Aladdin" style lamp floating in a nighttime sea of blue and green. The painting set a record, selling for $187,000.

This was a serious price, especially for so small a painting. Yet it was more of an isolated incident. Hundred-thousand-dollar prices would prove to be a rarity for Bleckner throughout the remainder of the late 1980s. His second biggest price was for a large "Stripe" painting with a Jewish star called *Modern Memory* that sold for $165,000 (S. May 90). Most of the other Bleckner material went within estimate or didn't sell.

The most significant statistic from these years was how Bleckner fared in comparison to his contemporaries. Bleckner was always collected but wasn't really an artist that collectors and dealers speculated on. His work wasn't considered as desirable as that of Eric Fischl, Julian Schnabel, David Salle, Francesco Clemente, or Jean-Michel Basquiat.

The list below lists the record prices for each of these artists. While a record

price is only one indication of an individual artist's market, it is a strong indicator as far as market perception is concerned:

Eric Fischl: $715,000, *The Stuntman* (C. May 90)
David Salle: $559,000, *Tennyson* (C. Nov. 90)
Jean-Michel Basquiat: $440,000, *Arroz con Pollo* (C. Nov. 90)
Francesco Clemente: $255,500, *Untitled* (C. Nov. 94, Gerald Elliott Estate)
Julian Schnabel: $242,000, *Portrait of David McDermott* (S. May 90)
Ross Bleckner: $187,000, *One Wish* (C. May 88)

Present

The state of Ross Bleckner's current market indicates a very unpredictable situation. On the positive side, there has been a reconciling of his auction and gallery prices. Currently, the going rate for a large painting at auction is between $50,000 and $75,000. This compares favorably with the gallery price for a new painting of $80,000 (less a presumed discount).

The highlight of the season was the sale of the best Bleckner to ever come up to auction, a painting called *Second Gold Count*. This work is from the artist's so called "Architecture of the Sky" series. The painting is an abstract composition of tiny golden discs (actual penny-size plastic discs glued to the surface and then painted over) that radiate out from the top in concentric circles. This work is Bleckner at his most spiritual.

Second Gold Count (96" x 72", 1990) came up at Christie's in November 1995 bearing a modest $40,000 to $60,000 estimate. After some spirited bidding the painting sold for a total price of $92,700, indicating that collectors will pay a premium for a special Bleckner. But if you look at the rest of the season's results, you realize that collectors want to pay below primary market prices, and often pass on some true bargains.

Future

Ross Bleckner has a very good reputation in the art world. When he was just getting started in the early 1980s, Bleckner was already very well connected socially. He used these connections to help his artist friends meet dealers and collectors (this may not sound like a big deal but in the art world this sort of generosity is remarked upon). In the process he built up a lot of good will. So when Bleckner's own work started to mature and his career began to take off, he was in a very strong position.

As it turned out, Bleckner needed this entire reservoir of good will.

In 1995, he had a retrospective at the Guggenheim Museum. The show was a curious affair; although tremendous in scope, it was poorly edited and indifferently installed. Some shows are enhanced by the Guggenheim's circular galleries (like Jenny Holzer's). Other shows are rendered incoherent. Bleckner's wasn't incoherent but neither was it helped by its surroundings. His paintings with birds looked terrific, the paintings with stripes looked just fair, and everything else looked weak. Overall, I would have given the show a solid C+.

But a funny thing happened. The press either said good things or kept quiet about most of the negatives. This was very surprising given that the New York art world press tends to jump all over things unless they are of indisputable quality (such as the 1996 Cézanne retrospective).

Ross Bleckner is the only "1980s generation" artist who is in effect a "Teflon" artist. He is immune to (though not above) criticism. The problem with that for an artist is no one tells you the truth when it comes to evaluating your work. Thoughtful criticism that might help the work grow is never offered.

Bleckner is a good artist with flashes of brilliance. But you sense that a large amount of woefully uneven work comes up at auction because he is not getting enough honest feedback from his dealers and friends. On the other hand, his 1996 show, the inaugural show at Mary Boone's new space, was the best work I have seen by the artist. Equally important, it was his most consistent show. Based on this show and a recent high price at auction, I would rate Bleckner's "Hold" rating as closer to a "Buy" than a "Sell."

LOUISE BOURGEOIS (b. 1911)

Estate Representation: Robert Miller Gallery, New York

Record Prices at Auction:

Sculpture: $200,500. *Nature Study*, marble, 29 1/2 " overall, 1960 (S. Nov. 93).

Drawing: $14,300. *Untitled*, ink/p, 19 1/2" x 13", circa 1950 (C. May 91).

Top Prices at Auction (Nov. 1994–May 1996):

Sculpture: $51,750. *Clutching*, bronze, 12' x 13" x 12", edition of 6, 1993 (S. May 95).

Drawing: $10,925. *Cumuls*, ink/p, 26" x 40", 1970 (S. May 96).

MARKET ANALYSIS

Past

Incredibly, Louise Bourgeois did not have a single work of art come up to auction during the late 1980s. Not one.

It was not until May 1991 that a Bourgeois finally came up for sale. Sotheby's had a small white marble sculpture (*Prison*, 16" x 14" x 7", 1986) that was estimated at $15,000–$20,000. The piece went over estimate to sell for $35,750. Thus began a winning streak that saw every single Bourgeois work that came up between 1991 and 1996 find a buyer. I can think of no other artist who can make the same boast.

The sale that signaled Bourgeois's arrival as a serious "auction artist" was the sale of an outstanding untitled wooden "totem" for $198,000 (C. Nov. 91). The estimate was $100,000 to $150,000. This work is best described as a singular column of 21 painted wooden blocks that are stacked to a height of 65 inches. Each block had a rough finish and was shaped like a parallelogram. *Untitled* was executed in 1950, just about when her mature sculpture vocabulary had developed.

While Bourgeois isn't exactly prolific, her work is readily available at galleries. However, collectors have a tendency to hang onto her work. Since May 1991, there were only seventeen works that saw the inside of an auction house.

Of these seventeen works, there were eight sculptures and nine drawings. The average selling price for a drawing was $9,400, for a major sculpture, $196,000.

Present

There were only two works by Bourgeois that came up for sale during the 1995-1996 season and both were minor. In fact, there hasn't been an important Bourgeois sculpture to appear at auction since the record-setting *Nature Study* back in the 1992–1993 season. This of course makes it very difficult to analyze what a similar work would bring in today's market. A good auction market for an artist is based partially on scarcity. But it also needs quality works (that bring big prices) to keep the interest level up for that particular artist.

Both works that appeared this season came up at Sotheby's in May 1996. The day sale contained the ink drawing *Cumuls* (26" x 40", 1970). This was an ordinary (but large) drawing of forms that resembled either a group of hills or clouds. It sold for $10,925 versus an estimate of $12,000–$15,000. The other work, *The Open Hand*, was designated by Sotheby's to be of evening sale quality. It wasn't. This small dark bronze (9" x 13 1/2" x 7", edition of 2, 1966) sold for $28,750. The estimate had been $30,000–$40,000.

Future

Despite a surge of interest by collectors in Louise Bourgeois's work (witness all the recent shows and publications), I'm still hesitant to make an outright "Buy" recommendation. Certainly Bourgeois can be accurately perceived as the "artist of the moment." Perhaps it's her advanced age (85 at this writing) or perhaps it's the quality of the work itself. Whatever the reason, Louise Bourgeois is on the collective art world's mind. However, this does not guarantee that she'll remain on peoples' minds.

Her sculpture does have a lot going for it. A key ingredient is its handmade quality. Bourgeois carves her own marble and wood. Believe it or not, this is an anomaly in an era where most sculptors have their work fabricated by others. Just think about the work of Richard Serra, Donald Judd, Joel Shapiro, or Carl Andre. Bourgeois's approach doesn't make her a better artist. Art is about using whatever technique best suits the statement you want to make. But it does add some warmth and personality to her work.

In a way, Louise Bourgeois has been rediscovered much like a folk/outsider artist. Her work really does look a lot like outsider art (work by artists who received no professional training). Bourgeois is obviously sophisticated. But she is not highly skilled from a technical viewpoint. If you look at one of her

carved marble works, you realize that her skill level is just adequate. Maybe only barely adequate. Her fans might argue that the raw quality of her work is part of its charm. But that forced "charm" is still no substitute for the skills that allow an artist to control the medium he or she chooses to work in.

Bourgeois's drawings are not worth acquiring at any price. She simply can't draw. Period. Another problem is that while her drawings do show the germination of ideas for sculpture, they have the appearance of a "private thought." They do not look as if they were intended to be released from the studio. At any rate, it's likely that they will remain under $10,000 for the foreseeable future.

The wisest thing for a collector would be to seek out Bourgeois's major wood sculpture from the 1950s. Bourgeois is at her best in wood (which is more forgiving then marble). Her tall vertical works are absolutely first rate and still a good deal at $100,000 to $200,000. Chances are they will go higher in price. Look for them to sell in the $200,000 to $250,000 range sometime during the next five years.

ALEXANDER CALDER (1898–1976)

Estate Representation: Pace Wildenstein, New York

Record Prices at Auction:

Standing Mobile (outdoors): $1,817,500. *Constellation*, painted metal (red and black), 14' 6" overall, 1960 (S. Nov. 93).

Standing Mobile (indoors): $992,500. *Laocoon*, painted metal (black and white), 75"" high, span of 120", 1947 (C. Nov. 95).

Standing Mobile (miniature–under 12" in height): $154,000. *Untitled*, painted metal (black, red, and white), 5 1/2" x 9 1/4" x 6 3/4", 1950 (S. Feb. 90).

Stabile (outdoors): $640,500. *Five Points*, painted metal (black), 84" x 88" x 50", 1957 (C. May 95).

Stabile (indoors): $137,500. *Stabile with Two Heads*, painted metal (black), 16 1/2" x 16 1/2" x 11", 1955 (S. May 89).

Mobile: $682,000. *Roxbury Red*, painted metal (red), 62" x 104", 1963 (S. May 89).

Top Prices at Auction (Nov. 1994–May 1996):

Standing Mobile (indoors): $992,500. *Laocoon*, painted metal (black and white), 75" high, span of 120", 1947 (C. Nov. 95).

Standing Mobile (miniature): $66,300. *Six Vari-Colored Dots and Brass on Red*, 10" high, span of 13 1/2", 1956 (C. May 96).

Mobile: $486,500. *Roxbury Red*, painted metal (red), 62" x 104", 1963 (S. Nov. 95).

MARKET ANALYSIS

Past

Alexander Calder is the only artist in the *Art Market Guide* who did not have a specific boom market. If you examine his top prices at auction, you discover that it's been one big boom market from 1988 to the present.

Calder's prices may have been a shade higher for Mobiles in the late 1980s

but not enough to merit discussion. Between May 1988 and November 1989, at the height of the market, 18 Mobiles came up that sold. The average selling price was $311,000. Between May 1990–November 1991, in a rapidly declining market, 12 Mobiles were sold. The average selling price was $284,500.

That meant that Calder retained approximately 90 percent of his value. Calder's was arguably the one market that was virtually immune to the shifts in the overall art market. The one exception was for miniature Calder works. Tiny Standing Mobiles brought more during the late 1980s.

Present

The 1995–1996 Calder market remained strong although it exercised a little greater selectivity than in past seasons. Prices also seemed to have stabilized. His market is now at a point where the auction house estimates are more in synch with what the work actually brings.

The most interesting event of the season was the reappearance of two major works, *Laocoon* and *Roxbury Red*. Laocoon is considered to be one of Calder's greatest sculptures. It's a textbook example of a Standing Mobile that incorporates the best of the artist's Mobiles and Stabiles. *Laocoon* originally came up to auction at Sotheby's in May 1990. At the time, it carried an estimate of $1.7 to $2 million and failed to sell, though the bidding ostensibly reached $1.6 million. Over five years later, the work came up again at Christie's in November 1995. This time *Laocoon* sold for $992,500, setting a record for a Standing Mobile.

Roxbury Red set a record for a Mobile when it sold for $682,000 back in May 1989. This sculpture recently came back on the block at Sotheby's in November 1995, at an estimate of $400,000 to $600,000. This time around, *Roxbury Red* brought $486,500. It remains one of the quintessential Calder Mobiles due to its beautifully balanced composition of shaped red elements.

Overall, ten Calder Mobiles came up, with eight selling and two passing. The average selling price for a Mobile was $220,000. Once again, demand continues to be strong for all facets of Calder's work. The only new development is the increased interest in the artist's paintings and drawings.

Future

Alexander Calder is one of the three greatest sculptors of the century (the other two are Constantin Brancusi and Henry Moore). His importance is beyond dispute, which is one of the reasons why his market is among the most stable in contemporary art. Another factor is the work's universal appeal. The simple

grace of a Calder appeals to both the naive child as well as the sophisticated curator.

Calder's significance in art history can be traced to his invention of the Mobile. The idea of a moving sculpture hanging in "real" space was a radical development. It was the birth of kinetic art.

Calder's Stabliles are the ultimate in simplified shapes derived from representational forms. These sculptures have included forms as diverse as elephants, giraffes, and armadillos.

The real treasures in Calder's oeuvre are the Standing Mobiles. These works combine the best of Calder: form and movement. Rather than compromise the Mobile or Stabile elements, a synergy is created by combining the two styles. The result is a dynamic sculptural fusion that delights the eye.

Last year's *Art Market Guide* gave Calder a "Hold" recommendation. The 1997 *Art Market Guide* has upgraded Calder from a "Hold" to a "Buy," even though prices and demand during the 1995–1996 season were little changed over the previous season (although the prices brought by *Laocoon* and *Roxbury Red* indicated that there was still plenty of money out there to be spent on Calder). So why is Calder now rated a "Buy"?

The answer has little to do with the auction market or the gallery market. It centers around a factor that will bring greater stability and confidence to the Calder market; the Calder Family Foundation finally has its act together. The Foundation was established to authenticate works by Calder. In previous years the artist's dealer, Perls Galleries, would issue letters of authenticity. With the closing of Perls Galleries, the Calder Family Foundation has stepped in to fill the void. In the near future, the auction houses will not sell Calders without a certificate of authenticity (with an "application number") issued by the Foundation.

The other significant contribution of the Foundation is the compilation of a Calder *catalog raisonné* of all the sculpture. This will certainly make the flow of Calder commerce a lot smoother, which should lead eventually to an even stronger market for his work.

Calder remains one of the most conservative blue chip artists that you can buy. He's the art-world equivalent to having your money in CDs. Like certificates of deposit, if you own a Calder, you are unlikely to see big returns. However, the work will gradually appreciate and you'll have financial peace of mind.

JOHN CHAMBERLAIN (b. 1927)

Primary Representation: Pace Wildenstein, New York

> **Freestanding Sculpture:** $365,500. *Coconino*, painted steel, 58 1/2" x 77" x 60 1/2", 1969 (S. May 95).

> **Wall Sculpture:** $255,500, *White Thumb Four*, painted steel, 71 1/2" x 112 1/2" x 32", 1978 (S. Nov. 95).

> **Miniature Sculpture:** $30,250. *Playskool*, painted metal, 7 1/2" x 5 1/2" x 5 1/2", 1959-61 (S. Nov. 88).

Top Prices at Auction (Nov. 1994–May 1996):

> **Freestanding Sculpture:** $365,500. *Coconino*, painted steel, 58 1/2" x 77" x 60 1/2", 1969 (S. May 95).

> **Wall Sculpture:** $255,500. *White Thumb Four*, painted steel, 71 1/2" x 112 1/2" x 32", 1978 (S. Nov. 95).

> **Miniature Sculpture (under 12 inches):** $11,500. *Auld Clootie*, 6" x 9" x 6 1/2", 1989 (C. Feb. 96).

MARKET ANALYSIS

Past

If you were to choose one word to describe the John Chamberlain market during the boom years, it would be "uneventful." Yes, Chamberlain was carried up in value along with the tide, but it was more of a medium tide than a high tide.

Several outstanding pieces from the 1960s came up to auction. Perhaps the best was *Arch Brown*, a colorful, three-foot in the round work that came up at the Tremaine Collection sale in 1988. This work sold for $143,000, a record at the time. To put this record into perspective, that kind of money wouldn't have bought a yellow 48" x 48" Josef Albers or a 26" x 34" Christo storefront collage in the same sale.

Arch Brown (1962) is in the top 5 percent of the artist's production. The Christo and Albers were just average examples in each respective artist's body of work. To have bought the best by an artist of Chamberlain's calibre for under

$150,000 is truly indicative of his limited (but sophisticated) audience.

In 1989, *Arch Brown*'s record was broken by a galvanized steel (no color) piece from the estate of Robert Mapplethorpe. This powerful work sold for a record-breaking $253,000 (estimate $60,000–$80,000) at the height of the market in November 1989. The strong price indicated that the celebrity "Warhol estate effect" may have rubbed off on the Mapplethorpe offering.

Another highlight from the boom years was a "Tonk" sculpture that sold for $24,000. These tiny Chamberlains are named for the Tonka toy trucks from which they are created. They are in many ways the artist's wittiest creations.

Present

Last year's *Art Market Guide* suggested that the record breaking-sale of the freestanding sculpture *Coconino* might be enough to boost the Chamberlain market. This seems to have been the case. The 1995–1996 season saw another record set, this time for a wall sculpture. Also, two major Chamberlains that had been to auction previously came up again and did quite well.

In November 1995 at Sotheby's, *White Thumb Four* (from the collection of Asher Edelman) broke the record for a wall sculpture when it sold for $255,500. Obviously, Sotheby's thought it would do well as it assigned it an estimate of $200,000–$300,000. *White Thumb Four* is a powerful work of pulsating color with a dynamic horizontal sweep. Like *Coconino*, it represents the best of its category.

Another market indicator was the resale of the former record holder for a wall sculpture, *Blue Flushing*. Way back in November 1988 at Sotheby's, this work sold for a record $110,000, a record that stood until the sale of *White Thumb Four*. In May 1996 at Sotheby's, *Blue Flushing* returned and sold for $96,000. It had been estimated at $100,000–$150,000. Considering how the art market has changed since the boom year of 1988, this was a very strong result.

A similar story was told by the reappearance of *Sphinx Tongue* in November 1995 at Christie's. It sold for $134,500. The estimate had been $60,000–$80,000. This very large freestanding sculpture (108" x 64" x 47", 1988) last appeared just as the art market was crashing, in May 1990, at Sotheby's. At the time the estimate was $180,000–$250,000. *Sphinx Tongue* just missed selling then for $170,000.

Future

John Chamberlain is one of America's three greatest living sculptors. The other two are Richard Serra and Joel Shapiro. Carl Andre, Claes Oldenburg, and

Mark Di Suvero rank just below.

Chamberlain was in many ways the Abstract Expressionist sculptor, more so than David Smith. He moved metal around the way de Kooning pushed paint. Chamberlain's sculptures function as three-dimensional paintings.

One of Chamberlain's most significant contributions was finding a way to use color indigenous to the material he worked with (weathered scrap auto metal). For comparison, David Smith would simply paint some of his pieces with bright "out of the can" color. This may seem like a subtle difference, but it's not. By introducing natural color, Chamberlain created works that were highly evocative of living forms.

Despite record prices at auction in 1995, most works can be bought for a song. Chamberlain remains underpriced considering his greatness. Since 1940, there have been fewer than ten important sculptors, and he is the least expensive of them.

Chamberlains are also relatively uncommon. The number of painted crushed metal Chamberlains (non-miniature) in existence remains below a thousand. Chamberlain has made mature work since 1959, a period spanning 36 years. If you do the math, that's not much work for an international market.

In 1996, Chamberlain had a stunning show of candy-colored-small-scale sculptures at Pace Wildenstein, New York. This was one of the few (if not the only) shows of small-scale works by Chamberlain ever done. The show emphasized the miniature "Baby Tycoons," which evolved from the 1980s "Tonks." All the Chamberlains at Pace featured his signature use of found painted metal, with the artist painting on additional color. All the works in the show ranged from $18,000 (for a "Baby Tycoon") to $40,000 (for a three foot tall sculpture). The entire show virtually sold out.

The significance of the Pace show was that it was democratic. It offered an "introductory" opportunity for a wide range of collectors to own their first Chamberlain. While most collectors tend to by a single representative work by an artist, a surprising number end up collecting an artist in depth. Some of these collectors, whose first Chamberlain purchase may have been a "Baby Tycoon," will become candidates for additional Chamberlains.

The above prices are inexpensive when you consider buying a work by his peers, Richard Serra and Joel Shapiro. A check for $40,000 doesn't even get you in their game (unless you want a miniature Shapiro). A medium-size work by these two artists is around $150,000.

Serra and Shapiro are marvelous artists, are in all the art history books, and are destined to stay there. Their work makes you more aware of all the sculptural forms in your surroundings. Chamberlain goes a step further by making you aware of the sculpture each of us produces daily. The next time you wad up

a piece of paper to throw away, stop yourself and place it on a table. You'll be amazed at its relationship to a Chamberlain. It's that profound subtlety that ensures the work's aesthetic durability. That, of course, is the key to the work's financial durability.

Buy

JOSEPH CORNELL (1903-1972)

Estate Representation: C&M Arts, New York

Record Prices at Auction:

> **Box:** $495,000. *Untitled. (Grand Hotel Pharmacy)*, assemblage, 14" x 13" x 4", 1942-48 (the Billy Wilder Collection, C. Nov. 89).

> **Collage:** $60,500. *The Puzzle of the Reward #1* (chocolate tea pot), paper collage on masonite, 12" x 9", circa 1965 (the Billy Wilder Collection, C. Nov. 89).

Top Prices at Auction (Nov. 1994–May 1996):

> **Box:** $96,000. *Untitled (Medici Variant)*, assemblage, 15 1/2" x 10 3/4" x 4 1/2", circa 1955 (C. May 96).

> **Collage:** $25,300. *Chambres Intimes Vaste Hall*, paper collage on masonite, 14 3/4" x 11 3/4", circa 1960 (C. Feb. 96).

MARKET ANALYSIS

Past

The defining moment in the Joseph Cornell market came when the Edwin Janss, Jr., Collection came up at Sotheby's in May 1989.

Cornell boxes had been stuck in the doldrums for years. The basic Cornell "Sun Box" or "Observatory" could be had for as little as $35,000–$55,000. This was true as late as 1987. Boxes appeared infrequently at auction, averaging perhaps two per seasonal sale. Collages came up a little more often, estimated at $7,500–$12,500.

The Janss sale featured three boxes. All three were attractive, but certainly not major in the way a "Medici" or "Pink Palace" are. Mr. Janss had acquired several of the boxes from Irving Blum at the Ferrus Gallery (Los Angeles) in the early 1960s. The story goes that Mr. Blum was working directly with Cornell but needed to guarantee the artist that several boxes would be sold. Mr. Janss vouched for Blum that if nothing sold he would buy them. Nothing sold, and Janss bought several boxes for approximately $2,000 each.

Nearly 30 years later, the Janss boxes drew active bidding and more than

doubled their high estimate. The finest Janss box set a record, fetching $220,000. The next night a "Medici Princess" (although a "Dovecote" variant) came up at Christie's and almost doubled the previous night's record, selling for $418,000. This excitement culminated in November, when movie director Billy Wilder's rare "Pharmacy" box sold for $495,000, a record that still stands.

Six months later, in May 1990, the euphoria wore off and began to fade rapidly. A record eleven boxes appeared at auction with seven selling, all at or well under estimate.

Present

The current season for Joseph Cornell material was a shade more interesting than the previous season. But not by much. Yet, despite a lack of strong material, there's plenty of interest in Cornell's work, which received plenty of exposure during the 1995–96 season. There was a small show of "Observatories" and related boxes at the Whitney Museum. C&M Arts did a major survey show (complete with a catalog) of both boxes and collages. Yet, without a major box or two at auction, Cornell's market lacked the vehicle to go up.

The best box to appear was at Christie's evening sale in November 1996. An early box (circa 1941–44) called *Untitled (Museum)* came up with an estimate of $80,000 to $100,000. This small box (8 3/4" x 9 1/2" x 8 3/4") opened to reveal eight removable glass bottles that were sealed with corks. Each bottle contained typical Cornell flotsam and jetsam; colored sand, a marble, a coiled wire, etc. This was more of a connoisseur's box, best suited for collectors trying to diversify their Cornell holdings. Apparently there weren't too many connoisseurs in the audience that night, as the box brought a modest $85,000. It would have retailed in a gallery for $125,000.

If there's a signature image that allows Cornell observers to track the Cornell market, it's the "Sun" box. There were two "Sun" boxes that came up this season. Both were mediocre and so were the results. Each box carried a $70,000–$90,000 estimate and each brought $68,500. The previous 1994-95 season saw a better quality "Sun" box sell for $90,000. Had this season's boxes been of higher quality, they too would have probably brought at least $90,000.

The collage action was also weak. A total of four collages came up with all four selling for between $8,050 and $25,300. However, even the one that brought the highest price (an image of two birds perched on a fence) was just a very average example. It made you realize how desperate the Cornell market is for great collages.

Of all the great postwar American artists, Joseph Cornell is the most under-rated. Much of his best work was produced during the heyday of Abstract Expressionism in the 1950s, yet his work is never spoken of in the same breath as de Kooning, Rothko, and Kline. It should be, not stylistically, but in terms of quality.

Someone once remarked, "Joseph Cornell could put a marble in a shot glass and get you to see the universe." That's quite an achievement. Cornell is simply that good.

Cornell is tremendously underpriced. His prices have been held back by two factors: scale and sophistication. Let's address scale first. Cornell's boxes are roughly the size of a shoebox. "Sand Trays" are even smaller. Most collectors want more bang for the buck. However, Fabergé Eggs, Vermeer paintings, and miniature Calder Standing Mobiles are also small.

Cornell boxes are as exquisitely composed as they are sophisticated. The ephemera and found objects, arranged to create a nostalgic environment within the box, encourage the viewer to make up a story. If one is to understand the iconography it helps to be well read. A working knowledge of the ballet, art history, astronomy, ornithology, and geography would also be helpful.

Then there is the difficulty of displaying the boxes. A box cannot be hung like a painting to create illusional space. Nor can it be placed on the floor to define physical space like a sculpture. Cornells are objects to be placed on a table so they can occasionally be held as works of intimate contemplation.

In a hypothetical situation, if a wonderful Cornell "Medici" box (so named because the interior contains a reproduction of an "Old Masters" painting of a royal Medici family member) came on the market it would be estimated at $200,000–$250,000. Let's say it sold at the high end. That means for only $250,000 you could buy the best example of one of the top 15 postwar artists. Try doing that with one of the other 14, such as de Kooning, Johns, or Twombly.

Even for half that ($125,000) you can still buy a first-rate Cornell. You could also buy a Bruce Nauman *Dog Biting Its Ass* (S. Nov. 94) made of foam, wire, and oozing glue. The title of the piece sounds better than what it looks like (if that's possible).

Cornell collages also represent good value. Basic collages sell at auction for $12,000–$24,000. A great collage hasn't appeared at auction in seven years. Should a "Penny Arcade" (the highest quality collage that utilizes actual pennies and refers to Cornell's early days wandering the penny arcades at Times Square) come up, it could easily bring $35,000–$50,000.

During the 1995–1996 season, C&M Art's Cornell show offered works for sale

that far overshadowed anything that recently traded at auction. At least for now, the Cornell market has become more of a gallery market than an auction market. Yet, the auction market for Cornell is poised to improve this season (provided the material is available).

In May 1994 at Christie's, a box titled *Untitled (Medici Variant)* came up for sale and failed to sell for its $80,000–$120,000 estimate (the box was bid up to $75,000, indicating it probably had an $80,000 reserve). Exactly two years later (May 1996) at Christie's, the exact same box came up and went over its estimate of $60,000 to $80,000 to sell for a surprising $96,000. It was surprising because this was a rather unattractive box that barely deserved the prestigious "Medici" designation.

The point is that a mediocre box, that couldn't find a buyer at $80,000 two years ago, readily found a buyer for 20 percent more this past season. The market is going up despite an absence of good material. *Untitled (Medici Variant)* is also an indication of buyer ignorance. It's obvious that whoever bought it was convinced that he or she had gotten an example of Cornell's most revered series (the "Medici" boxes) for way less than the estimated $200,000–$250,000 one would likely bring today. Wrong; this box is more of a footnote to the series.

The message is that if a world-class Cornell should come up during the 1996-1997 season, you're likely to see some fireworks. Cornell's record price of $495,000 is safe for now. But I believe we are entering an era where the going rate for a major Cornell is about to take a big jump from the current $200,000-250,000 to $250,000–$350,000. Joseph Cornell is a "Buy" and will remain so at least until his major boxes approach $500,000.

WILLEM DE KOONING (b. 1904)

Estate Representation: Independent (Post-1980 work available through Matthew Marks Gallery, New York)

Record Prices at Auction:

Painting: $20,680,000. *Interchange*, o/c, 79" x 69", 1955 (S. Nov. 89).

Woman Painting (1950s): $5,500,000 (estimate-painting was sold after sale). *Woman as Landscape*, o/c, 65" x 50", 1954 (S. May 90).

Woman Painting (1950s): $3,410,000. *Woman*, o/p mounted on canvas, 31" x 22", 1953 (S. Nov. 91).

Landscape Painting (1957-1963): $7,150,000. *Palisade*, o/c, 79" x 69", 1957 (S. May 90).

Landscape Painting (1970s): $3,520,000. *Untitled III*, o/c, 69 1/2" x 79 1/2", 1976 (S. Nov. 89).

Work on Paper: $1,870,000. *Two Women IV*, mixed media/paper, 16" x 20", 1952 (C. Nov. 88).

Sculpture: $660,000. *Cross-Legged Figure*, bronze, 24" x 16 1/2" x 15 1/2", edition of 7, 1972 (C. May 90).

Top Prices at Auction (Nov. 1994–May 1996):

Painting: $3,742,500. *Mailbox*, mixed media/paper mounted on panel, 23" x 30", 1948 (C. May 96).

Work on Paper: $1,047,500. *Untitled (Black and White Abstraction)*, enamel/p, 22" x 30", 1949-1950 (S. May 96).

Sculpture: $453,500. *Large Torso*, bronze, 36" x 31" x 26 1/2", edition of 9, 1981 (S. May 96).

MARKET ANALYSIS

Past

The most outrageous event of the boom market years at auction occurred on November 8, 1989. That night a Japanese art dealer paid $20 million for the Willem de Kooning painting *Interchange* (few remember the estimate had been only $4 to $6 million). This price broke the record for a contemporary work of art that was set only a year earlier when Jasper Johns's *False Start* sold for $17 million. Although the price was remarkable, it really shouldn't have been such a shocker. Prior to that sale, de Kooning's prices were already high and rapidly heading higher.

Willem de Kooning has always had a strong auction market. Even in the early 1980s , his work routinely brought well into six figures. The million-dollar prices began in May, 1987 when an early predecessor to the great "Woman" paintings of the 1950s, *Pink Lady* (1944), brought $3.6 million. Later that same year a classic small canvas from 1953-55 (30" x 23") called *Woman (Green)* brought $2 million.

But the event that signaled the highest level of respect for de Kooning's work was when a drawing brought over a million dollars. This occurred when the colorful *Women Seated and Standing* (21" x 25", 1952) topped its $650,000–$850,000 estimate to sell for $1,210,000 (S. May 88). The importance of this sale cannot be overstated. Willem de Kooning became the only contemporary artist to ever have a drawing bring over a million dollars at auction. Jasper Johns came close when *Land's End*, a colored ink on plastic drawing, brought $990,000 (S. Nov. 89).

The sale of *Women Seated and Standing* was validated when, in the fall of 1988 at Christie's, *Two Women IV* (16" x 20", 1952) became the most expensive contemporary drawing ever sold. It brought $1,870,000 against an estimate of $800,000–$1,200,000. No drawing has approached that price since.

Once again, the big prices realized by de Kooning's "Woman" pictures were predictable. What could not have been foreseen was the dynamic market for de Kooning's "Landscapes" of the mid 1970s. In the same sale that featured *Interchange*, the sale of *Untitled III* (69 1/2" x 79 1/2", 1976) for $3.5 million (est. $750,000–$950,000) was overlooked.

Getting back to that memorable evening, one of the more impressive statistics to emerge was that de Kooning also set a record for dollar volume generated by a single artist from a single sale. That night a total of five de Koonings appeared, with the dollar volume totaling $30,635,000. The paintings had been estimated to bring $7,750,000 to $11,250,000. Not a bad evening.

Present

The current season's first round of auctions, in November 1995, saw only two quality de Koonings appear at the evening sales. Both passed. The May 1996 sales were a different story. These sales cast a spotlight on the strength of de Kooning's market for works from the late 1940s.

Christie's cover lot was a superb small painting called *Mailbox* (mixed media on panel, 23" x 30", 1948) that had been off the market for over 25 years. Christie's had high hopes for the painting as evidenced by its pre-sale estimate of $2.5 million to $3 million. Mailbox did not disappoint as it brought $3.7 million. Over at rival Sotheby's, a black and white enamel drawing on paper *Untitled (Black and White Abstraction)*, from the same period as *Mailbox*, also went over estimate ($600,000 to $800,000) to sell for $1,047,500. This drawing had previously been on the cover of Sotheby's May 1993 sale, where it brought $965,000.

But the real de Kooning story, which was written about at great lengths, was the failure of *Woman as Landscape* to sell. The painting drew an inordinate amount of attention because of its celebrity owner (Steve Martin).

But what about the significance of the painting not selling? Sotheby's certainly pulled out all the stops in its catalog marketing strategy. The auction house did a four-page spread and compiled a list of all the "Woman" paintings in existence along with who owned them. Fifteen paintings were listed with only five (including *Woman as Landscape*) in private hands. The painting was estimated at $6–8 million. When the picture first appeared in May 1990 at Sotheby's, the estimate was $9–12 million.

The first time around the painting failed to sell. It was sold for a rumored $5.5 million after the sale to its current owner, who then later tried and failed to sell it again. What gives? After all, it is a rare large painting from America's greatest living painter's most important series.

The answer is simple. *Woman as Landscape* is a "B" painting being flogged as an "A" work. Aesthetically, it's just a little too undefined; the figure isn't pronounced enough to be considered an "A" painting. However, *Woman as Landscape* is probably worth buying if it could be bought in the neighborhood of $3.5 million.

Future

The sale of Interchange for $20 million turned out to be the boom market's last hurrah. But for the de Kooning market, it was just the start of a new level of respect.

Willem de Kooning has become America's Picasso. Investing in his work is

one of the most conservative moves a collector can make. This is not to say he is as great an artist as Picasso. But de Kooning has much in common with the modern master. Willem de Kooning has had a prolific 40-year-plus career that's seen him work successfully through a variety of styles. He's equally adept at painting, drawing, and sculpture. He's also been massively influential on other artists. Unlike Picasso, however, he never developed any printmaking skills.

The question is what, if any, are the opportunities in de Kooning's market? The best way to go about determining this is through a process of elimination. First off, the classic "Woman" paintings of the early 1950s are rare and beyond most collectors' reach. Ditto for the abstract paintings from the late 1940s and the "Urban Landscapes" (such as *Interchange*) from the mid-1950s. However, if you can afford it, the "Woman" drawings can still be found. Good ones can vary at auction from $250,000 to $600,000.

The work from the early 1960s to the early 1970s is largely forgettable. This represents the only period in de Kooning's career that is basically not worth buying. For whatever reason, the artist simply lost his direction. The work done in the late 1980s, has not appeared often enough at auction to make a determination. The guess here is that his later paintings will do well once examples finally start coming up.

That leaves only two possibilities for bodies of work that are undervalued: the "Landscapes" from the mid-1970s and the bronze sculptures from roughly the same period.

The 1970s "Landscapes" are currently in the $600,000-to-$750,000 range at auction. These should be "Million Dollar" paintings within five years. In fact, the best examples with great composition and color are more likely to go for $1.2 million to $1.5 million because these large-scale (but still apartment size) paintings are the best works de Kooning did since the "Urban Landscapes", about twenty years earlier. They have much of the same raw power. At approximately 15 percent of the estimated cost of his earlier work (a guess is that a 1950s "Urban Landscape" would bring at least $5 million), the "Landscapes" of the mid-1970s appear to be a bargain.

The other area of opportunity for financial appreciation are de Kooning's underrated bronze figurative sculptures. This is really the last unexplored territory in de Kooning's oeuvre. The art market got its first taste of the price potential of these works in November 1987 at Sotheby's "one owner" sale of works from the estate of Xavier Fourcade. Mr. Fourcade had been de Kooning's dealer. The sale included nine bronzes that varied in size from six inches to nine feet in height, with estimates from $20,000 to $550,000. The sale was a big success.

Recent sales of de Kooning sculpture have seen the work sell within or below estimate. Full-scale pieces (at least 20 inches in one dimension) start at

around $200,000. That may sound like a lot for an artist who is primarily known as a painter. But when you take into account that he is one of the best traditional figurative sculptors since Giacometti, de Kooning looks like a bargain.

RICHARD DIEBENKORN (1922-1993)

Estate Representation: Acquavella Contemporary Art, New York

Record Prices at Auction:

Painting (Figurative): $1,430,000. *Coffee*, o/c, 57 1/2" x 52 1/4", 1959
(S. May 89, Edwin Janss, Jr., Collection).

Painting (Ocean Park): $1,760,000. *Ocean Park #40*, o/c, 93" x 80 3/4", 1971 (S. May 90).

Work on Paper (Ocean Park): $198,000. *Untitled*, gouache/p, 28" x 23", 1972 (S. Feb. 90).

Print: $93,500. *Green*, etching, 44" x 35", edition of 60, 1986 (S. May 90).

Top Prices at Auction (Nov. 1994–May 1996):

Painting (Figurative): $574,500. *Girl Smoking*, o/c, 33" x 25", 1963 (S. May 90.

Painting (Ocean Park): $607,500. *Ocean Park #26*, o/c, 89" x 81", 1970 (C. Nov. 95).

Work on Paper (Healdsburg): $173,000. *Untitled #1*, a/p, 35" x 19", 1991 (S. May 96).

Print: $40,250. Large Bright Blue, etching, 40" x 26", edition of 35, 1980 (C. Nov. 95).

MARKET ANALYSIS

Past

Richard Diebenkorn's boom market moved his work into the million dollar category. This made the artist the only Californian besides Sam Francis whose work brought seven figures at auction.

The market was equally impressed with both his abstract works and his figurative paintings. First-rate examples of each could be counted on to bring between $1.2 million and $1.8 million. This was inevitable considering Diebenkorn's growing status as an American master.

What was more surprising was that the Ocean Park paintings on paper began bringing big bucks ($100,000–$200,000). Often seen in good Californian collections, they designated the owner as a tasteful, if conservative, collector. When the late 1980s hit, these works jumped from the mere pricey ($35,00–$50,000)

to the expensive. Suddenly Ocean Parks on paper were status items.

Another aspect of the growing Diebenkorn market was the diversity of work that became sought after. Previously, works from the Urbana, Albuquerque, and Berkeley periods had a limited audience. These works were always difficult for a dealer to place (they were never inexpensive). Collectors demanded Ocean Parks or figurative works, or they would have nothing. The boom market produced the lasting effect of making all Diebenkorns from all periods desirable.

Present

Diebenkorn's current season centered around two specific lots. Each is worthy of discussion.

In November 1995, Christie's evening sale contained an early "Ocean Park" painting, *Ocean Park #26*. The auction house's estimate proved accurate, as the painting split its $550,000–$650,000 estimate to sell for $607,500. This particular work was painted in shades of gray and black with a little burnt ochre thrown in. *Ocean Park #26*'s composition had all the right geometry but lacked the rich color that the later "Ocean Parks" are revered for. Since this wasn't considered a great example, *Ocean Park #26* unfortunately did not provide an accurate gauge for Diebenkorn's prime series. A major "Ocean Park" would probably currently sell for $1–1.5 million.

Perhaps the most interesting Diebenkorn to come up this season appeared at Sotheby's May 1996 evening sale. The auction featured the first "Healdsburg" painting to ever come up for sale. Healdsburg is a small town in Northern California's wine country, where Diebenkorn spent the last five years of his life. Visually, these paintings are a logical extension of the "Ocean Park" format. This particular example, Untitled #1 was an acrylic and charcoal work on paper that measured 35" x 19". This work was quite attractive and read more as a painting than a "work on paper." It sold for $173,000, nicely above its $100,000–$150,000 estimate.

Altogether, seven works appeared this season, with six finding buyers. The one work that failed to sell was an awful "Ocean Park" on paper that looked like it had been left out in the rain (C. Nov. 95). So the lone failure was justified. Overall, the six out of seven works that sold represented an improvement over the previous season when six out of nine sold.

Future

Richard Diebenkorn began his career as an abstract painter who derived inspiration from the landscape. The location of the studio determined his imagery.

He began painting in Albuquerque, moved to Urbana, then to Berkeley, did his most famous work in Santa Monica (Ocean Park series), and finished his career in Healdsburg.

Along the way Diebenkorn did some first-rate figure painting. These works enshrined him as a leading proponent of the Bay Area Figurative school. The figurative works eventually made the transition to abstraction. They evolved to a point where it felt like Diebenkorn wanted to paint the figure out of the picture completely. These works took on a geometry that became the Ocean Park series.

The Ocean Park works were accessible, to say the least. Collectors found them decorative and easy to live with. Critics found enough in their heavily worked and reworked surfaces to write about at length. Curators found plenty of latitude to plug them into shows ranging from the representational to the abstract. Dealers found enough demand for the work to create a market. Everybody won.

The most heavily traded works in the Diebenkorn market are the Ocean Park works on paper. The current going rate at auction for a quality work is between $125,000 and $200,000. Price is determined by how colorful and painterly the individual work is. Considering the small size of the works (approximately 30" x 24"), the fact that they're on paper, and the number available (you can always find one if you want to pay up), they're overpriced.

This is not to say they're not good works. They are. But $125,000 to $200,000 for a work on paper, by an artist lacking an international market, is absurd. Many collectors, especially in California, own Diebenkorns. Most bought them when they were $35,000–$50,000, the going rate before the art boom. Ocean Parks on paper shouldn't be priced much higher than $75,000, perhaps stretching to $100,000 for a truly exceptional work.

Diebenkorn's Ocean Parks on paper are unlikely to go down. With the artist no longer producing, there's now a finite number of works. On the other hand, his prices probably won't go up either. Where can they go? To $250,000? Don't bet on it.

Ocean Parks on paper are the province of conservative collectors. The collectors of the future are likely to be more informed in their decision making. They'll be value conscious. Upon examining Diebenkorn's place in art history and discovering that he wasn't an innovator, they may still buy him. But they won't up the ante.

However, Diebenkorn's 1996–1997 season (for all his work), could be helped not by the appearance of a major "Ocean Park" painting (though it wouldn't hurt), but by the emergence of David Park's market (see the John Berggruen Gallery listing in the Galleries section of the book).

The most undervalued segment of Diebenkorn's market is his figurative work. Diebenkorn's major Bay Area Figurative paintings would currently bring between $500,000 and $750,000 at auction. The recent record price brought by a small Park canvas ($178,500) should put upward pressure on the next Diebenkorn figurative canvas. Aesthetically, as well as financially, Diebenkorn's figurative paintings seem to look better as time goes on.

Another factor on the horizon, that could effect the Diebenkorn market, is the retrospective at the Whitney Museum in 1997.

Diebenkorn's print market rebounded a bit last season as the benchmark color woodcuts *Ochre* and *Blue* brought strong prices, selling for $17,250 and $20,700, respectively. Despite both prints' large edition size (200 each), the demand for these two prints appears to be increasing. Look for this demand to continue since both prints bear a strong resemblance to the "Ocean Park" gouaches. In fact, these two prints are better works of art than probably 60 percent of the gouaches. A $25,000 price for *Blue* and a $20,000 price for *Ochre* is a definite possibility during the 1996–1997 print sales.

JIM DINE (b. 1935)

Prime Representation: Pace Wildenstein, New York

Record Prices at Auction:

> **Painting:** $660,000. *Hearts*, acrylic on 57 canvases, each 8" x 6", 1969 (S. Nov. 89).

> **Work on Paper:** $385,000. *March, Without you (hearts)*, w/p on 16 sheets, each 23" by 29", 1969 (C. May 89).

> **Print:** $45,100. *Hand Painting on the Mandala*, etching w/ hand painting, 37" x 35", edition of 60, 1986 (S. Nov. 89).

Top Prices at Auction (Nov. 1994–May 1996):

> **Painting:** $134,500. *Paintings Pleasures*, o/c with objects, 83" x 83", 1970 (C. May 95).

> **Work on Paper:** $60,250. *4 Hearts (In the Night)*, w/p, 23" x 81", 1981 (S. May 95).

> **Print:** $20,700. *Rachel Cohen's Flags State II*, etching with hand painting, 17" x 132", edition of 14, 1981 (S. Nov. 95).

MARKET ANALYSIS

Past

Jim Dine was not an artist in whom dealers speculated. He was a collector's artist.

Dealers have usually been a step ahead of everyone when it comes to spotting trends. They have to be to make a living. During the 1980s, a dealer made money by predicting which artists were undervalued and then stockpiled their works. Dealers made vast sums on the work of Ed Ruscha, Richard Artschwager, Donald Sultan, Tom Wesselmann, Andy Warhol, and others. However, no one ever heard of anyone making a lot of money on Jim Dine.

The reason is that despite Dine's obvious talent, his work is boring and predictable. He doesn't excite a dealer's imagination. Another way a dealer made money was determining that collectors (and other dealers) would pay premium prices for vintage works from the 1960s by artists who came of age

during that era.

When it came to vintage Dines, dealers were indifferent. This was because a Dine "Heart" from the 1960s is virtually indistinguishable from a Dine "Heart" of the 1970s or 1980s. The work wasn't undervalued because it was never strong enough to be reevaluated.

Collectors, on the other hand, bought Dine precisely because of his predictability. They knew it and trusted it from seeing the same thing year in, year out. Prices rose as the result of a rising market for virtually every artist collected. With heavy dealer participation, Dine's prices could have risen at least twice as much as they did.

Present

When an artist's best work appears in a day sale and is estimated at only $10,000–$15,000, you sense that this isn't going to be his year.

Such a fate befell one of Jim Dine's underrated collages, which came up at Christie's day sale in May 1996. The 1970 work, *Large Heart Drawing #18*, can be described as two rows of hearts painted on a sheet of paper measuring 34" x 44". Dine labeled the hearts with written words and pasted on an illustration of a bunch of carrots. While this wasn't the best example from the series, it represented a brief period in Dine's career when he seemed to really be searching rather than resting on his laurels. At any rate, the drawing brought a sorry $11,500.

The lone evening sale work of any consequence was an all-black painting (36" x 24", 1962) called *Little Black Tools*. This small canvas was composed of a field of black paint with a row of small hand tools (actual hammers, screwdrivers, etc.) attached to the top of the canvas. The painting also had a meaningful provenance as it was originally shown in the early 1960s at Illeana Sonnabend's Parisian gallery. Thus the painting harkens back to a time when it appeared Jim Dine was destined to become a superstar. *Little Black Tools* exceeded its $40,000–$60,000 estimate, bringing $74,000.

Overall, the season saw 14 Dines come up with half selling and half passing. Prices were generally low. This can be attributed to the unusually poor selection of material from which collectors had to choose.

Future

Despite Jim Dine's longevity and vast market, he remains a disappointment as an artist. Dine is a good artist but he's not a great artist. The great artists constantly push themselves. They experiment with scale, surface, color, and,

most important, evolve new imagery. It is in this last category that Dine gets himself into trouble.

Dine broke into the art scene in the early days of Pop Art. He originally showed with the high profile Sidney Janis Gallery. Dine was considered an important newcomer. His draughtsmanship and painting skills were first rate. His use of found objects, which he incorporated into paintings, produced provocative results. He developed an original visual language that centered around three major themes: hearts, bathrobes, and hand tools.

All of this was fine and has certainly served Dine's market share well. Dealers live for an artist who keeps producing the same recognizable (saleable) images. The difficulty is that for the last 35 years later he has essentially done the same thing. Some may say similar things about an artist like Georgio Morandi, but make no mistake: Dine is not analogous to Morandi.

Morandi painted variations of the same still life for his entire career. The difference is that Morandi consistently wrung fresh layers of meaning out of the same image. The work became deeper, richer, and took on greater spiritual feeling over time.

Dine became redundant. The hearts, robes, and tools are no longer compelling and haven't been for years. It's Dine's right as an artist to paint whatever he wants as often as he wants. However, the art market (and art history) have their own rights to demand excellence.

You never read much critically about Dine, nor do you hear of him being included in important museum shows. For that matter, I've never heard an artist cite him as an influence. Over the long run, all these factors help the art market develop a consensus about an artist.

Let's play devil's advocate and pretend that Dine got a full dress survey show at MOMA. Let's also assume that the show was tightly edited and really showed the artist at his very best. There would be small sections of work from his major themes, "Hearts," "Robes," "Tools," and "Portraits," complemented by drawings from the same series. The curator would then intersperse small paintings from the 1960s and 1970s by Dine's peers such as Tom Wesselmann, James Rosenquist, and Andy Warhol. Thus Dine would be seen in a stronger context, which would lead (let's say for the sake of argument) to a great review in the *New York Times*.

If all this happened, would Dine's market go up? It just might. But the above scenario is asking an awful lot. Without a strong museum/press push, it's hard to see where the market boost is going to come from.

Dine is not overpriced. His work is fairly priced at auction. Colorful, well-developed works do well, but not ridiculously well. "Hearts" generally bring the most money, followed by "Robes" and "Tools."

In a hypothetical situation, if one major painting (6' x 5') of each of the above themes came up in the same sale, they'd likely bring the following: the "Heart," $150,000; the "Robe," $125,000; and "Tools," $75,000. Five years from now those prices will likely be little changed.

Dine is playing it safe and so is the collector who buys his work. You could do worse than buy his work. However, given the expense of his work and the fact he is unlikely to push himself artistically (why take a risk if it continues to sell?), there are simply too many other major artists to pursue.

Buy

RICHARD ESTES (b. 1936)

Prime Representation: Marlborough Gallery, New York

Record Prices at Auction:

Painting: $550,000. *Baby Doll Lounge*, o/c, 36 1/8" x 60", 1978 (C. May 88).

Print: $15,950. *D-Train*, screenprint, 36" x 72", edition of 125, 1988 (S. Nov. 89).

Top Prices at Auction (Nov. 1994–May 1996):

Painting: $244,500. *Williamsburg Bridge*, o/c, 36" x 66", 1987 (C. May 95).

Print: $10,925. *D-Train*, screenprint, 36" x 72", edition of 125, 1988 (C. April 96).

MARKET ANALYSIS

Past

Richard Estes's showing at auction during the boom years was characterized by a scarcity of major paintings. Between November 1987 and May 1990, only three large important paintings appeared. That's only one picture per season, not per auction. The average selling price for these three works was an impressive $524,000.

Another interesting aspect of Estes's past market is the vast difference in price between his work and the other Photorealists.

At the top of the pyramid is Chuck Close. If a major early Chuck Close portrait had come up (it didn't), you'd have been looking at $1,000,000+. Next is Estes. Right below him the drop-off in price for the next leading artist, Charles Bell, was steep. His top lot brought $187,000.

Below Bell (subject matter: gumball machines, toys) was Audrey Flack (subject matter: cakes, complex still lifes), whose top price was $104,500. She was followed by Ralph Goings (subject matter: diner interiors, trucks) at $77,000. Next was Richard McLean (subject matter: horses) at $38,500. A Robert Bechtle (subject matter: automobiles, suburban houses) came up but failed to sell (estimate $45,000–$55,000). It would be more accurate to be able to average each of these artists' prices, but their scarcity at auction makes it difficult.

The difference in Estes' stature and price is reinforced by the fact that you could total the above record prices for these five leading artists (a total of $457,000, including a $50,000 estimate for a Robert Bechtle) and you still couldn't have bought an Estes.

Present

The current Estes season lacked excitement, due to a dearth of outstanding paintings. Three works appeared that were worthy of inclusion in an evening sale. Only one of the three was from the 1970s, Estes's strongest period. Many Estes paintings from the 1980s are outstanding, but just a shade slicker. It's a subtle difference. However, since nuance is everything in Photorealism, a major 1970s work should bring a premium price. This wasn't the case during this season.

In fact, the lone work from the 1970s didn't even sell. The painting was titled *Valet* (42" x 66", 1972). It appeared at Christie's in May 1996 with an estimate of $300,000–$350,000. *Valet* ended up passing at $240,000. Why? First off, the painting had just been exhibited at a West Coast Gallery for $350,000 and obviously found no takers. Second, the painting was of a New York city block rather than a more desirable close-up of buildings and their reflecting windows.

Back in November 1995, the best Estes painting of the season came up at Christie's. This work depicted a classic Estes split view of an "above ground" subway car and the corresponding outside view. The painting, titled *Williamsburg Bridge* (36" x 66", 1987), was estimated at $250,000–$300,000 and sold for $244,500. This would have been in line with how a new painting (of similar size) would be priced on the primary market.

The third large-scale Estes to appear was an early 4' x 5' painting from 1969 titled *General Machinist*. The painting was a close-up of a storefront with plenty of reflections in the windows. The painting was estimated at $150,000–$200,000 and sold for $167,500. The price was surprisingly good considering the work was on masonite rather than canvas. If *General Machinist* had been painted on canvas, it probably would have brought at least $50,000 more.

Future

A while back, Richard Estes's longtime dealer Allan Stone gave a unique lecture. Stone would flash slides on a screen of a "mystery artist's" earliest professional works. Stone showed the slides in the chronological order of each artist's development. Members of the audience were invited to guess

who the artist was.

Since the lecture was in San Francisco, the audience quickly recognized the early works of ceramic sculptor Robert Arneson. It took them a little longer to figure out the next artist, Wayne Thiebaud.

The third artist left the audience totally baffled. Stone showed slides of poor quality figure paintings that were painted with an illustrator's touch. As the slides clicked on, the figures and their environments became more realistic. No one could decipher who it was. Finally, Stone gave up and projected some mature (post-1967) Photorealist urban landscapes. It was Richard Estes.

The point to this story is that Estes's brand of hyper-realism seemed to come from out of nowhere. Based on his early work (unlike Frank Stella and David Hockney, who produced mature work from the word go), there was no way of knowing Estes would make competent work, let alone develop into a major artist. I don't know what Allan Stone saw in the early work, but his perception was right on the money.

Now that Chuck Close (the top practitioner of Photorealism) has made the adjustment to being more of an independent painter than being part of a movement, Estes stands alone as the top Photorealist.

Estes's work isn't for everyone. His audience is limited mainly to realist collectors or those who admire his impressive technical skills. He could eventually appeal to a wider audience. Estes's work is so realistic that within a few seconds of viewing, the image quickly becomes abstract. His ability to paint shadows and reflections gives his paintings an edge that take them beyond mere likeness. Estes is as much an abstractionist as he is a realist.

Estes's market has always been efficient. This is an artist whose supply, by nature of the exacting style of work, is extremely limited. He probably couldn't paint more than three or four major pictures a year, no matter how great the market pressure to produce.

At auction, full scale (3' x 5') mature works have recently been selling for $200,000–$300,000. That's similar to what they would be in a gallery. Lately, many blue chip artists' works have been selling for less at auction than they would at a gallery. Not Estes. There are no deals for Estes at auction. If you want one, you have to pay up.

Should the trend continue, and there's no reason to believe it won't, Estes will remain a secure investment. There will always be an audience for representational painting, and there will always be a lucrative market for the best of this genre.

For those looking for a bargain, the only one that exists is in his print market. Estes did only three prints that are equal in scale and quality to his paintings: *Qualicraft Shoes*, *D-Train*, and *Holland Hotel*. The latter two sell in

the $8,500–$12,500 range. However, *Qualicraft Shoes* (silkscreen, 33" x 47", edition of 100, 1974) has been selling for only $2,500 to $3,500. Better yet, it's aesthetically superior to the other two prints. *Qualicraft Shoes* is from the 1970s, so, like the paintings of this era, it avoids the slickness of the 1980s work. If you're an Estes fan who can't afford a painting, this print is a steal.

DAN FLAVIN (b. 1933)

Prime Representation: Pace Wildenstein, New York

Record Prices at Auction:

> **Sculpture:** $231,000. *Untitled (To Pat and Bob Rohm)*, red, green, and yellow fluorescent light, 96" x 96" x 2 1/2", edition of 5, 1969 (C. May 90).

Top Prices at Auction (Nov. 1994–May 1996):

> **Sculpture:** $74,000. *Untitled (To Philip Johnson)*, pink, green, blue, and red fluorescent light, 96" x 9" x 4 1/2", edition of 3, 1964 (C. Nov. 94).

MARKET ANALYSIS

Past

Dan Flavin achieved exactly one big price during the 1980s ($231,000) and then he sort of disappeared. Leading up to this price were two works sold in the $60,000 range. After that, the drop off was to a couple of works that brought $30,000-plus. And that was it.

In the early 1990s, the pattern was repeated. Once again there was one big price, of $170,500. This was followed by a couple of sales in the $60,000-plus range and a few in the $30,000 range. Only this time about a third of the works offered ended up passing. The big price was brought by a single-white-tube work titled *The Diagonal of May 25, 1963 (To Robert Rosenblum)*. But there were better works to come up that brought a lot less money. For instance a work from his finest series, the multitube "Tatlin Monuments," brought just $99,000 (S. Nov. 91).

What made Flavin's market difficult to analyze was that there seemed to be no differentiation between classic works from the 1960s and later post-1970s sculptures. The dominant factor wasn't necessarily size or color. The success of a work at auction was usually based on one or more collectors wanting a piece (because they simply liked it), rather than a conscious decision by collectors to pursue a piece because it was from the artist's best period.

Present

A total of eight Dan Flavins came up for sale during the 1995–96 season, with six passing and only two selling. The sad thing was the two that sold averaged only $19,550 per work. That's pathetic for an artist of Dan Flavin's stature. One of the two works to sell was a red cross of two fluorescent tubes (25" x 25", ed. of 5, 1969) for $25,300. The other was an eight foot-tall yellow-fluorescent-tube work from 1990 that brought just $13,800.

The big disappointment was the evening sale work from the "Tatlin Monument" series. This prime 1960s work was composed of eight cool-white tubes, measured 96" tall, and was part of an edition of eight. This Flavin was estimated at $100,000 to $150,000. There was virtually no bidding and the piece stalled out at $85,000. The reserve must have been at least $90,000. No matter. The failure of a major work by an important Minimalist to bring at least $100,000 is pretty disappointing.

Try and buy a major vintage work for $100,000 by one of the other major Minimalists (Donald Judd, Carl Andre, Robert Ryman, or Brice Marden). You can't. A good work from a vintage period by an important Minimalist sculptor would start at $150,000. The starting price for a prime work by an important Minimalist painter would start at $250,000. It is indicative of how low Dan Flavin's art market status has sunk in the art world.

Even if you look at Flavin's market another way and base it on the going rate for a full- scale work, regardless of period or historical significance, you can buy a work for less (by far) than any of the above artists. A quality Flavin can be bought routinely for $20,000–$25,000. The minimum price for a good work by any of the Minimalists, regardless of period is at least $50,000 for the sculptors and $75,000 for the painters.

Future

Think about a hypothetical artist who produces work that's so intense you can't look at it for more than a few seconds at a time. Only that artist isn't hypothetical. He exists and his name is Dan Flavin.

The intensity of the light emitted by one of Flavin's fluorescent tubes (the same tubes used in offices for overhead lighting) is impossible to stare at for more than five seconds at a time. Your eyes simply can't take it. In a world where being able to look at something long enough so that you can contemplate its meaning is essential, Dan Flavin has a problem.

A Flavin is at its best in a museum setting. The intensity of the work's glow, as well as how it bathes the wall in "painted" light, necessitates the need for

lots of surrounding space. If you hang a Flavin in your home, you had better be prepared to hang it in its own room. A Flavin sculpture dominates every space it's installed in as well as any other work of art within close proximity.

It would be helpful if Flavins looked good with their lights turned off. But they don't. They look like what they are; dull fluorescent tubes. Oddly enough, his most underrated works, the circular fluorescent tubes, are interesting enough forms and look good when they're not activated. Unfortunately, they're not popular with collectors. The few that have come on the market have not found buyers. The most recent, a work titled *Untitled (Fondly to Margo)* (white tubes, 96" high, ed. of 5, 1986) came up with a modest estimate of $35,000–$45,000. The bidding went no higher than $20,000 before the sculpture passed (S. May 1992).

From a purely historical viewpoint, Dan Flavin is an important artist. His use of electric current to create an artwork was highly innovative. Flavin's work was quite controversial when he began working in the 1960s. In fact, Leo Castelli's decision to show Flavin in 1967 (the artist was originally with the Jill Kornblee Gallery) convinced his director Ivan Karp to resign from the gallery. Regardless, Flavin has always found plenty of dealers to show his work. That's never been a problem. The problem has been finding collectors to live with the work. It is a problem that will continue into the future.

SAM FRANCIS (1923–1994)

Prime Representation: Andre Emmerich Gallery, New York

Paintings from Key Periods:

"Floating Island": $1,870,000. *Round the World,* o/c, 108" x 136 1/2", 1958–59 (C. May 90).

"Blue Ball": $990,000. *Silvio Set One,* o/c, 47 1/2" x 40", 1963 (S. Nov. 89).

"Bright Ring": No lots appeared.

"Edge": $99,000. *Untitled,* a/c, 55 1/4" x 19 1/4", 1967 (C. May 89).

"Grid": $330,000. *Golden Rod,* a/c, 76 3/8" x 51 1/2", 1974 (C. May 90). Note: A gargantuan-size grid brought $385,000 in February 1990.

Paintings on Paper from Key Periods:

"Floating Island": $550,000. *Untitled,* g/p, 29 3/4" x 22 1/4", 1958-60 (C. Nov. 89).

"Blue Ball": $145,000. *Tokyo Blue,* g/p, 51 1/2"" x 32, 1961 (C. May 94).

"Bright Ring": $198,000. *Untitled,* g/p, 26 3/4" x 40 1/2", 1963-64 (C. Nov. 89).

"Edge": $41,250. *Untitled,* g/p, 39 3/4" x 28", 1966 (S. Nov. 90).

"Grid": $88,000. *Untitled (Tokyo)* a/p, 22 1/4" x 29 1/2", 1974 (S. Nov. 89).

Print: $49,500. *King Corpse,* screenprint, 42" x 59", edition of 65, 1986 (C. Nov. 89).

Top Prices at Auction (Nov. 1994–May 1996):

"Floating Island Painting": $167,500. *Verticle Blue and Yellow,* o/c, 32 1/2" x 16", 1959 (C. Nov. 95).

"Floating Island Painting on Paper": $365,500. *Untitled,* g/p, 59 1/2" x 44", 1958 (S. Nov. 95).

"Blue Ball Painting": $90,500. *Composition in Blue and White,* o/c, 35" x 46", 1960 (S. Nov. 95).

"Blue Ball Painting on Paper": $45,000 - $65,000 (passed). *Blue Five*, a/p, 29" x 41 1/2", 1960 (C. May 95).

"Grid Painting": No lots appeared.

"Grid Painting on Paper": $57,500. *Untitled*, a/p, 22" x 30", 1977 (S. May 96).

Print: $14,375. *King Corpse*, silkscreen, 42" x 59", edition of 65, 1986 (C. April 96).

MARKET ANALYSIS

Past

Sam Francis is a loaded subject. This is an artist who has been salable since day one. Because he is so easily bought and sold, one immediately suspects the work. On the other hand, there is something to be said for an artist who produces work that critics want to write about, dealers want to exhibit, and collectors want to live with.

Francis is usually bought and sold with reckless abandon regardless of aesthetics. This has always been the case. The artist's failure to edit himself, the dealers' lack of discernment, as well as the collectors' abdication of connoisseurship all contribute to this dilemma. The market has never practiced any restraint by rejecting the vast number of mediocre works that enter it. Eventually it will become more disciplined.

The boom market for Francis had its highlights. Three major "Floating Island" paintings were sold for between $1.3 million and $1.8 million (C. Nov. 88, C. May 90, S. May 90). If these works were to appear again at auction, chances are excellent that they would all sell for only about 25 percent less. By comparison, the great Mark Rothkos that were bringing $2.5 to $3.5 million would now sell for 50 percent less.

The most commonly traded Francis works are the acrylic on paper "Grids" from the 1970s. Their standard size sheet is 22 by 30 inches. At the start of the decade, they were selling for $6,500. By the end of the decade their value had increased tenfold. The going rate was $65,000 and $75,000–$85,000 was not out of the question.

Present

The 1995–1996 season provided market observers with the first opportunity to gauge the posthumous Sam Francis market. The funny thing was that nothing happened. The market wasn't flooded with people wanting to sell nor was the buying particularly heavy. Prices did not go up or down. It was as if nothing had changed and in fact nothing had.

The biggest surprise was that not a single person consigned a major Francis painting to the November 1995 sales. The most important picture offered was a small late 1950s canvas, *Verticle Blue and Yellow* (32 1/2" x 16", 1959), which was estimated at $150,000–$200,000. It sold for a "matter of fact" price of $167,500. All told, 18 works came up in November, with 15 selling.

It was a similar story in May 1996. No major pictures appeared but almost everything that came up sold (18 out of 21 works). Prices ranged from $5,500 for a 1987 postcard-size painting on canvasboard to $109,750 for a four-foot-square canvas from 1983. Most of the other prices fell somewhere in between, proving yet again that the strength of the Francis market has always been its democratic nature: something for everyone.

It should also be mentioned that an exceptionally colorful "Grid" painting on paper, from the 1970s, brought a strong price of $57,500 (the estimate had been a typical $35,000–$45,000). If there's such a thing as a market indicator for Francis, the 1970s "Grids" on paper are it.

Future

Of all the major contemporary painters, Sam Francis was the second most prolific behind only Andy Warhol. Even that might be debatable. When talking about the Francis market, you are really talking about numerous mini-markets based on all the different periods of work. The following periods are among the most collected.

At the top of the pyramid are the so-called "Floating Island" paintings of the late 1950s. Art history will ultimately judge Francis primarily on this work. The major large-scale canvases hold their own with the best of the first generation Abstract Expressionists. Evidently the market thinks so too, as these pictures still command a million dollars-plus when they come up to auction.

The "Blue Balls" from the early 1960s are exceptional. There was no precedent for these globular blue forms in the history of painting. In terms of price, the canvases ($150,000–$450,000) are undervalued while the works on paper ($50,000–$150,000) are probably "maxed out."

Chronologically the next significant body of work is the "Bright Ring"

period of the mid-1960s. These are first-rate works that combine poetic color, lyrical paint handling, and highly original composition. These works are undervalued ($35,000–$75,000 for works on paper; canvases come up too infrequently to comment). The reason is they are the rarest of all Francis's major periods. "Bright Ring" drawings were only made from 1963 to 1965.

By far the most undervalued of Francis's oeuvre are the "Edge" paintings of 1965–1970. These paintings have never sold well. The dominance of white space seems too challenging for most collectors. Francis once remarked that these were his best paintings. While this isn't true, they are among his best.

The "Edge" paintings have a beauty that reveals itself slowly, much like a flower that gradually opens. It is only a matter of time before collectors gain the patience necessary to enjoy the work and begin pursuing them. Works on paper are estimated at approximately $20,000–$40,000. The canvases rarely come up and usually pass at estimates of $75,000–$200,000.

The last significant period of Francis works are the "Grids" of the 1970s. Paintings that were painted in Tokyo (especially from the years 1973–74 and 1976–77) are special. Works on paper always do well at auction and sell for between $35,000–$45,000. Canvases routinely fall in the $75,000–$150,000 range.

After the "Grids" (post-1980), Francis didn't produce any work of significance. That's 14 years' worth of large quantities of dubious production on the market, which tells the collector to be extra careful when buying a late Francis.

When Francis passed away, in 1994, the biggest concern was the possibility his market would be flooded with late work. For that reason, the 1995–96 *Art Market Guide* listed Sam Francis as a "Hold." During the past season, these fears proved unfounded. While the Francis market was never tested at the highest end, the rest of it acquitted itself quite well. The auction houses seemed to exercise good common sense and apparently took on only as much work as they thought they could sell.

With the danger of too many works on the market no longer a concern, the recommendation for Francis has shifted to a "Buy." Francis remains one of the most accessible artists to both beginning and more sophisticated collectors. He's one of the first artists that collectors look at when they start to acquire. He's also a favorite of seasoned conservative collectors. Those are two of the biggest collecting segments of the market. The bottom line is that Francis remains one of the three most popular artists to collect (along with Andy Warhol and Roy Lichtenstein) and apparently will remain so.

HELEN FRANKENTHALER (b. 1928)

Prime Representation: Knoedler & Company, New York

Record Prices at Auction (May 1988–May 1990):

 Painting: $715,000. *Yellow Caterpillar*, o/c, 93 1/2" x 120", l961 (S. May 90).

 Painting (Post 1970): $220,000. *Cravat*, a/c, 62 3/4" x 58 3/4", 1973 (C. May 89).

 Print: $44,000. *Savage Breeze*, woodcut, 29" x 43", edition of 31, 1974 (S. May 89).

Top Prices at Auction (Nov. 1994–May 1996):

 Painting: $112,500. *Approach*, o/c, 82" x 78", 1961 (C. May 96).

 Painting (Post-1970): $103,700. *This Morning's Weather*, a/c, 88 1/2" x 112 1/2", 1982 (C. May 95).

 Print: $20,700. *East and Beyond*, woodcut, 32" x 27 1/2", edition of 31, 1974 (C. Nov. 95).

MARKET ANALYSIS

Past

Helen Frankenthaler's showing at auction during the late 1980s was not much different from her current market. Generally, paintings sold for $50,000–$150,000 on a fairly consistent basis.

 If anything was established, it was the scarcity of material from the late 1950s and early 1960s. Only a couple of these works made an appearance. One of them, *Yellow Caterpillar*, set a record, selling for $715,000 (estimate $600,000–$800,000). This was one of Frankenthaler's great early paintings.

 The "bookend" and better painting, *Blue Caterpillar*, came up four years later (C. May 94). It sold for only $189,500 (estimate $200,000–$300,000). Why? Besides being a later work, there's a more subtle reason. *Blue Caterpillar*, despite being of similar size and slightly better quality, had one thing working against it: It is vertical, whereas *Yellow Caterpillar* is horizontal.

 When buying "decorative" paintings (this is said respectfully), collectors place a tremendous premium on horizontal works. If *Blue Caterpillar* had been

horizontal it probably would have sold for around $300,000–$350,000.

Present

The art market has always had an appetite for Helen Frankenthaler. Unfortunately, only one out of three of her paintings that come up to auction is worth buying. This, of course, has led to some depth on the demand side for quality paintings. The one-out-of-three theory more or less held true during the 1995–1996, season as seven Frankenthaler canvases came up to auction and only two sold.

By far and away the best work to come up was an early painting called *Approach* (82" x 78", 1962), which came up at Christie's in May 1996. While *Approach*'s lyrical red, blue, and brown composition was not of the first tier (which accounts for its low selling price), it was still a scarce early painting. The purchaser got a bit of a bargain by paying only $112,500 against an estimate of $100,000–$150,000.

Sotheby's November 1995 sale featured three late Frankenthalers. All were of about equal quality, which is to say that all three were good but not great. The first to appear was *Ashes and Embers* (59 1/2" x 90 1/2", 1988), a composition in blacks, whites, and reds. It passed (est. $60,000–$80,000). Next to appear was *Lilac Frost* (78" x 114", 1977), a composition in turquoise, browns, and yellow. It also passed (est. $60,000–$80,000). Finally, *Wellspring* (48" x 51 1/2", 1985), a composition in browns, mauve, and small patches of metallic gold, came up and sold for $57,500 (est. $40,000–$50,000). Why did only *Wellspring* sell when all three were of indistinguishable quality? The best guess is a combination of reasonable size and the allure of the metallic gold pigment.

Future

There is a subtle buzz in the air that decorative works of art by well-known artists are slowly being bought again. Chances are unlikely that this "feeling out there" will help the markets of Color-Field painters Kenneth Noland, Morris Louis, Jules Olitski, or Larry Poons. Helen Frankenthaler may be a different story.

Louis is an important artist, but his best works are often too large and too expensive. Noland's "Targets" are certainly worthwhile, but there are too few great ones that ever come on the market. It's hard to believe that one once sold for an astounding $2 million (S. Nov. 89). The rest of Noland's work (with the possible exception of the diamond-shaped canvases from the 1960s) is forgettable. Poons and Olitski are similar stories. Finally, Morris Louis's prices have peaked.

However, Frankenthaler's market has more going for it. Her work is firmly grounded in art history. Most art world followers are aware of her contribution of inventing a technique that involved staining raw canvas with poured paint. This development greatly influenced Louis and Noland. More significantly, it allowed Frankenthaler to develop her own brand of lyrical abstraction.

Early in her career, Frankenthaler made the right connections. She had been with the Andre Emmerich Gallery from 1959–1989. She's also had plenty of museum exposure. *Mountains and Seas*, at MOMA, is one of the great post-War paintings, period. The critics of her era have written respectfully about her work. She's always been collectible. In other words, this is a long, successful, ongoing career.

Despite all these positive factors, Frankenthaler has never been that expensive. If you throw away the prices for a few exceptional early paintings, you find most of her work selling for $45,000–$125,000 for a full-size, mature painting. Since she really doesn't do much work on paper or small canvases, a collector has to consider owning a full-blown large (6' x 4' and up) canvas.

If you are a fan of the work and if market considerations are important to you, your best bet is to go for overall composition and color rather than buying the best period (pre-1970). The period should matter, but it doesn't seem to. The market generally prefers the later work. Paintings with little white space, bright, evocative color, poetic marks, and reasonable scale should do well in the future.

Another opportunity lies in certain Frankenthaler prints. The woodcuts done at ULAE are some of the best ever done by a painter. For instance, there have been beautiful woodcuts by Richard Diebenkorn (*Blue* and *Ochre*). But these were actually translations of his gouaches done by Japanese woodcut masters (in Japan). Diebenkorn had little to do with the final results. Frankenthaler's great woodcuts, *Savage Breeze* and *East and Beyond*, were done by her. The printshop ULAE did the printing. Both prints look like what Frankenthaler wishes she could accomplish by painting on paper, but never has been able to. I also like the fact that the edition size of these prints was kept small (31 each). Compare this to the huge editions (200 each) done for Diebenkorn's *Blue* and *Ochre*.

The going rate for *Blue* and *Ochre* is approximately $20,000 and $17,000, respectively. At the height of the market, Blue sold as high as $45,000 and Ochre got up to $27,500. The current going rate for *East and Beyond* is $20,000 and *Savage Breeze* is in the $10,000 range. At the height of the market, East and Beyond brought $28,600 while *Savage Breeze* brought $44,000. Although Diebenkorn is a better painter than Frankenthaler, at this point Frankenthaler is the more important historical figure. Given the quality and small editions of these two Frankenthaler woodcuts, they offer a potential opportunity that should be investigated.

Buy

ARSHILE GORKY (1904–1948)

Prime Representation: Estate was dissolved

Record Prices at Auction:

Painting: $3,962,500. *Scent of Apricots on the Fields*, o/c, 31" x 44", 1944 (S. Nov. 95).

Drawing: $431,500. *Virginia Pastel,* pastel and graphite/p, 20" x 27 1/2", 1942 (S. Nov. 95).

Top Prices at Auction (Nov. 1994–May 1996):

Painting: $3,962,500. *Scent of Apricots on the Fields*, o/c, 31" x 44", 1944 (S. Nov. 95).

Drawing: $431,500. *Virginia Pastel,* pastel and graphite/p, 20" x 27 1/2", 1942 (S. Nov. 95).

MARKET ANALYSIS

Past

Unlike his fellow Abstract Expressionists, Arshile Gorky did not participate in the run-up of prices that occurred in the late 1980s. It wasn't due to his failure to produce quality work. Rather, it was due to the failure of quality examples (or virtually any examples for that matter) to come onto the market. Basically, Gorky was somewhat of a novelty at auction rather than a regular participant.

Between May 1988 and May 1990, a total of six "evening sale quality" works appeared, with the dollar volume totaling only $1.6 million ($880,000 of that was for just one painting). That wouldn't even equal the sale of a single good de Kooning. Gorky's dollar volume is a joke when compared to the tens of millions of dollars worth of work sold by Pollock, Kline, Rothko, and de Kooning.

The single Gorky of consequence to appear was in the Edwin Janss, Jr., sale of May 1989 at Sotheby's. A painting titled *Delicate Game* (34" x 44", 1946) came up with an estimate of $1.2 to $1.5 million. In a sale where virtually everything went way over estimate, the Gorky brought only $880,000. What's the explanation? Despite its solid composition, the painting had only a minimal amount of color. Still, the scarcity of mature Gorky canvases should have kicked-in to produce a bigger price.

Present

The present Gorky market really needs to be thought of as the "recent present" rather than the current season because, since 1993, a major Gorky canvas has come up each year (a total of four canvases). That may not sound like much by other artists' standards, but for an artist with as short a career as Gorky, it's akin to striking the motherlode.

In November 1993 at Christie's, *Year After Year* (34 1/2" x 41", 1947) came up at the tail end of a down art market with an estimate of $2.5 to $3.5 million. This first-rate painting sold for $3.85 million, mainly because *Year After Year* was the best Gorky to appear in memory.

Six months later, an arguably better painting from the important Gates Lloyd estate, *Dark Green Painting*, came up with an optimistic estimate of $3.5 to $4.5 million. It sold for a still impressive $3.5 million. Next came the greatest Gorky ever to appear at auction, the wonderfully titled *Scent of Apricots on the Fields* (31" x 44", 1944). This work came up at Sotheby's in November 1995 with a logical $2.5 to $3.5 million estimate. The painting's beautiful saturated color led to a record-setting $3.96 million.

In May 1996 at Sotheby's, the fourth major Gorky to appear in as many years came up. The 1947 painting was titled *Study for Agony* (its counterpart *Agony* is in MOMA's collection) and measured 36" x 48". The estimate was the "usual" $2.5 to $3.5 million. It sold for $2.4 million, a respectable price given that it wasn't as fully painted as the record-setting *Scent of Apricots on the Fields*.

Future

Does Arshile Gorky even have a future at auction? The answer is yes for his drawings and probably not for his paintings. Arshile Gorky had a very short career that saw less than ten years of mature production. During those ten years he produced less than 100 paintings. As anyone who saw the gorgeous 1996 Gorky retrospective will tell you, most Gorkys are in museum collections. The likelihood of four major canvases coming up in four years again is about as likely as four Joseph Cornell "Medici" boxes coming up in four years.

Unlike most significant artists, Gorky didn't produce minor canvases. Almost all were the result of the culmination of many drawing studies. I know of no other artist who's in the same category. For this reason the inclusion of a Gorky painting at auction is an event. Collectors of blue chip art were spoiled by the unusual circumstances of the last four years.

Chances are excellent that the next great Gorky to come up will set a new

price record ($5 million is certainly possible). This is even more likely if the auctions go two or more seasons without a Gorky. The market for fully developed, colorful Gorky drawings should remain strong and continue to hover in the $250,000 to $450,000 range. It's unlikely they'll go over $500,000. His drawings are good but feel more linked to Surrealism than his paintings, which are more attuned to Abstract Expressionism.

Since a serious collection of Abstract Expressionism has to have a Gorky painting, the price for a Gorky should in theory have nowhere to go but up. But most serious collectors aren't like museums who need representative examples by all the important artists. Collectors tend to buy their favorite artists. In the case of "Ab Ex" that usually means Mark Rothko or Willem de Kooning (maybe Franz Kline). Few collectors can afford great examples by all the major artists of that era. Clyfford Still, Barnett Newman, and yes, Arshile Gorky are too sophisticated for most collectors. So the market for Gorky will go up but has its limitations (a likely ceiling of $5 million) due to the work's sophistication.

PHILIP GUSTON (1913–1980)

Estate Representation: McKee Gallery, New York

Record Prices at Auction (May 1989–May 1995):

Painting (Abstract Expressionist): $1,056,000. *Summer*, o/c, 63" x 60", 1954 (C. Nov. 90).

Painting (Representational): $577,500. *Rug III*, o/c, 69" x 110", 1976 (S. May 92).

Painting on Paper (Representational): $71,500. *Roma #1*, o/p, 19" x 27 1/2", 1971 (S. Feb. 90).

Drawing (Representational): $52,800. *Untitled* (hood, pile of shoes), charcoal/p, 28" x 32", 1971 (C. May 89).

Top Prices at Auction (Nov. 1994–May 1996):

Painting (Representational): $101,500. *The Painter (hooded figure)*, oil on panel, 24" x 26 1/2", 1969 (S. Nov. 94).

Drawing (Representational): $26,450. *Untitled (two hooded figures)*, ink on sheetrock, 23 1/2" x 42", 1970 (S. May 95).

MARKET ANALYSIS

Past

Philip Guston didn't really have much of an auction market until the late 1980s. He was simply an artist whose works infrequently appeared. Guston was more of a market waiting to happen.

Guston's late works first came into art world consciousness with a traveling museum show around the time he died (1980). But it wasn't until 1984 that the art market responded. A marvelous painting of two cigar-smoking hooded figures in an automobile with fat tires came up at Sotheby's (Nov. 94). The painting, *Out for a Ride* (43" x 33", oil on masonite, 1969), came up with a then serious estimate of $60,000–$80,000. It sold for a surprising $96,250.

Four years later, another late Guston came on the market (S. May 88). This time the psychological barrier of $100,000 was breached by *Dark Room* (68" x 80", 1976). Although not a great painting, it still managed to set a

record while selling at the low end of its estimate for $220,000.

A year later, at the market's acme, Guston's representational paintings climbed to the $500,000 level. Over the next few years, despite a falling market, five major late paintings came up, with an average selling price of $525,000. In the heart of the recession the record was set for a late Guston when *Rug III* brought $577,000 (S. May 92). The growing strength of Philip Guston's market was now a matter of fact.

Present

The "highlight" of Guston's 1995–1996 auction season was the sale of one of his "transitional" abstract paintings on paper, *Pink Light* (30" x 40", 1963) for $36,800. The sarcasm in calling this a highlight is based on the fact that not a single important Guston came up for sale.

However, the sale of one of his 1960s transitional paintings (for about half of what one of his representational works on paper from the 1970s would bring) raises the issue of whether this body of work will ever go up in value. For that matter, will transitional bodies of work ever go up for any artist? The answer is probably not, especially if the artist is a great one like Philip Guston.

What's likely to happen is the "rich get richer" theory. A transitional work by a mid-level artist, such as Malcolm Morley, is very difficult to sell (it's hard enough to sell his best work, the early Photorealist pictures). His paintings that are viewed as transitional (crudely painted realist works) usually pass at auction. The few that sell generally go to collectors who can't afford the best and are only buying a "name" (the idea is to buy a name but a work that's indicative of why that artist became a name).

With an important artist like Guston, you're generally dealing with a more sophisticated collector who can afford the best. For that reason, the competition becomes increasingly keen for the top works of a great artist (and prices go up). The artist's transitional work doesn't go up because its only competition is among those who can't afford the best (with this group, there will always be a limit in what they can spend).

Future

Philip Guston probably took the biggest career gamble of any established artist over the last 40 years. The gamble paid off in spades.

Guston was already an established Abstract Expressionist painter whose work had more of an abstract Impressionist feeling to it. He then risked it all and switched to representational imagery (around 1969–70). The result was work

that met with ridicule. Guston, like most great artists, was a step ahead of his audience.

In the 1980s collectors realized that while Guston was simply a good abstract painter, he was a great representational painter. Guston invented his own pictorial language as well as an original palette of colors to depict his images. These colors were muddy yet distinctive shades of orange, red, pink, blue, gray, and green. The iconography included hooded KKK figures, shoes, dangling lightbulbs, spiders, and bloated heads smoking cigars (self-portraits).

Guston's prices, while not giveaways like they were in the early 1980s, are still relatively cheap. The reason is that Guston's paintings have the potential to eventually sell for Cy Twombly prices. Interestingly, both artists are currently linked as among those cited most often as influences by artists under age 45.

Guston probably has more potential for appreciation than 90 percent of the artists rated in the Art Market Guide. The other most promising ones are Andy Warhol, Joseph Cornell, Donald Judd, and Robert Rauschenberg.

Currently, a bargain in Guston's market are his fully developed black ink drawings and charcoal drawings. They sell for between $10,000 and $20,000. Last season's auctions saw a good drawing of hooded figures (one holding a cigar), from the collection of Harold Rosenberg, go for only $12,000 (*Hooded Smoker,* 18" x 22", 1970, S. Nov. 95). The current market for these drawings reminds you of where Agnes Martin drawings were about ten years ago: selling for under $20,000 and usually available when you wanted one. Today you can barely touch one of her drawings for under $35,000, when you can find one. If you're a Guston fan, now is the time to acquire a drawing.

Another good deal are Guston's paintings on paper. Comparable works on paper by Twombly (in quality and size) sell for $50,000–$150,000. Guston's prices should catch up over the next ten years. The reason is twofold. There are fewer Guston paintings on paper in existence than Twomblys on paper. Also, Twombly's reputation as one of the greatest artists of his era has already been established; Guston's reputation is still growing.

Guston's canvases ($150,000–$400,000, on average) also offer a golden opportunity for the wealthy collector. His best paintings should eventually cost a million dollars. For this to happen it will take serious promotion from Guston's dealer (or future dealer), analogous to the promotion of Twombly by his main European dealer. Again, this is possible ten years down the line.

DUANE HANSON (1925–1996)

Estate Representation: Not determined at this date

Record Prices at Auction:

 Sculpture (Polyvinyl): $297,000. *Bank Guard*, polyvinyl and articles of clothing, life-size, 1975 (C. May 88).

 Sculpture (Bronze): None have appeared at auction

Top Prices at Auction (Nov. 1994–May 1996):

 Sculpture (Polyvinyl): $79,500. *The Jogger*, polyvinyl and articles of clothing, life-size, 1983-84 (C. May 96).

MARKET ANALYSIS

Past

For an artist who is as recognized as Duane Hanson, you are not likely to spot his works at auction. They seem to come up more often than they actually do because they're so memorable. Once you've seen one of his life-size hyper-realistic figures (made all the more real because they're dressed in actual cloth-ing), you never forget it.

During the market's boom years there were only three Hanson sculptures to come up for sale. In fact, over the last seven years there have been only seven full-size sculptures to appear at auction. While that doesn't seem like enough activity to make a market, in Hanson's case it's just right. It makes the appear-ance of a Hanson a bit of an event.

This is not to say that Hanson has done particularly well at auction. The results have been mixed. Two works came up in May 1988. Christie's had a sculpture called *Baton Twirler*, a female figure dressed in a majorette's red and white striped uniform. The figure was posed in a marching position; one arm holding the baton aloft and one knee up as if she was about to take a step. Sotheby's had a work called *Bank Guard*, a male figure dressed in a bank guard's uniform, complete with a badge and a gun in a holster.

The *Baton Twirler* looked a lot more like a mannequin than a living breath-

ing figure (which is what the best of Hanson's works look like). In a way, it was Hanson at his worst as the figure looked like kitsch. It was estimated at $80,000 to $100,000 and did not sell. By contrast, *Bank Guard* was Hanson at his most brilliant. The figure looked ordinary, his pose was casual, and his "occupation" was blue collar. The transformation from real life to sculpture spoke volumes about the banal in our daily existence. *Bank Guard* was estimated at $250,000 to $300,000 and sold for a record $297,000.

In November 1988, a first-rate work called *Young Shopper* came up for sale. This work resembled a weary overweight woman clutching four shopping bags. It went way over its $100,000 to $125,000 estimate to sell for $209,000. Like *Bank Guard*, this was Hanson at his best. It would be five more years until a work this good came up again (*The Photographer*, S. May 93).

Present

Only two Duane Hansons came up for sale during the 1995-1996 season. The first was from an ill-advised move in Hanson's career: a miniature study. In 1990 Hanson created a cast resin sculpture of a fat sunbathing woman, complete with miniature pool paraphernalia. The piece measured 8" x 25" x 12" and looked like a toy doll rather than a work of serious sculpture. *Sunbather Study I* failed to sell as the bidding reached only $17,000. The work was estimated at $25,000 to $35,000.

In May 1996 at Christie's, one of the last sculptures Hanson made out of polyvinyl (before he switched to bronze) came up for sale. Titled *The Jogger*, it carried an $80,000 to $120,000 estimate. The work was a life-size seated man wearing only a pair of running shorts. He was seated on the floor (with one running shoe off) massaging his foot, as if he had just come back from a long run. The sculpture sold, but at a low price of $79,500. Perhaps the thought of living with a barely clothed male figure was too much for potential Hanson buyers.

Future

Duane Hanson passed away in 1996. At the time of his death, his career was in decline. Hanson has been viewed by most critics and curators as a source of amusement rather than as a serious artist. Mention his name and most people smile and shake their heads. They forget that he was once taken quite seriously, so seriously that MOMA curator Kirk Varnedoe wrote the text for a book on Duane Hanson in 1985.

When it comes to sculpture that speaks of the human condition, no one

makes a greater statement than Duane Hanson. In 1970, Hanson made a break-through with the work *Tourists*. This work consists of two life-size figures that are posed as stereotypical tourists in all their glorious regalia (Hawaiian shirts, camera, shopping bags, etc.). Your first reaction is one of amazement. The figures are so realistic that you listen for their breathing and anxiously wait for them to take a step. After that initial rush passes, you focus on the message that the sculpture so poignantly drives home.

A Duane Hanson speaks to that everyman/everywoman quality in all of us. Whether we are blue or white collar, most of us can relate to a Hanson sculpture of a house painter. As the Beatles once said in the song *Nowhere Man*, "Isn't he a bit like you and me?"

Duane Hanson did his best work in polyvinyl, and these are the only pieces that are worth buying. Late in his career, Hanson began suffering from the side effects that were a result of inhaling poisonous fumes from casting polyvinyl resin. He switched to bronze, but the work lost something in the translation. They looked good but they just didn't feel psychologically as realistic. Also, the bronzes were done in editions of three (each was the same figure but dressed in a different set of clothes). However, the bronzes were priced on the primary market as unique works. They retailed for approximately $150,000.

Hanson did fewer than 100 polyvinyl sculptures. Yet on the basis of what amounts to only a handful of works (for a career) he became world renowned. The going rate for a Hanson on the secondary market is currently $100,000 to $150,000. This is a ridiculously small price to pay for a work by the greatest postwar realist sculptor. John de Andrea has his fans and his works are even technically better than Hanson's. But Hanson is the better artist. Robert Graham is also a first-rate realist sculptor but lacks the important social content of Hanson.

When an artist passes away, his or her career is considered ripe for reevaluation. It's inevitable that the art world will take another look at the relevance of Duane Hanson. In a world that's constantly speeding up and is increasingly about the "sound bite," Hanson gives us reason to slow down and look around. Hanson keeps us locked into one of the basics of the visual world; the nameless and faceless individuals who make up our surroundings.

With only one or two Hansons coming onto the market each year, the work should have no trouble finding buyers at its current price level. Hanson's career was hurt by not having powerful dealers who could show the work in the "right" context. Now that the artist is gone, all it will take to heat up Hanson's market overnight is one high-profile collector to buy him and publicize the purchase.

KEITH HARING (1958-1990)

Estate Representation: Andre Emmerich Gallery, New York

Record Prices at Auction:

Painting: $148,500. *Untitled* (3 figures), acrylic on yellow leather, 34 3/4″ x 72 3/4″, 1983 (C. Feb. 90).

Ink Drawing: $49,500. *Untitled* (multiple figures), red sumi ink/p, 38″ x 50″, 1983 (S. Feb. 90).

Top Prices at Auction (Nov. 1993–May 1995):

Painting: $46,000. *Untitled*, a/c with collage, 60 1/2″ x 60″, 1988 (C. Nov. 95).

Ink Drawing: $29,900. *Untitled* (multiple figures and a dog), black ink/p, 72″ x 84″, 1983 (C. May 95).

MARKET ANALYSIS

Past

Like most artists, Keith Haring's boom market years saw heavy speculation. What was odd was that you got the impression that no one bothered to hang the works once they were delivered. It was as if they existed only to be traded.

The most astounding statistic was that a 21″ tall fiberglass vase, covered with characters drawn with magic marker, brought $110,000 (C. Feb. 90). Think about it. This was a decorative object with dubious fine art value. This sale was indicative of the mentality of those who bought Haring. They were amateur players.

A lot of the buying was obviously based on the artist's then-recent death. The unsophisticated have always believed the myth (which started with Van Gogh) that an artist's work goes up dramatically in value whenever he or she dies. In fact, this couldn't be more false.

The recent deaths of Sam Francis, Robert Motherwell, and Joan Mitchell had no noticeable effect on their markets. Motherwell's market has actually dipped a bit. What usually happens is a brief flurry of interest followed by a small flooding of works in the market, which in turn leads to slightly lower prices. If

the artist is important, the price bounces back within a couple of years.

The two notable exceptions were Andy Warhol and Jean-Michel Basquiat. In Warhol's case, he was grossly undervalued to begin with. Collectors were just starting to realize this in the year before his death. When he died, everything was in place to take full advantage of a boom market.

With Basquiat (as opposed to Keith Haring), collectors were a little slow to recognize the genuine importance of his work. When he died, it refocused attention on the work and his prices skyrocketed (with the cooperation of a boom market).

Present

The highlight of this season's Keith Haring market was not his paintings or drawings, but his sculpture, a facet of his market that gets far less attention. However, this sculpture is the commercial art world equivalent of Erté bronzes.

The February 1996 sale at Christie's featured a painted steel sculpture called *Blue Dog*. This work was a three-dimensional version of the artist's trademark barking dog (50" x 40", edition of 3, 1985). Estimated at $25,000–$35,000, *Blue Dog* sold for $46,000. A few months later at Sotheby's, another sculpture came up and sold at a price that exceeded estimate. This work, *Untitled*, consisted of a three-man balancing act that took on the appearance of a totem pole. Each figure was painted a different color (red, yellow, or green). *Untitled* measured 11" x 9" x 6" and was done in an edition of six in 1987. It sold for $25,875 against an estimate of $10,000–$15,000.

The other Haring material was a run-of-the-mill assortment of drawings and vases, but surprisingly few paintings. With the exception of the sculpture, prices generally went within or below estimate, demonstrating that the Haring market is becoming less speculative.

Future

During the summer of 1996, Viking released the book, *Keith Haring: Journals*, which reproduces the artist's diaries. Excerpts from the diaries reveal the enjoyment Haring got out of being a famous artist. The diaries also show the serious side of Haring as he worries about his responsibilities as an artist. The book should be of interest to both Haring fans and people who follow the art world and miss the 1980s.

While the book should lead to some fresh business for those who deal in Haring's work, it does nothing to change Haring's "Sell" evaluation. The work hasn't changed nor has the perception that the work is not historically

important. Despite the fact that the Haring estate has been with the respected Andre Emmerich Gallery for over a year now, the equation hasn't been altered: Keith Haring's future value lies in the world of design, not the world of art.

Haring was, of course, a major player in the short-lived but dynamic East Village scene in the mid-1980s. He developed a high profile reputation for creating hit and run graffiti drawings in the New York subways. What separated Haring from the legion of other graffiti artists was a highly original vocabulary of buoyant marks and characters.

Haring's crawling babies and radiant barking dogs, graphically drawn with white paint on black paper, captured the imagination of the media. This led to wide exposure and high profile opportunities. Haring scored big when he was commissioned to design a huge mural for the famous dance club, Palladium. Other deals followed to design Swatches and sweatshirts. Haring should have stayed in this territory.

Haring was an ace designer. A visit to his Pop Shop in SoHo will leave you impressed. But his work isn't serious art. It's highly commercial despite the artist's apparently sincere convictions.

This is an important distinction, especially since Haring sells for a lot of money. How can the current market justify $50,000–$75,000 for a painting on tarpaulin, $10,000–$25,000 for a sumi ink drawing, or $7,500–$15,000 for felt tip pen on a large vase? It can't in the long run.

There will always be collectors to buy the work. There have always been buyers for Peter Max, too. Some collectors will point out that Sotheby's and Christie's cheerfully accept the work on consignment. Well, they also accept Paul Jenkins and Richard Lindner. Buy Keith Haring if you genuinely love the work, but don't fool yourself that you're making a wise investment.

DAVID HOCKNEY (b. 1937)

Prime Representation: Andre Emmerich Gallery, New York

Record Prices at Auctio:

Painting: $2,200,000. *A Grand Procession of Dignitaries in the Semi-Egyptian Style*, o/c, 84" x 144", 1961 (S. May 89, the Edwin Janss, Jr., Collection).

Colored Pencil Drawing: $330,000. *Portrait of Andy Warhol*, colored pencil/p, 25 5/8" x 19 3/4", 1974 (S. May 88, the Andy Warhol Collection).

Print: $275,382. An Image of Celia, litho., screen., collage, 59 " x 41", edition of 40, 1984-86 (S. Tokyo Nov. 90).

Top Prices at Auction (Nov. 1994–May 1996):

Painting: $134,500. *K is for King*, o/c, 45" x 32", 1961 (C. May 95).

Colored Pencil Drawing: $46,000. *Marinka Nude*, colored pencil/p, 17" x 14", 1977 (C. May 96).

Print: $70,700. *An Image of Celia*, litho., screen., collage, 59" x 41", edition of 40, 1984-86 (C. May 95).

MARKET ANALYSIS

Past

David Hockney's boom market years were highlighted by the emergence of his colored pencil drawings at six-figure prices. The fact that these drawings are generally under 24 inches in both dimensions is even more remarkable. Also, colored pencil is such a humble medium. No other major artist comes to mind who works in this neglected medium.

The public's awareness of the potential value of a Hockney drawing was kicked off in May 1988 at the sale of Andy Warhol's personal collection of contemporary art. Warhol owned a portrait of himself that Hockney drew from a photograph, taken when the two artists visited each other in Paris. The drawing was so terrific that Sotheby's put it on the cover of the slipcase that held all six catalogs from the massive sale.

Portrait of Andy Warhol was estimated at a seemingly realistic $60,000–$80,000. Instead, it soared to $330,000 and was acquired by the entertainer Steve Martin. The drawing was special, but the price seemed excessive even for the times. No matter, it touched off a mini-boom in Hockney colored pencil drawings.

Over the ensuing months, three more drawings brought over $100,000, proving the Warhol portrait was no fluke. These three included the colorful *Bedroom* (estimate $20,000–$30,000; sold for $132,000); a portrait of Henry Geldzahler in a Hawaiian shirt, *Henry, Grand Hotel, Calvi* (estimate $70,000–$90,000; sold for $209,000); and a swimming pool with deck chairs, *Luca* (estimate $60,000–$80,000; sold for $143,000).

Present

Last year's *Art Market Guide* referred to the 1994–1995 season's Hockney material as rating a solid 2.5 (on a scale of 1 to 10). Well, this year's material wasn't much of an improvement. It might rate a 3.

There were only two evening sale works. One was a rather static canvas (*Trees*, 30" x 28", 1964) that was offered at $125,000–$175,000. It passed. The other evening sale work deserved to be in the day sale. It was an unattractive colored pencil drawing of a nude woman that sold within estimate for $46,000. You know it's been a tough season for Hockney material when the top lot for the year is under $50,000.

Just like last year, a total of nine mediocre works came up, with five selling. The message is that there's strong demand on the international market for anything of quality by Hockney. There is simply a lack of quality material currently out there. Not that good Hockneys have ever been common. There have always been more buyers than sellers for his work in general.

The greatest Hockney shortage has been for canvases. Most of his works are on paper. The other big consideration is subject matter. Many potential buyers are turned off by his homoerotic imagery. Since these works make up a considerable portion of Hockney's body of work (mainly the drawings), the competition for "acceptable" subject matter is keen.

First on most collectors' lists is anything with a pool in it. Also desirable are palm trees, interiors, and portraits of Celia, the artist's favorite female model. What's surprising is that most collectors are unaware of how few pools exist. Despite Hockney being so closely identified with this image, probably fewer than five percent of his works depict a swimming pool.

Future

In terms of pure all-around artistic ability, David Hockney has few peers. His southern Californian suburban portraits of places and people from the late 1960s to early 1970s are the best of their genre. Hockney also became a celebrity in his own right, transcending the art world much like Andy Warhol.

Hockney's prodigious talent is both a gift and a burden. Since his audience has gotten used to such greatness it feels like he's been in decline since the late 1970s. Perhaps he is, or perhaps his audience can't keep up with him.

On the one hand, you look at his recent work and say he's capable of so much more. The flip side of the coin is that perhaps Hockney had his moment of brilliance, that few can sustain, and is living up to his potential. A third way of looking at Hockney's "decline" is to draw a comparison with the musician Paul McCartney.

As anyone who follows the music scene can tell you, Paul McCartney, as an individual, has never approached his collaborative genius with the Beatles. It's true, of course. Perhaps a healthier way of looking at it is that McCartney earned the right to do whatever he wants as a musician. If it's his pleasure to work with his minimally talented wife and others not on his level, that's all right.

We may not like what Hockney's doing now as much as his "Beatles period" (so to speak). But if he continues along his current path, experimenting, keeping it light, and enjoying himself, we should accept it like we do late Picasso (that doesn't mean we have to buy it, though). Putting it another way, if McCartney goes on to make 25 mediocre records, he will always be judged by his highwater mark.

David Hockney is an analogous situation. Hockney has nothing left to prove. So why not enjoy himself by exploring themes and historical movements that intrigue him? Who knows? Art history may judge his later works to be important.

Market considerations are different, of course. It remains prudent to go with the sure thing when it comes to buying Hockney. Hockney's pictorial genius is for witty realism. That means early work. The one exception might be the colorful paintings from his "Matisse" period during the 1980s.

Hockney's colored pencil drawings are the most undervalued aspect of his production. A finished drawing currently brings between $25,000–$50,000 at auction, though a great one would sell for above $75,000.

In 1996, David Hockney had a wonderful drawing retrospective of about 100 works at the L.A. County Museum. The show confirmed the greatness of his late 1960s/early 1970s colored pencil drawings. Unfortunately, virtually all the great ones are owned by collectors or museums. I don't recall a single one in the

hands of a dealer. This means that Hockney colored pencil drawings will continue to be a scarce commodity at auction and in galleries.

Hockney's colored pencil drawings are also a steal compared to the price of his prints. Although Hockney's most popular prints from the 1980s are first-rate decorative art, they don't belong in the same room as his drawings. These drawings will be a good buy even if they go above $75,000. Hockney's best drawings could some day be in league, in terms of price, with Matisse ink drawings. They're that charming, beautiful, and satisfying.

Hockney also was the featured artist of a prestigious two-gallery show in 1996 at Andre Emmerich and Robert Miller. Both galleries showed new paintings. In evaluating the work you'd like to give an artist as great as Hockney the benefit of the doubt. Only this isn't doubt, it's certainty. The new paintings are really that poor. Five years from now, they are likely to be worth less than what the buyer paid for one.

What's happened is that Hockney's late canvases from the 1990s continue to look worse and his late 1960s through early 1980s paintings continue to look even more remarkable. In some ways Hockney's market is starting to approach Roy Lichtenstein's in terms of demand for any "B" or better painting. Virtually any painting of this quality or higher can be sold by a dealer with a phone call or two. Hockney remains one of the few happy situations in the art market: plenty of buyers and too few sellers.

Buy

JASPER JOHNS (b. 1930)

Prime Representation: Leo Castelli Gallery, New York

Record Prices at Auction:

Painting: $17,050,000. *False Start*, o/c, 67 1/2" x 53", 1959 (S. Nov. 88).

Drawing: $990,000. *Land's End*, ink and watercolor on plastic, 36 1/4" x 25 1/4", 1977 (S. Nov. 89).

Print: $351,877. *Flags I*, screenprint, 27 1/2" x 35 1/4", edition of 65, 1973 (S. Tokyo Oct. 89).

Top Prices at Auction (Nov. 1994–May 1996):

Painting: $3,082,500. *Winter* , o/c, 75" x 50",1986 (S. Nov. 95).

Drawing: None appeared.

Print: $107,000. *Flags I*, screenprint, 27 1/2" x 35 1'4", edition of 65, 1973 (S. May 96).

Note: A unique trial proof of the right side of *Flags I* sold for $123,500 (C. May 95).

MARKET ANALYSIS

Past

More than any other artist, Jasper Johns symbolized the contemporary art boom of the late 1980s. The watershed event of the era was the sale of *False Start* for $17 million. The estimate had been $4 million to $5 million. The artist's previous record was set in 1988, when *Diver* sold for $4.1 million.

The sale of *False Start* prompted the dealer Thomas Ammann to call it "a triumph for American painting." It was actually a triumph for Jasper Johns. He would now be considered the most prestigious American artist to own (at least until de Kooning's *Interchange* sold for $20.6 million, twelve months later).

As the Johns market became overheated, rumor had it that various international galleries would concoct "Homage to Leo Castelli" shows just to have a

Johns painting available (the hope was that Castelli would consign one). Such was the demand for the work.

It got so frenzied that by the end of the boom a third-rate 10" x 8" oil on canvas from 1959 of the figure 7 came up to auction with an estimate of $1.5 to $2 million (S. May 90). The painting was withdrawn. It eventually sold for $79,500 in 1994 (S. May 94). The estimate had been $80,000 to $100,000.

Present

Once again, a Jasper Johns painting remained a scarce commodity at auction. There were only two paintings, both significant, that came up for sale during the 1995-1996 season.

The bargain of the year may well have been the Johns painting *Winter*. This was one of four paintings that made up the series The Four Seasons, a group of paintings that can be termed nothing less than a landmark in the history of American art. The Four Seasons are also considered the last truly great work done by Johns. *Winter* (75" x 50", 1986) was estimated by Sotheby's at a conservative $1.8 to $2.2 million. The painting's final selling price was $3 million. Even $3 million represents a true bargain, especially compared to, say, de Kooning's *Woman as Landscape* (estimated at $6–8 million, but it passed at Sotheby's in May 1996). If *Winter* isn't a $5 million dollar painting, then I don't know what is.

Six months later at Sotheby's in May 1996, Johns collectors had another opportunity to buy a significant painting, Gray Painting with Ball. This early small canvas (31 1/2" x 24 1/2", 1958) was painted in encaustic in shades of rich gray. It was actually composed of two small canvases that were joined together. The connected canvases gave the illusion of being pried apart in the middle by an actual small ball. This was an important painting that unfortunately had been shopped around (most recently at "The Art Show" at the Armory in New York, a few months before the auction). Rumor had it that it had been on the market for between $2.5 and $3 million.

Gray Painting with Ball came up to auction with a $1.5 to $2.5 million estimate. It came nowhere near selling, as the bidding only reached $1.3 million. What a shame. Despite the painting having been "burned," it remains both an attractive and historically significant work of art.

Future

Jasper Johns remains America's greatest living artist. He's as close to being a national treasure as any American in the arts.

The work itself has everything going for it. Johns's best paintings are of

paramount historical significance. In the mid-1950s they helped change the direction of art by reintroducing subject matter that wasn't what it appeared to be ("It wasn't a picture of a target, it was an actual target.") The work's emotional paint handling grounded it in the past (Abstract Expressionism). At the same time, Johns pointed the way to the future with use of common real life subject matter (Pop Art).

A major Johns painting remains expensive and difficult to find. Part of the reason for this is that Johns has always held on to half of his annual production. To my knowledge, no other major artist has had the foresight (or could afford) to do this. The other reason for scarcity is the work has been in demand since day one. Johns (and later Lichtenstein) financially carried the Castelli Gallery in its formative years.

Johns will always be a prudent buy because no serious collection of post-1960 contemporary art can be without one. You can have a Rauschenberg, Lichtenstein, Warhol, and Stella, but without a Johns a collection lacks connoisseur status.

In some ways, there has never been a better time to buy Jasper Johns. As anyone who follows the art market knows, Johns prices reached the stratosphere in the late 1980s. But the story was entirely different in the 1990s. Because the market for million-dollar paintings (by any contemporary artist) is thin, demand for Johns slackened to a point that very few paintings see their way to auction without being offered privately first. Auction has often become a last resort (unless the work comes out of an estate) for selling a great work by an artist like Johns.

A smart buyer knows that an owner would rather sell a million-dollar picture privately because it's less risky. For that reason it's a good time to be making offers on any Johns that's available privately. On the other hand, if you believe in a picture (like *Gray Painting with Ball*) and are gutsy enough to take the chance of it passing at auction, you might be able to pick it up after the sale for a song.

The big excitement in the Johns market is the big retrospective that opens at MOMA in the fall of 1996. The prediction here is that it will help fuel interest specifically in the late work (post-Four Seasons paintings, which would be post-1986). These late works have never appeared at auction. It's likely that this will change during the 1996-1997 season.

The "high end" Johns print market appears to have taken a turn for the better and should continue to consolidate its gains during the 1996–1997 season. The past season featured two $100,000 Johns prints that sold in the same sale for the first time since 1989. Sotheby's May 1996 sale saw *Flags I* sell for $107,000 and *Ale Cans* sell for $101,500. This should encourage consignors to put up even better material during the next season. That in turn should help the less expensive Johns prints, which have lagged behind.

DONALD JUDD (1928–1994)

Estate Representation: Pace Wildenstein, New York

Record Prices at Auction:

Stack: $286,000. *Untitled*, stainless steel and yellow Plexiglas, 10 units, 9" x 40" x 31" (each), edition of 2, 1968 (S. May 89).

Single Stack: $71,500. *Untitled*, stainless steel and green plexiglas, 6" x 27" x 24", unique, 1968 (C. May 90).

Progression: $187,000. *Untitled*, brushed aluminum and brass, 6" x 110" x 6", unique, 1976 (C. Nov. 89, the Manilow Collection).

Note: Record price for a Progression was set (S. Nov. 93): $255,500. *Untitled*, red lacquer on wood, 5" x 25 1/2" x 8 1/2", unique, 1964.

Swiss Piece: $88,000. *Untitled*, pulvar on aluminum (blue, turquoise, yellow, and white), 12" x 71" x 12", unique, 1985 (S. Feb. 90).

Top Prices at Auction (Nov. 1994–May 1996):

Stack: $244,500. *Untitled*, stainless steel with cadmium red enamel, 10 units, 6" x 27" x 24" (each), unique, 1972-9 (C. May 95).

Single Stack: $29,900. *Untitled*, brass and bronze tinted Plexiglas, 6" x 27" x 24", unique, 1967- 1969 (C. May 96).

Swiss Piece: $51,750. *Untitled*, pulvar on aluminum (red, black, and white), 12" x 71" x 12", unique, 1984 (C. May 96).

MARKET ANALYSIS

Past

Donald Judd's past market was more of a footnote to the boom market than a chapter. Works appeared infrequently. When they did, they often sold within estimate. Judd's work was so invisible at auction, it was as if it were in hibernation.

What's interesting is that Judd was one of the only artists, that came up in the late 1980s, whose work sold within estimate (almost every artist went over estimate). Why was this the case with Judd? Rather than comment on his past prices (which really aren't that different from today's prices), commentary on how the auction houses arrive at their estimates will be discussed here.

As you would imagine, there's a tremendous amount of psychology behind estimates. An auction house has to walk a tightrope between estimating a work too high or too low. If you're too low, you lose the consignor. Remember, he or she can play one house off the other to get the desired estimate. If you're too high, you run the risk of the item not selling. If the item passes, no one makes money.

In a hypothetical situation, let's say you walk into one of the two main houses with an Andy Warhol 24" x 24" "Flowers" painting from 1964. What happens next? The auction house has a myriad of decisions to make. They have to strike a balance that will get them the property at a realistic price. The auction house has to come up with an estimate that's based on the following ten questions:

1. What did the last 24" x 24" "Flowers" painting sell for?
2. How long ago did it sell for that?
3. How does this example compare in quality?
4. How important are "Flowers" paintings?
5. What were the art market conditions for Warhol when the last "Flowers" painting sold?
6. What were world economic conditions?
7. What are the art market and world economic conditions now?
8. Does the rival house have a similar painting coming up?
9. Is this painting an "evening sale" work or a "day sale" work?
10. How important a client is the consignor?

Conversely, the consignor has to make a decision to consign the Warhol based on all the above questions and the following issues:

1. What would the rival house estimate the painting at?
2. Which house will give better terms?
3. Which house will give better service?

The answers to all these questions determine if the Warhol will be consigned and how the auction house and the consignor will do financially with it.

Present

A Donald Judd set a new auction record when *Untitled*, an eight-unit, large-scale floor piece, sold for $409,500 (C. May 96). The estimate had been only $150,000–$200,000, which led to bidding that was some of the heaviest of the evening. Part of the price can be attributed to the fact that Judd did only six multipart floor pieces (similar in design to this work) and four of the others are in museum collections. The previous record for a Judd was $288,500, ironically for an incised relief painting (not a sculpture).

Another strong price was realized for an untitled "Progression" (5" x 75" x 5', 1979 whose colors were a pleasing combination of natural galvanized aluminum and painted green pulvar on aluminum. This handsome work went over its $80,000–$100,000 estimate to sell for $112,500. This work represents a good buy as the price for a medium-size "Progression" should reach $150,000 in a few years.

The best values at auction during the 1995-1996 season were the two single "Stacks" that came up at Christie's. The first one came up in November 1995 at an estimate of $25,000–$35,000. The "Stack" was a unique work composed of brass and red fluorescent Plexiglas. It sold for $28,750. In May 1996, a unique "Stack" made of brass and bronze colored Plexiglas sold for $29,900 against an estimate of $25,000–$35,000. Both these works represent excellent buys.

Judd's signature image is the "Stack" (of 10). A single "Stack" represents an opportunity to own the most important innovative work by one of contemporary art's most important artists for under $30,000. Look for collectors to catch on and push the price up to $50,000 within a few years.

Future

Donald Judd, like Clyfford Still, was an iconoclast. Both fought the system, insisting on the rights of the artist to dictate how his or her works should be permanently displayed.

Works from Still's estate still languish in purgatory. However, Judd managed within his lifetime to set up a foundation (the Chinati Foundation through money from the Dia Foundation) that permanently displays some of his best works under the best circumstances (Marfa, Texas). He is the only American artist to pull off this Herculean feat on his own. It is this extraordinary vision and execution that make Judd such a smart investment.

Donald Judd, along with Carl Andre, radically altered the course of American sculpture. While Andre was the first to explore the flat space of the

floor, Judd pioneered the three-dimensional exploration of the wall. Judd's "Stacks" (individual rectangular steel and Plexiglas boxes that resemble drawers and are attached to the wall, often in units of 10 with space between them) remain his most significant contribution.

A Judd "Stack" currently brings $150,000–$250,000 at auction. That's a joke. Judd, along with Carl Andre, John Chamberlain, and Joel Shapiro, are the most important sculptors who produce livable interior works of the last 30 years. Claes Oldenburg is close.

You really can't include Richard Serra and Mark Di Suvero. Both are outstanding but heavily depend on massive scale to be effective. Their best works have to be seen in commercial or institutional settings or be placed outdoors. You can't live with their best works in your home.

Judd's most undervalued works are his "Swiss" pieces. These were created out of assembled horizontal open metal boxes that resemble open candy boxes. Often colorful, these wall works currently sell for $20,000–$60,000 at auction, depending on size. It's a startling thought to know you can own a unique work by one of our greatest sculptors for as little as $20,000.

Since Judd's death in 1994, an increasing number of collectors have been acquiring his works. But not at as rapid a pace as the quality and scarcity of the work warrants. The perception is that there always is work available. While that's true, it seems that whenever you want a particular style of Judd, say a two-foot "Swiss" piece, you can never find one.

Why is this the case? The reason is works by Judd are being absorbed at a pace that's quicker than the market perceives. Try surveying the galleries that deal in his work on the secondary market. With the exception of material that Pace Wildenstein has from the estate, you would be hard pressed to find more than a dozen typical works (not furniture) available nationally.

Speaking of furniture, who are the other sculptors that also made furniture? Richard Artschwager and Scott Burton are sculptors whose inspiration is derived from furniture (so they don't count). The architect Frank Gehry designs great furniture, but he's an architect. The following is the surprisingly short list of artists:

Charles Arnoldi, Larry Bell, Donald Judd, Isamu Noguchi.

Buying furniture by the above artists is likely to be a good long-term investment (with very little capital outlay), especially as more museums of modern art develop design departments.

ALEX KATZ (b. 1927)

Prime Representation: Marlborough Gallery, New York

Record Prices at Auction:

 Painting: $121,000. *The Light III*, o/c, 72" x 120", 1975 (C. Feb. 90).

 Cutout: $82,500. *Frank O'Hara*, oil on wood, 62" x 6 1/2" x 15", no date (C. Nov. 89).

 Print: $26,400. *Red Coat*, silkscreen, 57" x 29", edition of 73, 1983 (S. May 89).

Top Prices at Auction (Nov. 1994–May 1996):

 Painting: $28,750. *Repose*, o/c, 49" x 58 1/2", 1963 (S. May 90).

 Cutout: $6,900. *Ada II*, oil on aluminum, 36" x 4", 1982 (C. Nov. 95).

 Print: $8,050. *Red Coat*, silkscreen, 57" x 29", edition of 73, 1983 (C. Nov. 94).

MARKET ANALYSIS

Past

The boom market years all but ignored Alex Katz. He had only one painting sell in excess of $100,000. Most of his full-size paintings (at least 48 inches in one dimension) sold for between $35,000 and $75,000. However, the most commonly traded Katz paintings were the small studies (under 15 inches in both dimensions), which sold for between $7,500 and $15,000. There was also some activity in the market for his painted aluminum cutouts. Most of these works (of variable dimensions) fell into the $15,000 to $35,000 range.

Basically, collectors seemed to prefer images of Katz's most common subject matter: his striking wife, Ada. The next most popular images were of random women. This was followed by close-ups of flowers. A distant fourth choice were portraits of men. However, portraits of a man and woman in the same picture definitely had an audience. There was also a preference in scale. Generally, paintings in the 4' to 6' range (the size most preferred by decorators) were in the most demand.

Another observation is that collectors apparently preferred Katz's paintings

from the 1970s to those of the 1960s. What's ironic is that the artist made better paintings in the 1960s. These works were more painterly; they featured thicker paint application and looser brushwork. Katz became far more commercial in the 1970s. He began simplifying his images. He also adopted an economic painting technique that gave the surface of his paintings the look of having been painted by a house painter.

Present

The current auction season featured the usual assortment of Katz material. There was a pretty good variety of both small and large paintings as well as some cutouts. But collectors weren't biting. A total of eleven works were offered for sale with only five selling. The breakdown was five paintings (three sold), two drawings (both sold), and four cutouts (one sold). More discouraging was that the five works that did sell went for between $4,025 and $28,750. That's not a lot of money for an established artist like Alex Katz.

While it's true that the material offered wasn't that exciting, there were two good paintings that should have sold but didn't. Christie's May 1996 sale had a large painting of Ada called *Dark Glasses* (40" x 112", 1989) that was estimated at $50,000 to $70,000. Back in November 1995, Christie's had a self-portrait called *Green Jacket* (72" x 48", 1989) that was estimated at only $35,000 to $45,000.

The painting that brought the highest price, *Repose* (50" x 58", 1963, $28,750), sold way below its estimate of $35,000 to $45,000. It was disconcerting because the painting was a first-rate work of art regardless of who painted it. Katz's early paintings were decent and worth considering for inclusion in a serious collection of figurative art. The failure of *Dark Glasses* and *Green Jacket* to sell underscores the reality that, nine times out of ten, Katz's audience prefers the vacuous late work.

Future

Alex Katz's market is a mystery. How could two highly regarded galleries like Robert Miller (previously) and Marlborough (currently) represent an artist as blatantly commercial as Katz? (Then again, Marlborough does show Larry Rivers's late work.)

As mentioned earlier, Katz's early work does have merit. But his painting rapidly degenerated into highly commercial efforts that are more about illustration than art. If Katz had pushed the illustrative quality of his work (a la Saul Steinberg), it may have resulted in more authentic work. The funny thing is

that his work was still tolerable in the 1970s. But the last remnants of credibility were lost with the invention of his cutout paintings of the 1980s. These portraits and full-figure images are painted on shaped pieces of aluminum, which are in turn mounted to freestanding bases. There is no reason for these works to exist.

But Alex Katz is not alone in contemporary art. The following is a list of artists with big reputations (at least at one point in their careers) whose work since the 1960s has become commercial: Red Grooms, Kenneth Noland, Jules Olitski, Larry Poons, and Larry Rivers. If Katz wants to avoid the reputation of what's befallen these artists, he's going to have to return to his 1960s roots.

FRANZ KLINE (1910–1962)

Record Prices at Auction:

Painting (Black and White): $2,750,000. *August Day*, o/c, 92" x 78 1/2", 1957 (C. May 89).

Painting (Color): $2,860,000. *Scudera*, o/c, 111" x 78 1/2", 1961 (C. May 89).

Drawing (Ink): $154,000. *Untitled*, India ink/p, 8 1/2" x 11", 1961 (S. May 89).

Top Prices at Auction (Nov. 1994–May 1996):

Painting (Black and White): $1,047,500. *Figure*, o/c, 71" x 44 1/2", 1956 (S. May 95).

Painting (Color): $2,500,000–$3,500,000 (passed). *Andrus*, o/c, 79" x 131", 1961 (S. May 96).

Drawing (Ink): $68,500. *Double H*, o/panel, 11" x 8 1/2", 1954 (S. May 96).

MARKET ANALYSIS

Past

Most people who follow the art world correctly think of Franz Kline's powerful large-scale black and white abstractions as his most important works. However, they are not necessarily his most valuable.

The late 1980s saw Kline's large black and white paintings soar into the million-dollar stratosphere. That was not unexpected. The big surprise was the big prices brought by his late large-scale color works. Witness the prices brought by *Red Painting* (S. May 89) and the record setting *Scudera* (C. May 89): $1.76 million and $2.86 million, respectively.

Kline began introducing primary colors into his paintings in 1956. The artist continued to explore color, while retaining the gestural structure of his black and white works, up until his death in 1962.

The surprising thing about Kline's late 1980s market was the large number of great paintings that came up for sale. Not all collectors were aware that Kline was not as prolific as Mark Rothko and Willem de Kooning, so there were fewer pictures to begin with. As a result, a false impression was created that there

would always be plenty of great Klines available. All you had to do was have your checkbook ready. The reality was that the availability of scarce great material was brought on by the hefty prices that the paintings were bringing. As we all know, big prices bring paintings onto the market.

The works that appeared in the late 1980s would have created a first-rate retrospective. They include *Scudera* ($2.86 million), *Bigard* ($1.43 million), and perhaps his greatest painting *Leigh* ($2.31 million). There were also numerous midsize canvases that weren't too shabby along with a host of works on paper. Once again, the late 1980s auction market for Franz Kline will be looked back on with nostalgia, not only for the high prices but for the incredible quality.

Present

The pivotal event of the Sotheby's May 1996 evening sale was the failure of the cover painting to sell. The painting just so happened to be one of the most significant Klines to ever come up for sale: *Andrus*. This large-scale color painting was also the cover painting for the catalog from the Franz Kline retrospective, that opened at the Cincinnati Art Museum in 1985. *Andrus* was also illustrated in color on the exhibition brochure and poster. In other words, *Andrus* couldn't have been better publicized.

This painting was estimated correctly (seemingly) at $2.5 million to $3.5 million. Andrus appeared to have everything going for it, including a horizontal format, a composition alive with Kline's gestural brush strokes, and rich tones of purple, blue, black, and orange. Perhaps it was a little large (79" x 131"), but this was truly a museum-quality painting. There was some bidding, but Andrus was ultimately bought-in at $2.2 million. The air went out of the evening sale, but not out of the Kline market.

The night before at Christie's, a fresh-to-the-market black and white painting called *Swanee*, that measured only 35" x 47" (a good apartment size), brought almost a million dollars ($965,000 versus an estimate of $600,000–$800,000). The painting was quite strong and the best black and white work to come up during the 1995–1996 season.

The same sale yielded a larger (but not better) black and white canvas called *Sabro*, that went below its ambitious $800,000–$1,000,000 estimate to sell for $662,500. Sabro had failed to find a buyer when it was offered at Sotheby's in May 1993 at an estimate of $1.5 to $2 million. A third major black and white Kline (*Accent Aigu*), over at Sotheby's in May 1996, carried the same estimate and sold for slightly more at $717,500. The story was the same during the November 1995 sales, not a single million-dollar Kline sale took place. In fact, it's hard to remember an auction season without a million-dollar Kline.

Future

There are five Abstract Expressionists with great markets: Jackson Pollock, Mark Rothko, Willem de Kooning, Arshile Gorky, and Franz Kline. The artist Clyfford Still is a great painter but for some reason is difficult for most collectors to appreciate. It's hard to say why. When a major painting comes up for sale it's not a "given" that it will sell. Barnett Newman is also first-rate and certainly salable when a major painting comes on the market. A record price for a Newman of $3 million was set for *The Word II* in November 1995 at Christie's. But important Newmans rarely appear.

A major Franz Kline seems to be a sure bet. But then how do you explain the failure of Andrus to find a buyer? Perhaps it's the big painting theory, explored by Alexandra Peers in a 1996 article in the *Wall Street Journal*. Peers discussed a long held belief among art dealers that the market for large-scale pictures is rapidly fading. In fact, a fellow dealer once commented "If you can't pick it up, you can't sell it."

Regardless, great Kline works on canvas and paper will generally do well because the best Abstract Expressionism is more or less a sure bet. How can it not be? It's already viewed in all quarters internationally as classic, and the mythology surrounding the artists and the works' creation is wonderful.

However, the market for Kline's works on paper does have some serious potential problems. Kline produced some terrific black-ink-on-paper drawings. Most of these were done on paper that, while not of the best quality, was at least white. However, some were drawn on pages torn from New York telephone directories.

These "phone book paper" sketches were done in the 1950s, on newsprint paper, that turned yellow and brittle within the year it was painted on. One argument is that Kline was too poor to afford good paper. Maybe so, but he somehow found the money to buy canvas. The other argument is that these phone book pages were just throwaway studies. If so, then why didn't the artist throw them away? The point is these works didn't deserve to come to market.

Drawing is a serious pursuit and has been treated by artists with respect throughout the history of art. Collectors who purchase a Kline drawing on a telephone book page are making a serious mistake in viewing it as important work. They are actually buying little more than memorabilia. These drawings were not meant to be finished works in their own right. Yet they continue to sell for between $15,000 and $25,000 at auction. Not only are the works physically unstable, they are mere souvenirs. Better to pay up and buy a drawing on white paper ($25,000 to $75,000) that was meant to be viewed as a finished work of art.

JEFF KOONS (b. 1955)

Prime Representation: Jeffrey Deitch, New York

Record Prices at Auction:

Stainless Steel Sculpture: $233,500. *Louis XIV*, stainless steel, ed. 3 with 1 A.P., 47 1/2" x 28" x 16", 1986 (C. Nov. 94, Gerald Elliott Estate).

Vacuum Cleaners: $198,000. *New Shelton Wet/Dry Triple Decker*, three vacuum cleaners in Plexiglas boxes with fluorescent lights, 124" x 28" x 28", 1981 (S. Nov. 91).

Basketball Tank: $154,000. *Two Ball 50/50 Tank*, two basketballs in a steel tank with distilled water, 62" x 36" x 13", 1985 (S. Nov. 91).

Top Prices at Auction (Nov. 1994–May 1996):

Stainless Steel Sculpture: None appeared

Vacuum Cleaners: None appeared

Basketball Tank: $123,500. *Three Ball Total Equilibrium Tank*, three basketballs in a steel tank with distilled water, 60" x 49" x 13", 1985 (C. May 95).

MARKET ANALYSIS

Past

Jeff Koons's boom market years didn't coincide with the rest of the market. His pinnacle was reached a few years later (in the early 1990s) when the first major Koons works appeared at auction. A "Vacuum Cleaner" work came up first and sold for $198,000 (estimate $100,000–$150,000), followed by a "Basketball Tank" that sold for $154,000 (estimate $100,000–$150,000). The former commodities trader had now ironically become a commodity to be traded.

Koons's most recognizable image had become the floating basketballs in an aquarium filled with water. Over the next few years a total of four (including the above) came up for sale, averaging $126,500 per work.

In fact the average selling price for a major work by Koons (between May 1991 and Nov. 1992) was $134,000. Not only that, but all eight major works

that came up in this span sold. That's impressive when you consider he had no previous track record at auction. Koons had become a "$100,000 artist" at auction literally overnight.

Present

In May 1995, at Christie's, a Koons "Basketball Tank" came up and sold for $123,500. Six months later two more came up and the results were far different. Christie's November evening sale offered a "two ball" version for $80,000–$120,000. It passed at $60,000. The next night at Sotheby's, a "three ball" example came up with an estimate of $100,000–$150,000. This one passed at $65,000. Basically, there wasn't any bidding on either one of them.

The season also contained three works from Koons's "Posters of Athletes" series. These works are nothing more than actual Nike promotional posters of famous professional athletes (ironically, usually of basketball players surrounded by lots of basketballs). The posters themselves were giveaway promotions that Koons's appropriated by signing and framing. The artist said the posters had something to do with consumerism. At any rate, two of the three works sold. The average selling price was $7,475.

Future

Jeff Koons burst on to the scene in the 1980s with floating basketballs, Plexiglas-encased vacuum cleaners, and his unforgettable inflatable bunny cast in shiny stainless steel. The work rapidly disintegrated into kitsch statues of Michael Jackson. From there it was all downhill as the work gathered negative momentum. The culmination was an embarrassing series of somewhat pornographic images of the artist and his wife "doing it" in some unsavory positions.

Up until the most recent sale, the work has done well at auction. Koons, like Warhol, mastered the art of self-promotion. Somehow he convinced the art establishment that what he did mattered in a big way. Trendy collectors and a surprising number of museums bought into it.

The problem is Koons's work has begun to look like what it was parodying: kitsch. There is nothing thought-provoking, let alone aesthetically sublime, about a life-sized carved and painted Disneyesque bear talking to a goofy-looking London "bobby."

Critics argue that Koons provokes and thus there's "something there." What's there is a collector who once shelled out between $100,000 and $150,000 at auction for a work that will eventually be sold at 10 cents on the dollar, at Sotheby's Arcade Sales and Christie's East (where the sales of minor works,

often by has-been artists, take place).

It's always possible that this young artist will create new works that will wear better. Outside of the stainless steel shiny rabbit, I cannot think of another work that still holds up.

Collectors who are propping his prices up at auction are making a big mistake. They believe that works that are this controversial (but only for the sake of controversy, not compelling issues) will increase in value. Unlike a Duchamp "urinal," which changed the way we think about art, Koons's work changes nothing.

As predicted in last year's *Art Market Guide*, Jeff Koons's tremendous success at auction came to an end this season. It's not that his career is over or that he'll never sell another work for a good price. He'll still sell and there will be the occasional big price. What's happened is that he's now unlikely to be an artist that collectors speculate on.

When there was no bidding on either "Basketball Tank," it finally proved that the work was entertaining but had a short life cycle. How could it not? It's likely that the next one to come up (probably one of the same works at a substantially lower estimate) will sell. Especially if it's estimated at a more realistic $40,000–$60,000. At $50,000, a major Koons makes more sense. This would bring his prices more in alignment with others of his generation such as Peter Halley.

The question then becomes, if you are offered a Koons "Basketball Tank" for $50,000, should you buy it? The answer is buy it if you can afford to loose the money and you view it as a period piece (East Village-1980s) that fills a gap in your collection. Otherwise it's still not something to speculate on. There's an expression that stockbrokers use: "Never catch a knife when it's falling." This knife is still falling.

ROY LICHTENSTEIN (b. 1923)

Prime Representation: Leo Castelli Gallery, New York

Record Prices at Auction:

Cartoon Painting: $6,050,000. *Kiss II*, o/c, 57" x 67 3/4", 1962 (C. May 90).

Non-Cartoon Painting: $1,650,000. *Razzmatazz*, o/c, 96" x 120", 1978 (C. May 91).

Small Drawing: $242,000. *Crying Girl*, colored pencil/paper, 5 3/8" x 5 1/4", 1964 (C. Nov. 88, the Tremaine Collection).

Print: $49,500. *Sweet Dreams, Baby!*, screenprint, 35" x 25", edition of 200, 1965 (S. May 90).

Top Prices at Auction (Nov. 1994–May 1996):

Cartoon Painting: $2,532,500. *Kiss II*, o/c, 57" x 67 3/4", 1962 (C. May 95).

Non-Cartoon Painting: $332,500. *Still Life with Lamp*, o/c, 54" x 74", 1976 (C. May 96).

Small Drawing: $57,500. *Craig!!*, colored pencil/paper, 5 7/8" x 6", 1964 (C. Nov. 95).

Print: $37,950. *Sweet Dreams Baby!*, silkscreen, 35" x 26", edition of 200, 1965 (S. Nov. 95).

MARKET ANALYSIS

Past

Roy Lichtenstein's market officially kicked into high gear at the Andy Warhol Collection sale (S. May 88). Not only was the contemporary art cover lot a Lichtenstein (who could forget the circular canvas *Laughing Cat*?), but a total of seven works appeared. This total was greater than any artist other than Robert Rauschenberg. Roy Lichtenstein certainly met with Andy Warhol's approval.

All of the works sold over estimate. The most meaningful sale was a rather abstract painting loosely titled *Sailboats*. Though large (64" x 90"), it was just an ordinary painting from the mid-1970s. When it brought $605,000 (estimate

$350,000–$450,000), it signaled that the Lichtenstein rush was on.

The next big push was at the wonderful Tremaine Collection sale in November 1988 at Christie's. The dramatic cover lot, *I Can See the Whole Room . . . and There's Nobody in It!* (a Cartoon image) doubled the high end of the estimate to sell for $2,090,000, a new record.

Another record was set at the same Tremaine sale for a drawing. A Cartoon study titled *Crying Girl* brought $242,000. Surprisingly, the auction house expected it to possibly go higher (estimate $150,000–$250,000).

Onward and upward. November 1988 at Sotheby's yielded the sale of another sailboat painting, *Sailboats III*. This version was better than Warhol's (but not that much better). It more than doubled the previous sailboat price as it sold for $1.32 million (estimate $500,000–$600,000).

Then came the Robert B. Mayer Collection sale at Christie's in November 1989. Yet another Lichtenstein graced the cover, a war picture titled *Torpedo . . . Los!* (67 3/4" x 80 1/4", 1963). This "Cartoon" painting shattered the previous record, breaking the $5 million barrier to sell for $5.5 million (estimate $3–4 million).

The culmination of the Lichtenstein craze came in May 1990 as the market started its decline. To set the context, a total of nine Lichtensteins came up in the evening sales. An amazing five paintings carried million-dollar estimates. Of the nine lots, only three sold. One of the three set a record that stands to this day: $6 million for the Cartoon painting (without words) *Kiss II*.

Present

While this season's Lichtensteins lacked the drama of last (when *Kiss II* sold for $3.6 million and *I . . . I'm Sorry* brought $2.5 million), it did have its moments.

The most important picture to come up was *Emeralds*, one of Lichtenstein's earliest "Cartoon" paintings (68 1/2" x 68 1/2", 1961). The painting was classic Lichtenstein; red, yellow, and blue color, benday dots, and comic book imagery. The image itself was of a Buck Rogers type hero sitting in his spaceship and uttering to himself, "One Thing's Sure . . . He's Still got Those Emeralds!" Just for good measure the artist put a flying saucer in the background. *Emeralds* was estimated at $2 million to $3 million and sold for a disappointing $1.7 million. The painting was a bargain at that price. Still, as Judd Tully pointed out in *Art & Auction*, it became the 12th Lichtenstein painting to sell for over $1 million at auction.

Why did *Emeralds* go so low? Explanations ranged from "It wasn't in very good condition" (not true), "It had been shopped" (probably not true), and "It was too early and had too much of a hand-painted quality" (true and false).

The last comment hit the nail on the head but for positive reasons rather than negative.

Early Lichtenstein paintings (roughly 1961–1963) had a wonderful hand painted quality. The benday dots were smaller and the artist didn't erase the pencil lines which left evidence of how the artist sketched out his image (before he switched to an overhead projector). This "crude" side of Lichtenstein is very special. It is the first and last mature work of the artist before he probably became self-conscious of his immense success.

Other successes during the 1995–1996 season were the sale of two "Modern Paintings," Lichtenstein's tribute to the Art Deco era. In November 1995 at Christie's, a painting called *Modern Painting with Yellow Interweave* (56" x 48", 1967) sold for $255,500. The estimate had been $100,000 to $150,000. Six months later at Christie's, a better painting from the series, *Modern Painting with Steps* (48" x 60", 1967) brought $299,500. The estimate was $300,000 to $350,000.

Why such modest prices for good-size pictures from the 1960s? Lichtenstein collectors have always preferred works with recognizable imagery. Naturally, if collectors aren't too keen on these pictures, then dealers tend to shy away. It's a mistake. The "Modern" paintings are high-quality works and will someday be more sought after.

The overall Lichtenstein results for the season saw 21 works appear with 14 of them finding buyers. But approximately a third of the works that sold were of dubious quality (late work multiples such as "Brushstroke Sculptures" and "Suspended Mobiles"). Also, two of Lichtenstein's ceramic "Tea Sets" came up, with one of the two selling (for $14,950).

Future

If the art world were transformed into major league baseball, Jasper Johns would be Babe Ruth, the top home run hitter. Roy Lichtenstein would be Ty Cobb, the top hitter for batting average. Of all the greatest living American artists, Lichtenstein is by far the most consistent.

Lichtenstein never seems to falter. Sure, he's had his weak moments (the Brushstroke Heads, the Perfect/Imperfect series), but overall no contemporary artist has matched his wide reaching inventiveness on such a high level.

Roy Lichtenstein has covered almost every possible aspect of subject matter. He has commented on art history (Picasso, Monet), architecture (Pyramids, Greek Temples), the landscape (Sunrises, Brushstroke Landscapes), popular culture (Cartoons), figurative art (Nudes), suburbia (Interiors), and on and on. What's remarkable is that by using his highly recognizable style (benday dots,

primary colors, and graphic simplification), he's able to transform any subject into his own. This transformation is something akin to genius.

Lichtenstein's market has been big time since day one. He's always been a big seller. He may be the last great consensus in art. He's the fine art equivalent of the Beatles. Not liking Lichtenstein seems as perverse as not liking the sun. Though Andy Warhol is the most important artist of the second half of the twentieth century, Lichtenstein is the most collectible.

Lichtenstein's market, like every artist's, has gone up and down during the recent boom/bust cycle. The difference is that collectors have always wanted to buy his work. Only Alexander Calder has shared that distinction.

Lichtenstein's prices are in the top five percent of the contemporary art world, whether at auction or in a gallery. Considering that his place in art history is assured, he is fairly priced. Buying one of his paintings is like putting your money into an insured money market account. You know the money will be there when you need it. Lichtenstein is closer to being a sure bet than any artist in the world.

What opportunities still exist in his market? It has been said among dealers that the only salable works are those with representational subject matter. Paintings that are predominantly abstract are difficult to sell. My opinion is that those bodies of work may be better than people think. This could very well be where the opportunities lie.

Works from the Art Deco Modern Painting series (late 1960s), Entablatures (mid-1970s) and Mirrors (early 1970s) are all undervalued. Their abstract qualities that are spurned by most collectors are their strength.

The most ambiguous works, the round shaped Mirrors, are the real sleepers in the group. A small to medium example would probably fetch $75,000–$125,000 these days at auction. That wouldn't even buy you an undesirable Sam Francis painting from the late 1980s. I could probably cite at least a dozen other examples.

Lichtenstein paintings from the mid-1970s (Still Lifes, Interiors, etc.) are also undervalued. While they are not as visually dynamic as the Cartoons, the paintings are highly decorative in the best sense of the word. Their going rate at auction is between $250,000–$350,000 for a medium-size picture.

Yet another underrated group of works are Lichtenstein's post-1970 small drawings. Even though they are studies for paintings, they are often finished works in their own right. Some actually sell for less than a number of his prints. That's absurd. You can buy a non-Cartoon drawing for $10,000–$20,000 at auction. That's very little money to be able to live with a unique signed work by one of the postwar masters.

These drawings have been taken for granted for years. You see more

Lichtenstein drawings at auction (which isn't many) than in the galleries. There are fewer of them available than people think.

The 1995–1996 season revealed an interesting investment opportunity: Lichtenstein's 1970 brass sculpture multiple, *Untitled Head I* (25" x 9" x 6", edition of 75). Two of them appeared at this season's print sales and each brought $23,000. The sculpture is best described as a very abstract but clearly Art-Deco-style profile of a head. The highly polished golden brass exudes a warm glow.

It was just a coincidence that two of these appeared in one season. Despite the large edition of 75, you rarely see them. At the height of the market, one brought $78,100 (S. Nov. 89). As recently as February 1995 (at Sotheby's), an example brought $43,125. When you look around for a good piece of sculpture that you can buy by a big name for under $50,000, you usually come up empty handed. For this reason, Lichtenstein's *Untitled Head I* is a pretty sure bet to go up from its current $23,000 level.

As far as his current work, Roy Lichtenstein remains as active an artist as ever. He continues to invent new imagery, his most recent being a few paintings that draw their inspiration from early Chinese landscape painting (he also recently explored this theme in the print medium). Are there any worlds left for Lichtenstein to conquer?

At this writing, the only big question mark confronting the Lichtenstein market is what will become of the collection of the late German megacollector Peter Ludwig? Lichtenstein was an early favorite of Ludwig. He bought major Cartoon paintings as well as later works. Much of his collection is housed in a museum. But you have to assume that he also had personal holdings that may come on the market. It will be interesting to see if his collection remains intact or if parts of it are dispersed. The last big collection of Pop Art (including three Lichtenstein paintings) to come up to auction was that of Karl Ströher (S. May 89).

BRICE MARDEN (b. 1938)

Prime Representation: Matthew Marks Gallery, New York

Record Prices at Auction:

Painting: $1,100,000. *Untitled* (diptych, gray and olive panels), encaustic/c, 69" x 90", 1968 (C. May 90).

Work on Paper: $572,000. *Untitled*, oil and graphite/p, 18 3/4" x 39 5/8", 1984-88 (C. Nov. 89, the Robert Mapplethorpe Estate).

Drawing ("Gestural"): $99,000. *St. Barts No. 4*, black ink/p, 16 1/2" x 11 3/4", 1986 (S. Feb. 90).

Print: $8.970. *Cold Mountain Series, Zen Studies 3*, etching, 27" x 35", edition of 35, 1991 (S. Feb. 90).

Top Prices at Auction (Nov. 1994–May 1996):

Painting: None appeared

Work on Paper: $129,000. *Untitled*, charcoal/p, 20" x 22", 1966 (S. Nov. 95).

Drawing ("Gestural"): $85,000. *The Virgins 10*, ink and gouache/p, 14 3/4" x 7 1/4", 1993 (C. Nov. 94, Gerald Elliott Estate).

Print: $8,970. *Cold Mountain Series, Zen Studies 3*, etching, 27" x 35", edition of 35, 1991 (C. Nov. 94).

MARKET ANALYSIS

Past

Brice Marden's boom market years were dramatized by a pair of insane prices for two drawings (more on that later) rather than the logical prices brought by his paintings.

Only four Marden paintings appeared at auction during the boom years. The first to come up was an early monochromatic light brown canvas (69" x 45", 1967-68) at the Andy Warhol sale (S. May 88). Estimated at $80,000–$100,000,

Flesh sold for $104,500. The record for a Marden at the time was $352,000 for *Interrogatio* (C. May 87, the Lambert Collection).

The above record was smashed by *Untitled* (a large gray and olive green diptych, 69" x 90", 1968) that brought $1.1 million near the height of the market (C. May 90). The same sale yielded a price of $880,000 for *Summer Painting* (a blue and green diptych, 69" x 45", 1976–77), proving the million-dollar price was no fluke.

The real story of Marden's past market was the performance of the Tokyo dealer Shigeki Kameyama (of the unfortunately named Mountain Tortoise Gallery). In November 1989, at Christie's day sale, the two best Brice Marden works on paper ever to appear came up for auction. Both drawings were of the "Column and Lintel" variety (a term not used by Marden but used here for description). Each work had bars of gray and drab green and measured 18 3/4" x 39 5/8". They were created in 1984-88.

The estimates of $35,000–$55,000 appeared accurate prior to the sale. During the sale all hell broke loose as the drawings sold for an obscene $528,000 and $572,000, respectively. The real question was who was the underbidder? To put the results into perspective, two other Marden drawings in the same sale brought $165,000 each against equally low estimates.

Mr. Kameyama, you may recall, had a busy month. He was also the proud purchaser of the most expensive contemporary painting ever sold at auction, Willem de Kooning's *Interchange*, for $20,680,000.

Present

With the exception of one drawing, Brice Marden's 1995-1996 season was barely worth commenting on. Not a single canvas appeared. This of course makes an analysis of the state of his market a difficult task. The previous season saw only a single canvas come up, *Dylan Study I* (yes, it was named after Bob Dylan, a personal friend of Marden's), a two-panel black and gray work (42" x 50", 1963). It failed to sell for its estimate of $250,000–$350,000.

The one major drawing that appeared dated from 1966, one of the first three years of mature work by Marden. This work, *Untitled*, was a velvety surface of rich black charcoal, broken up by a grid (which created 96 small compartments). This drawing was estimated at $60,000–$80,000. It sold for $129,000, recalling the late 1980s when Marden drawings routinely brought six figures.

Other results included the sale of another early black charcoal drawing (23" x 31", 1967) for $35,000 at Christie's in November 1995. The same sale also contained a three-unit "Card Drawing" (6" x 6" each, 1982), which sold for $40,250.

Future

Brice Marden's early monochromatic canvases put the period at the end of the sentence on how far abstract painting could be taken. Had he stopped there, he still would have been a towering figure in the history of abstract painting. Instead, around 1986, Marden made a dramatic move to gestural abstraction.

These new paintings, especially the Cold Mountain series, established Marden as America's greatest pure abstract painter. (Willem de Kooning no longer paints, Cy Twombly is an expatriate, Robert Ryman and Agnes Martin are less innovative. Ellsworth Kelly is more about form, and Frank Stella has become more of a sculptor.) Marden also makes fantastic drawings. Jasper Johns and Cy Twombly are the only artists who come to mind that make great paintings and great drawings. That's serious company.

With all that praise it is easy to justify Marden's relatively high prices. Let's start with the drawings. Marden's past drawings include dense graphite works as well as colorful ink splashes with ruled black lines. Many of these drawings are quite beautiful, but few approach his current gestural ink drawings in beauty and sophistication.

Current auction price range is hard to determine since so few "Gestural" (a descriptive term referring to the imagery resembling calligraphy) drawings come up. The last to appear was a wonderful example that was sold at the Gerald Elliott Estate evening sale (C. Nov. 94). This particular drawing, *The Virgins 10*, was enhanced by Marden's use of white gouache to "erase" passages of black lines, creating phantom blue lines. The resultant work made a strong statement about the evocative powers of drawing. *The Virgins 10* was estimated at $35,000–$45,000 (a gallery price, at the time). The drawing sold for an impressive $85,000.

A price of $85,000 for a Marden work on paper may seem high, but it's not. There's room for growth when you compare it to the cost of buying a major Twombly drawing or recent Johns drawing. So far, there haven't been any recent Johns drawings at auction. An educated guess is that one would bring $150,000–$250,000. Recent major Twombly drawings come up occasionally. Their expected price range is similar.

The only Marden paintings to appear at auction have been monochromatic "panels." These paintings, depending on the quality of color, have settled in the $350,000–$750,000 range. An exceptional work, such as a multicolor "Column and Lintel," could bring a million dollars.

The most growth potential (in terms of dollars, not percentage) lies in the recent gestural paintings. These may be the most important American paintings done in the last ten years. If you subscribe to this point of view, you can easily envision a major work such as a large Cold Mountain painting bringing

$1–2 million within five years (one has yet to come up).

If the above scenario holds true, that would make Brice Marden the most expensive active abstract American painter of our times, by a wide margin. When you factor in his relatively young age (58, making him 8 years younger than Johns and 9 years younger than Twombly), his financial growth should be impressive.

Brice Marden's 1996 show of new paintings at the Matthew Marks Gallery received a lukewarm critical reception. The show consisted of approximately ten of his recent gestural abstractions painted on canvases that were approximately 6' x 4 1/2'. The paintings' loopy lines were painted in rich tones of color such as olive, blue, and ochre. The paintings, at least to this eye, were consistently beautiful. All the paintings were sold. New paintings by Marden range from $300,000 to $500,000. Yet, the general consensus was that the paintings were "transitional works" (a polite way of saying the paintings weren't fully realized).

Why the criticism of one of America's greatest abstract painters? In the early 1990s, Marden was crowned by the press as the new "king" of American art. Articles about his work and deluxe life-style ran not only in art magazines but in fashion magazines as well. Praise was heaped upon praise. Naturally, some backlash could be expected (which is what is occurring now). But the bottom line is that Marden is still making great work. However, his career is suffering slightly from overexposure.

Marden remains a "Buy" and is likely to remain so through the end of the decade. The work is still hard to come by. Buying a work of his is not a function of having the money. It's a function of finding one for sale. You still don't see his paintings at auction nor do you ever see them on resale at galleries such as Pace Wildenstein, Gagosian, or Mary Boone (all of whom have dealt in the work).

AGNES MARTIN (b. 1912)

Prime Representation: Pace Wildenstein, New York

Record Prices at Auction:

 Painting (pre-1968): $525,000. *The Tree*, oil and graphite/c, 75" x 75", 1964 (S. May 96).

 Painting (post-1973): $385,000. *Untitled #14*, acrylic and graphite/c, 72" x 72", 1980 (C. May 90).

 Drawing: $60,250. *The Shell*, watercolor and ink/p, 12" x 12", 1963 (S. May 96).

Top Prices at Auction (Nov. 1994–May 1996):

 Painting (pre-1968): $525,000. *The Tree*, oil and graphite/c, 75" x 75", 1964 (S. May 96).

 Painting (post-1973): $222,500. *Untitled #7*, acrylic and graphite/c., 72" x 72", 1974 (S. May 96).

 Drawing: $60,250. *The Shell*, watercolor and ink/p, 12" x 12", 1963 (S. May 96).

MARKET ANALYSIS

Past

Prior to the boom market Agnes Martin had been a well-kept secret. Naturally, if you collected Minimalism, you were keenly aware of her work. But there's nothing like big prices to get people talking about an artist's work. With the onset of the late 1980s, the art world began talking about Martin.

Agnes Martin has been living in New Mexico since 1973. Her move from New York raises the age-old question about how important living in New York is to an artist's market. We all know that the answer is "of course it makes a difference." But how much in dollars and cents? While there can be no exact answer, we can speculate.

Let's examine the issues. The first issue is that a lot of art is sold in New York from artists' studios. Dealers often find that allowing a potential collector to visit the artist's studio creates a bond between the collector and the work.

A sale is often the result.

The next point is that the art world is an extremely social place. Dealers frequently dine with their clients and often the dinner will include an artist the dealer is trying to promote. A dealer often has a problem with his or her clients because the line between friendship and business often blurs. Conversely, collectors often find themselves purchasing an artist's work out of a developing friendship. The system is imperfect, but it works. But for it to work the artist has to be in town and available.

Another consideration is that dealers hate to pay big shipping bills. Why work with an artist from California when there are so many fine ones in New York? Local artists present fewer logistical problems. Besides shipping, other hassles include long-distance phone calls, lack of continuous fresh inventory, and being out of touch with the work's development.

Despite Pace Wildenstein's art world prowess, Agnes Martin still cost herself a lot of money by leaving New York (then again, the work may not have developed as well as it did had she stayed). An educated guess would be that her prices would have been within 20 percent of Brice Marden's boom market range. Martin probably would have sold for $600,000–$750,000 versus $750,000–$1,000,000 for Marden. Of course, we'll never know for sure.

Present

Agnes Martin paintings set two records during the 1995–1996 season, both at Sotheby's May 1996 evening sale.

An early Martin canvas, The Tree, broke the old record of $495,000 (set in 1990) by *The Peach*. The new record was set when *The Tree* exceeded its pre-sale estimate of $250,000–$350,000 to sell for $525,000. Besides being a very elegant painting, The Tree was well served by being off the market for over 30 years. It was originally purchased from Martin's first New York dealer, Robert Elkon, in 1965.

The same sale contained *The Shell* which set a record for a drawing by Martin. *The Shell* carried a teaser estimate of $15,000–$20,000. It surprised no one when it went way over to sell for a record $60,250. Once again, the record was the result of all the right factors; a superb work, from the artist's best period, that couldn't have been fresher to the market. *The Shell* eclipsed the old record of $49,500, set in 1990 by Water.

The above sale offered a third Martin, this time a pale blue and beige painting from 1974 (the year Martin returned to painting after a six-year hiatus). The painting, *Untitled #7*, brought $222,500, exceeding its $180,000–$220,000 estimate. Six months earlier at Christie's, a 1988 painting of alternating

horizontal bands of light and dark gray sold for the same $222,500. This work was expected to bring $200,000–$250,000.

Future

Agnes Martin is a market waiting to happen in a big way. Many market factors are in place. The artist is in her 80s, yet has recently done some of the best work of her career. The most powerful gallery in America (Pace Wildenstein) represents her. Her work is fairly scarce on the secondary market. Finally, Martin's auction market continues to gather steam.

Martin's work has always been respected. But its obsessive quality has perplexed a large group of collectors. Sophisticated collectors who were willing to educate themselves and stretch a bit have reaped rewards, both in terms of pleasure and financial appreciation.

Martin's minimalist canvases rank just a shade below those of Brice Marden and Robert Ryman in importance. In recent years Marden and Ryman have developed a relatively wide base of popularity. Martin's work is probably a little more difficult to comprehend and thus less popular.

It helps if you've visited New Mexico. Martin's studio is located in the middle of the high desert splendor of red sandstone cliffs. Her 6' x 6' canvases (now 5' x 5') are based on spiritual feelings derived from the landscape. You have to experience this part of the Southwest to "get" her work.

If you examine Martin's boom market prices and compare them to her present market numbers, you'll see very little difference. Major early paintings generally sell for $250,000–$450,000. Later works realize $200,000–$300,000. In the not-too-distant future they will bring more. A 1964 painting recently cracked the $500,000 barrier. It won't be long until these early works bring $600,000–$750,000. Later works should plateau at $350,000–$450,000.

These predictions are based on a number of current conditions. First, Minimalism looks more important as time goes on. Martin is one of only three Minimalist painters that matter (Robert Mangold is a good artist but eventually will be regarded as a member of the supporting cast just as Mel Ramos and Robert Indiana are in Pop Art).

Second, the gap between Martin's prices and those of Marden and Ryman is too great. A major Marden would currently be estimated at $600,000–$800,000, a Ryman $400,000–$600,000, and a Martin $350,000–$450,000.

Martin's works on paper are another unexploited area. Those with subtle color (often the later works) are exceptional. Works on paper appear infrequently at auction. When they do, expect to pay $30,000–$45,000. Once again, this is a lot less than what you would pay for a comparable Marden ($45,000–

$85,000 for a late "Gestural" work).

Agnes Martin is nearing the end of her career. In early 1996 Agnes Martin's representative, Pace Wildenstein (Beverly Hills), held a mesmerizing show of her most recent paintings. The new paintings, painted in thin washes of earthen red and sky blue, had the ethereal quality of her watercolors. A gallery staff member mentioned that he hoped viewers would savor the show. Why? It turns out that Martin is planning to take a break from painting.

If you read between the lines, given her age, this was likely to be her last show of new paintings. If that turns out to be the case, from a market perspective, her timing couldn't be better. Coming on the heels of her record-setting season at auction, Martin's work should be more sought after than ever.

JOAN MITCHELL (1926–1992)

Estate Representation: Robert Miller Gallery, New York

Record Prices at Auction:

 Painting: $506,000. *Untitled*, o/c, 74" x 70 1/2", 1958 (S. Nov. 89).

 Work on Paper: $20,900. *Untitled*, pastel/p, 22 3/4" x 15 1/2", 1983 (S. May 89).

Top Prices at Auction (Nov. 1994–May 1996):

 Painting: $464,500. *To the Harbormaster,* o/c, 76" x 118", 1957 (C. May 96).

 Work on Paper: $14,950. *Untitled*, oilstick/p, 14" x 16", circa 1959 (C. May 96).

MARKET ANALYSIS

Past

The Joan Mitchell market expanded dramatically during the boom years. A combination of factors converged to drive her prices beyond the quarter-million-dollar level. First off, the works were relatively inexpensive (below $100,000) prior to the boom, thus creating a sense of opportunity. The work was also lively, decorative, and easy to live with. The final factor was Mitchell's historical roots. The other Abstract Expressionists had become too expensive for most collectors, leaving Mitchell next in line.

There were fourteen large paintings that sold between May 1988 and May 1990. Five sold for over $100,000, three went for over $200,000, three for over $300,000, and three for in excess of $400,000. As the 1980s wore on, the estimates for Mitchell kept increasing with each auction, yet the work kept pace and usually outran its estimates.

Mitchell's market boom years distanced her prices from the third tier of Abstract Expressionist artists. She was now a solid member of the second tier. If forced to rank the Abstract Expressionist artists by price level, they would shake out as follows (in alphabetical order):

First Tier	Second Tier
de Kooning	Francis
Gorky	Gottlieb
Kline	Guston
Newman	Hofmann
Pollock	Mitchell
Rothko	Motherwell
Still	Reinhardt

Present

The last *Art Market Guide* advanced the "Joan Mitchell Market Rule," which was another way of saying her market put a greater premium on color over period. Essentially it meant collectors would rather have a late painting with bright color than a more important painting from the 1950s. With the exception of the Grand Vallée paintings, the 1950s work is superior to the late work, but does possess a less vivid palette.

This theory may have been proven false by the sale of *To the Harbormaster* for a near-record $464,500 (C. May 96). This large vintage Mitchell (76" x 118", 1957) had been estimated at $300,000–$350,000. The price was justified as this was one of the finest Mitchells ever to come up to auction.

But most important, the painting may have signaled a more thoughtful approach by collectors in buying Mitchell. While *To the Harbormaster* certainly had rich strokes of red and blue, it lacked the brighter, more decorative color of the late work. While the Grand Vallée paintings of the 1980s are standouts, Mitchell's 1950s work should certainly bring greater prices than everything else. They haven't necessarily in the past.

The 1995–1996 season saw the emergence of higher prices for Mitchell's small-scale canvases (under 30" x 24"). A total of four examples appeared, with three selling. The average selling price was $36,400, with one painting selling for a high of $51,750. Finally, almost every Joan Mitchell that came up found a buyer. A total of 15 works were offered with an amazing 14 selling (always within or above estimate).

Future

Joan Mitchell is largely a still developing market. For this reason her prices still have a way to go. She is still relatively inexpensive.

Mitchell benefited greatly from the boom market of the late 1980s. Dealers

discovered that Mitchell was a living link (at the time) to the glories of the Abstract Expressionist era. While she wasn't a great painter, she was certainly good enough to take seriously. Better yet, she was a woman.

Once again the gender factor came into play. The only serious female Abstract Expressionist painters were Mitchell, Grace Hartigan, Elaine de Kooning, and Lee Krasner. Hartigan was just a fair painter, de Kooning was a lightweight, and Krasner was a good painter but derivative (of Jackson Pollock). That left Joan Mitchell as the one serious talent.

Another interesting factor was that Mitchell was superior to the entire third tier of male Abstract Expressionists. This group included Jack Tworkov, Michael Goldberg, Milton Resnick, and Bradley Walker Tomlin. I would rank Mitchell equal to Adolph Gottlieb in importance.

Even though Mitchell's work bears little visual relationship to Gottlieb, her market is in a similar price range, but will likely surpass his in the near future. This is based on the belief that Gottlieb's work seems to fade in relevance while Mitchell's work looks more timeless.

Currently, a large Gottlieb canvas can be expected to bring from $150,000 to $300,000 at auction. (The record for a Gottlieb is $352,000, C. May 89.) Mitchell paintings are in a similar range. That equality should evaporate as Mitchell's works will rise as high as $500,000, similar to her boom market years.

Interestingly, some of Mitchell's best paintings are not her 1950s works nor those from the 1960s or 1970s. They are the Grand Vallée series from the 1980s. These paintings are light-drenched, lusciously colored, and inspired by the French countryside. These works are now selling for $200,000–$250,000. They will eventually sell for $350,000–$450,000.

As far as financial opportunities, one lies in Mitchell's fine pastels. Produced late in her career, they combine spontaneity with deep color that appears derived from wildflowers. Unfortunately, they don't appear often at auction. They would currently be expected to bring $15,000–$25,000. Look for them to top out at $25,000–$50,000. For comparison, Adolph Gottlieb works on paper currently sell for roughly $15,000–$30,000.

A final Mitchell buying opportunity lies in acquiring her small canvases. While most bring $25,000–$45,000. Last season, one broke the $50,000 barrier. These small canvases are often very attractive and could easily go to $75,000 within five years.

ELIZABETH MURRAY (b. 1940)

Prime Representation: Pace Wildenstein, New York

Record Prices at Auction:

Painting: $126,500. *New York Dawn*, o/c, 89" x 65", 1977 (S. Nov. 91).

Pastel: $24,750. *Car, pastel on paper*, 33" x 47 1/2", 1982 (S. Nov. 89).

Print: $9,900. *Down Dog*, lithograph, 41" x 50", edition of 65, 1988 (S. May 91).

Top Prices at Auction (Nov. 1994–May 1996):

Shaped Painting: $57,500. P*ompeii (Winter 1987)*, o/c, 87" x 69 1/2" x 13", 1987 (S. Nov. 95).

Pastel: $13,800. P*ainter's Partner*, pastel on paper, 58" x 22", 1989 (S. Nov. 95).

Print: $5,175. *Updog*, lithograph, 52" x 36", edition of 62, 1987-88 (S. Nov. 94).

MARKET ANALYSIS

Past

Elizabeth Murray was a nonparticipant in the boom market. Not a single canvas came up to auction between 1987–1989. The only work to come up was a meager total of two pastels—hardly a test of the health of her market.

It wasn't until April 1991 (Sotheby's evening sale) that any sort of legitimate test of Murray's market occurred. Two paintings from the famed Saatchi Collection came up for sale. Both were early, large (around 10' x 10'), non-shaped canvases. Each carried estimates of $80,000–$100,000. Each went over estimate, selling for $110,000 and $121,000, respectively.

Since these paintings came up in the depths of a sharp recessionary market, the results were impressive. The true test would have been if a signature shaped canvas had come up. The only one to do so was in November 1990 (Sotheby's evening sale) as the market was starting to plunge. A very attractive magenta work, *War and Peace*, failed to sell for $100,000–$150,000.

It's surprising that during an outrageous boom market there was no specu-

lation on Murray's work (at least at auction). The real question is with virtually every artist doing extremely well, why not put up a Murray? There are only two possible answers. Perhaps owners were afraid her work would be the exception and bomb at auction. The other plausible explanation is the artist's dealer did a good job of placing the work with collectors who were buying mainly for enjoyment.

Present

Compared to last season, there was a little more action for Murray during the 1995–1996 season. For the first time in two seasons, a large-scale canvas came up to auction. Sotheby's November 1995 evening sale contained the painting *Pompeii* (87" x 69 1/2" x 13", 1987), which was estimated at $60,000–$80,000. The painting was of decent quality, perhaps a 7 on a scale of 1 to 10. *Pompeii* hammered at $50,000, which means the consignor received $45,000 (final selling price was $57,500 with the premium). For an artist touted by many as one of America's top abstract painters, this amount represents a pittance.

The current season also saw the sale of two transitional canvases by Murray at Christie's (Feb. 96). The two paintings, *Try* and *Twist of Fate*, each measured 56" x 54" and were painted in 1979. Both sold for $11,500 a piece. The estimates for each had been $10,000–$15,000. Finally, an early Murray pastel, *Painter's Partner* (58" x 22", 1980) brought $13,800 against an estimate of $15,000–$20,000.

Future

The big news in the Elizabeth Murray market was that after a long-term relationship with the Paula Cooper Gallery, the artist moved over to Pace Wildenstein. It should be said that Paula Cooper did a first-rate job taking a very average artist like Murray and developing an international reputation for her. As to why Murray left, her comment to the press was that she was simply ready for a change. The reality is that Paula Cooper had probably run out of clients for the work.

What are the implications for her market? Well, that depends. On the surface it should be positive. Pace Wildenstein doubtless has clients that Paula Cooper never had access to. Whether they are interested in Murray or can be persuaded to take a look at her work remains to be seen. One significant factor is whether Murray will grow as an artist. Her current work isn't really up to Pace standards. Another factor is whether Pace will support her work at auction. Assuming that both a Murray exhibition takes place at the gallery and a major

painting comes up to auction (during this season), we should have our answers soon.

Elizabeth Murray is generally considered to be one of the greatest living female painters. The others are Agnes Martin, Helen Frankenthaler, and Susan Rothenberg. However, Murray is simply not in their league.

Murray has gone further than she would have if she were a male painter. Politically correct or not, when you discuss the financial potential of an artist you have to consider all the external factors. There is obviously more to an artist's reputation than the aesthetics of his or her work.

Politics play an increasingly greater role in determining an artist's visibility. This includes reviews in the *New York Times* and inclusion in museum shows such as the Whitney Biennial. The right exposure obviously affects an artist's saleability in the marketplace, at least in the short run. Simply put, Murray gets a lot of press and museum exposure because she is a woman.

Judged solely on the merits of her paintings, Murray is only a "B" artist. Sure, she has produced a handful of first-rate paintings. Overall, though, the body of work she has created is flawed. The work is dependent on the gimmick of the sculpted canvas. This is the work's strength and weakness all rolled into one.

Murray is at her best when she keeps the paint application and imagery simple. When she starts to add on superfluous appendages, the overpainting of the surface kicks in. If you examine a Murray up close, the quality of the paint handling is appalling. It's as if she can't help herself from applying too many layers of paint.

Great painting looks great both up close and standing seven feet away. Just examine the works of artists as diverse as Jasper Johns and Chuck Close. Their paintings hold up beautifully upon intimate inspection as well as viewing from a few steps back.

The other difficulty with Murray is her prices. Her paintings aren't exactly rare on the primary market. If you want to buy one, you can easily do so by paying roughly $80,000 to her gallery (since they infrequently come up to auction). That's too expensive. If they were selling for $35,000–$45,000, it would make sense to acquire one. But for $80,000, a collector has far better options.

On a positive note, an overlooked aspect of Murray's work are her pastels. They rank among the best in that medium. I would put her up there with Sean Scully, Francesco Clemente, and Jennifer Bartlett. In terms of price they offer excellent value. They tend to sell at auction in the $10,000–$15,000 range. If you want to own a Murray, this is where the value lies.

Sell

BRUCE NAUMAN (b. 1941)

Prime Representation: Leo Castelli, New York

Record Prices at Auction:

> **Painting:** $1,925,000. *One Hundred Live and Die*, neon, 118" x 132" x 21", 1984 (S. Nov. 92).

> **Drawing:** $407,000. *Fever Chills Dryness and Sweating*, graphite and acrylic/p, 67" x 88", 1984 (S. May 90).

Top Prices at Auction (Nov. 1994–May 1996):

> **Sculpture:** $255,500. *Henry Moore Bound to Fail,* cast iron, 25 1/2" x 24" x 2 1/2", edition of 10, 1970 (S. Nov. 94).

> **Drawing:** $85,000. *Welcome Shaking Hands*, gouache and graphite/p, 76 1/2" x 85", 1985 (C. May 96).

MARKET ANALYSIS

Past

Despite producing mature work since the late 1960s, Bruce Nauman wasn't considered an auctionable artist until the late 1980s. At least he wasn't considered evening sale material.

The shape of things to come began with the sale of a large-scale, four-color drawing at Sotheby's in February 1989. The study was titled *White Anger, Red Danger, Yellow Peril, Black Death* (acrylic on paper, 50" x 38", 1984) and estimated at a modest $15,000 to $20,000. It ended up selling for almost ten times its low estimate, as it brought $148,500. The rush to speculate on Nauman was on.

Just three months later, Nauman had reached evening sale status. A large-scale sculpture, that was the completed work of the above, study sold for a record $429,000 (est. $150,000 to $200,000). The work is best described as four life-size steel chairs that were painted red, yellow, white, and black. The chairs were then mounted to two steel I-beams, which were in turn suspended from

the ceiling. The whole piece measured 14 feet in diameter.

Nauman's drawings reached their high at Sotheby's May 1990 sale, just as it seemed almost every other artists' prices were falling. First, *Seated Storage Capsule (For Henry Moore)* went way above its estimate of $80,000–$100,000 to bring a whopping $330,000. Then *Fever Chills Dryness and Sweating* easily hurdled its $100,000–$150,000 estimate to a record $407,000. Rumor had it that Europeans had bought both pieces.

Nauman reached million-dollar status at Sotheby's in November 1992, the market's low point. A giant wall work, titled 100 Live and Die, that listed 100 "commands" written in multicolor neon, sold for almost $2 million. The commands were actually lists of trivial daily functions that centered around life and death, such as "Live and Die," "Eat and Die," "Run and Live," etc. The bidding was the heaviest of the evening and confirmed there was indeed a big market for Bruce Nauman.

Present

The 1995–1996 season featured very little Nauman material. Two examples of the neon multiple *Double Poke in the Eye II* (from an edition of 35) came up. Both went a bit over estimate, selling for $40,250 and $42,550, respectively. This particular piece, which is best described as two neon heads and hands that flicker and poke each other in the eye, has been an auction mainstay for Nauman. I've lost track of how many times it's come up.

The most important Nauman of the season was a large color study of four nude men shaking hands called *Welcome Shaking Hands*. Appearing at Christie's May 1996 day sale, with an estimate of $50,000–$70,000, it was one of the bright points of the morning as it sold for $85,000.

Contrast the above with the 1994–1995 season which centered around one of the artist's few visually seductive pieces, the wall relief *Henry Moore Bound to Fail*. This cast iron piece was from an edition that was cast from the wax original. The object resembles a person's back and arms that are bound with rope. The piece split the $200,000–$300,000 estimate to sell for $255,500 (a record for a non-neon Nauman sculpture).

Future

This may sound like some form of heresy, but Bruce Nauman as a visual (not conceptual) artist is the most overrated major artist working today.

In the late 1960s, Nauman began receiving a large amount of critical and museum attention that culminated with his 1993–95 traveling retrospective.

Critics couldn't praise the work fast enough. The reviews were a mystifying group of statements. Most were about how Nauman's work dealt with psychological interpretations of how we think and function. Nauman's work is considered innovative because he was the first artist to use his body as his medium. Basically, he used the artist as the subject. An early example was a photograph of Nauman spitting water from his mouth that was titled *Self-Portrait as a Fountain*.

Conceptually, Nauman is interesting and certainly a major influence on many artists. He has a secure place in art history. Visually, with the exception of an occasional neon piece, he's a dud.

The Whitney Museum of American Art sporadically displays a Nauman from its permanent collection called *Six Inches of My Knee Extended to Six Feet* (1967). The work is nothing more than a skinny vertical piece of dull fiberglass, mounted to the wall. That's it. Now perhaps the thought of the artist stretching the fiberglass (before the resin hardener was applied) is a mentally stimulating thought (I realize the idea of the body serving as a point of departure for making art was original at the time). But the visual results are appalling.

A better example is Nauman's sculpture *Dog Biting Its Ass*, which appeared at Christie's evening sale in November 1994. This work measured 35" x 30" x 34", was made of yellowed polyurethane foam taxidermy molds, and dangled by a wire from the ceiling. Nauman found the molds at a taxidermist's shop in New Mexico and proceeded to cut them up and rearrange the animal's anatomy. The work was estimated at $120,000 to $150,000 and sold for $123,500.

Dog Biting Its Ass has got to be one of the ugliest (and I don't mean so ugly that it's actually beautiful) works of art that I've ever seen come up for sale at an evening auction. It is typical of the visual quality of Nauman's work (with the exception of his attractive Neon works). There is an excellent chance in years to come that most of his sculpture will be viewed basically as artifacts. I won't even comment on his "drawings", which are no more than throw away studies, saved by the artist only for the market place. They may still be collected in the future, but they'll be valued more like rare art books than works of art.

Lord knows that Nauman has heavy support in the art world in all the quarters that count. But collectors who own the work will someday realize that art is ultimately a visual experience. The "idea" is meaningless unless it looks like something. Time to sell Bruce Nauman.

LOUISE NEVELSON (1900–1988)

Estate Representation: Jeffrey Hoffeld & Co., New York

Record Prices at Auction:

Black Sculpture: $203,500. *Sky City I*, painted wood construction, 93" x 62" x 20", 1957 (S. Nov. 88).

Gold Sculpture: $195,000. *Royal Tide-Dawn*, painted wood construction, 91" x 63" x 11", 1960–64 (C. Nov. 93).

White Sculpture: $253,000. *Dawn's Wedding Chapel I*, painted wood construction, 90" x 51" x 6", 1959 (S. May 89).

Box: $30,250. *Cryptic*, painted wood box construction, 9" x 9 1/2" x 6 1/2", 1966 (S. May 89).

Top Prices at Auction (Nov. 1994–May 1996):

Black Sculpture: $74,000. *Dame Edith VIII*, painted wood construction, 30 1/2" x 55 1/2" x 8", 1968 (S. Nov. 94).

Gold Sculpture: $80,000–$100,000 (passed), *Sun XXVI*, painted wood construction, 86" x 38 1/2" x 9", 1962 (C. May 86).

White Sculpture: $48,300. *Dawn's Landscape XXXVI*, painted wood construction, 47" x 37" x 6", 1976 (C. Feb. 96).

Box: $18,975. *Cryptic*, painted wood construction, 5" x 7" x 4", circa 1967 (S. Nov. 94).

MARKET ANALYSIS

Past

Louise Nevelson had a solid if unspectacular 1988–1990 auction showing. Major constructions brought between $100,000 and $250,000. Large-scale works from the 1950s found an especially strong reception. While Nevelson's signature image will always be the construction of found pieces of wood that have been painted black, it was an elegant white construction that commanded the

highest price of the 1980s.

In May 1989, at Sotheby's evening sale, a construction called *Dawn's Wedding Chapel I* exceeded its pre-sale estimate of $150,000–$200,000 to sell for a record $253,000. Sotheby's catalog astutely pointed out that a similar piece from the series (the slightly larger but not necessarily better *Dawn's Wedding Chapel II*) was in the collection of the Whitney Museum. Part of the reason for the big price was the work's white color. Nevelson's classic black works are dark and mysterious. The works' components tend to become homogenous. However, her white sculptures' components cast dramatic shadows that give these works greater spatial depth than those painted black.

Nonetheless, the black works most likely have the largest audience and the majority of those that came up for sale found ready buyers. The classic Nevelsons are the multi-box units that contain found manufactured objects (such as a bowling pin) and assorted wood scraps. These boxes are then stacked and the entire piece is placed against a wall. A great example was *Sky City I*, which set the record for a black sculpture when it sold for $203,500 at Sotheby's in November 1988.

The market was equally solid for Nevelson's freestanding constructions (sometimes made from aluminum) and her constructions that hang on the wall. The late 1980s also saw a large number of small coffee-table-size boxes come up for sale and usually sell. These miniature black Nevelsons are actual hinged boxes that are covered with, and also contain, found objects. They consistently brought prices in the $10,000 to $25,000 range.

Present

Louise Nevelson had an active 1995-1996 season, but it wasn't particularly lucrative. A total of eighteen works appeared. The categorical breakdown of what sold was five black constructions (seven passed), three white constructions (all sold), no gold constructions (both passed), and one collage that sold. There were no six-figure prices, but that was because only one work appeared that could be classified as important.

However, the failure of the one important work to sell was disturbing. Christie's day sale of May 1996 included the gold construction, *Sun XXVI*. This work was a full size (86" x 38 1/2" x 9") sculpture from 1962. The estimate had been $80,000 to $100,000. The only negative was that the 24 box units (that composed the piece) were all the same size. In other words, this particular Nevelson was too symmetrical. Her best works are composed of different size boxes that are then combined to form one big construction. Still, *Sun XXVI* was an early work, attractive, and attractively estimated. It should have sold.

Future

The failure of *Sun XXVI* to find a buyer revealed a "truth" about the current Louise Nevelson market: her best work is undervalued.

These days, Nevelson is not part of the art world's consciousness. Informed collectors, who are buying the latest sculpture of our times, acquire artists such as Robert Gober. Collectors who pursue sculpture that is already established as significant are likely to purchase artists such as Joel Shapiro, John Chamberlain, or Donald Judd. But collectors who are interested in contemporary art's roots (the days of Abstract Expressionism) would be wise to reevaluate Louise Nevelson.

Nevelson's earliest works (from the late 1950s through the early 1960s) hold their own with some of the best of contemporary sculpture. While the work isn't groundbreaking like Carl Andre's or Donald Judd's, it is solid. Her work also helps provide an historical link between the artists of the 1950s that used found objects in their work (such as Robert Rauschenberg), and the many Pop artists who incorporated the found object (such as Jim Dine).

Equally important, Nevelson's work is inexpensive. The going rate at auction for one of her marvelous small hinged box constructions is only $7,500 to $15,000. They compare favorably in value to John Chamberlain's small "Tonks" ($12,000 to $18,000 at auction) or current "Baby Tycoons" (approximately $18,000 in a gallery).

The major large-scale early work is also a good deal (current estimates would fall in the $75,000 to $150,000 range). These figures are quite a bit less than what one would expect to pay for a large-scale work from the 1960s by George Segal and (once again) John Chamberlain (both artists use found objects, though obviously in different ways. In fact, the starting point for a comparable Nevelson is about half of the starting point for works by these two artists. That's good value. If in the near future Nevelson should receive a serious museum show that focuses on her early sculpture, the rush will be on to buy these works.

 Hold

CLAES OLDENBURG (b. 1929)

Prime Representation: Pace Wildenstein, New York

Record Prices at Auction:

> **Sculpture ("Store"):** $495,000. *Bacon and Egg*, painted plaster over muslin, 42 1/2" x 35" x 6 1/2", 1961 (S. May 89, Karl Ströher Collection).

> **Sculpture ("Soft"):** $387,500. *Soft Light Switches* ("Ghost" version), paint on canvas filled with kapok, 52" x 52" x 9 1/2", 1963 (S. Nov. 94)

> **Drawing:** $71,500. *Sketch of Toilet from Overhead*, crayon and tempera/p, 17" x 14", 1963 (S. May 89, Karl Ströher Collection).

> **Multiple:** $37,400. *Profile Airflow* (car), molded plastic over lithograph, 32" x 64", edition of 75, 1969 (S. Nov. 88).

> **Print:** $31,900. *Double Screw Arch Bridge, State II*, etching, 23" x 50", edition of 35, 1980–81 (S. Nov. 89).

Top Prices at Auction (Nov. 1994–May 1996):

> **Sculpture ("Store"):** $288,500. *Bacon and Egg*, painted plaster over muslin, 42 1/2" x 35" x 6 1/2", 1961 (C. Nov. 95).

> **Drawing:** $19,550. *Objects in the Bathwater – Toys*, crayon and watercolor/p, 12 1/2" x 18", 1977 (S. May 95).

> **Print:** $25,300. *Double Screw Arch Bridge, State II*, etching, 23" x 50", edition of 35, 1980–81 (S. May 96).

MARKET ANALYSIS

Past

Claes Oldenburg returned to the art world's consciousness thanks in part to the boom market.

The late 1980s saw dramatic price increases for all the Pop artists. Jasper Johns, Robert Rauschenberg, Roy Lichtenstein, Andy Warhol, and James Rosenquist, who were always sought after, became even more so. Tom Wesselmann

began moving up. Even Robert Indiana and Mel Ramos enjoyed mini-booms. Oldenburg's boom market prices brought him in line with Rosenquist.

The big event for the Oldenburg market was the auctioning of the remainder of Karl Ströher's collection. Ströher, along with fellow German Peter Ludwig, was one of the first major collectors of Pop Art. He had particularly attractive Oldenburg holdings, including important works from The Store. (In 1961 Oldenburg created objects–household goods, food, clothing–that he displayed and sold in an actual store. The show was a commercial and aesthetic success.)

Ströher's four major pieces sold for an average of $440,000 versus the average estimate of $202,500-$255,000. The sheer quality and quantity (a total of six Oldenburgs) and the high profile of the sale called attention to Oldenburg's market.

An interesting subcategory in Oldenburg's market is his Typewriter Erasers. This is by far his finest "editioned" sculpture (edition of 18). Constructed out of aluminum, fiberglass, and steel, each one measures 32" x 24 3/4" x 34 3/4" and was fabricated in 1977. Aesthetically it's the perfect Oldenburg.

In recent memory, four have come up to auction. Here's what they have done:

$253,000 (est. $75,000–$100,000) (C. Nov. 89)
$308,000 (est. $100,000–$150,000) (S. Feb. 90)
$178,500 (est. $80,000–$120,000) (S. Nov. 93)
$129,000 (est. $80,000–$120,000) (C. May 94)

The most recent price was a bargain. The piece should currently be worth $150,000-$200,000, based on the relative prices of other major sculptors.

Present

The 1995–1996 auction season saw the continuation of the Oldenburg *Bacon and Egg* saga. *Bacon and Egg* was the record setting-sculpture that was also the cover lot of the "Karl Ströher Collection" of Pop Art (S. May 89). Back then it sold for $495,000, a record that remains to this day. This colorful enamel painted wall-sculpture had been estimated at $250,000-$300,000.

Exactly a year later, the owner of *Bacon and Egg* tried to cash out and put the sculpture back up at Sotheby's. Only this time, despite a falling market, it carried an estimate of $600,000–$800,000. The bidding only got up to $525,000 and the Oldenburg passed.

Lo and behold, *Bacon and Egg* recently came up again at Christie's in November 1995, only this time it found a buyer at $288,500. The estimate had been $180,000–$250,000.

Oldenburg drawings continued to sell for low prices. Two appeared this season. The first was an attractive 1960s drawing, done in tones of light black watercolor and black crayon, of a proposal for a colossal vacuum cleaner sculpture. The finished work was to have been placed in a park in New York City. The drawing had an impressive provenance and had been off the market since 1965. Yet all *Vacuum Cleaner* could muster was a winning bid of $10,350. The estimate had been only $8,000–$12,000, illustrating the auction house's low expectations for the work.

The other drawing was an orange pastel and black charcoal rendering called *Apple Core* (13" x 9", 1989). It was estimated the same as *Vacuum Cleaner* but sold for more. *Apple Core* brought $13,800 at Sotheby's in May 1996. Why did this late work do better than a more important drawing from the 1960s?

Vacuum Cleaner was loosely rendered and set in an environment (a park). *Apple Core* was both more realistic and it was isolated on the page. The Oldenburg market (incredibly) preferred a drawing of an object taken out of context (but decorative because it had some color) to a legitimate working drawing that had more integrity (from the artist's Pop days).

Future

The Oldenburg market continues to struggle for lack of major soft sculptures as well as first-rate drawings. The fact that the excitement during the 1995–1996 season was over the twice recycled *Bacon and Egg* says something about pent-up demand. But it also says something about how little Oldenburg sculpture exists that's worth buying. Most of his great pieces don't circulate because they're in museum collections. It's hard to have a successful market when there's little to trade.

Oldenburg's most recent exhibition at Pace (1994–95) emphasized the reworking of his ideas from the 1960s: blowing objects up in scale and recreating them out of soft pliable materials. The best work at his show was a large soft clarinet made of painted and stuffed canvas. The accompanying drawings were also nice.

But where was the innovation? The problem with repeating yourself as an artist is that you cheat yourself and your audience. A mind as fertile as Oldenburg's can do better. Also, the recent collaboration with his wife, Coosje van Bruggen, certainly isn't helping the work. Oldenburg secured a place in art history a long time ago. If he wants to enhance that place, he's going to have to take a few more risks.

As revealed by his 1995 traveling retrospective, it is Oldenburg's drawings that really stay with you (and offer the best value). Other sculptors have made

and continue to make impressive drawings. The list includes David Smith, Joel Shapiro, Richard Serra, and John Newman. But only Oldenburg's drawings show off a facility for fluid line, shape, and realistic rendering. In other words, Oldenburg can draw in a traditional sense. You just don't see that anymore.

The market for Oldenburg drawings is low right now. Drawings currently bring between $10,000–$25,000 at auction (they were $35,000–$75,000 during the boom). That should rise to $25,000–$50,000 over the next five years. The positive reaction to his retrospective should help demand, as should an improving market for works on paper in general.

Claes Oldenburg is rated a "Hold" because his most important work, his sculpture, is unlikely to change much in value.

His most important works from "The Store" have held up in price. They resonate as objects of historical importance rather than as great sculpture. In the long term, that's a problem. The current trend is that collectors are buying for visual rather than historical appeal. As mentioned elsewhere in the *Art Market Guide*, many collectors would rather buy a more decorative piece from the 1980s than pay a premium for a vintage 1960s piece.

Oldenburg's other major works, the original 1960s "soft" sculptures, have held up aesthetically and financially. The problem here is that too few of them ever come up for sale. So these works are unlikely to give a needed boost to his market. Overall, the Oldenburg market's best bet is simply to be carried up by the likely rising tide for Pop Art, as we approach the year 2000.

JACKSON POLLOCK (1912–1956)

(Drip Paintings) (Everything else)

Estate Representation: Jason McCoy Gallery, New York

Record Prices at Auction:

> **Painting:** $11,550,000. *Number 8, 1950*, various paints on canvas mounted to board, 56" x 39", 1950 (S. May 89).

> **Work on Paper:** $1,155,000. *Number 18, 1951*, water color and ink on paper, 25" x 38", 1951 (S. May 90).

Top Prices at Auction (Nov. 1994–May 1996):

> **Painting:** $2,422,500. *Something of the Past*, o/c, 56" x 38", 1946 (C. May 96).

> Note: *Number 1, 1952* (est. $4–6 million) passed, but was sold after the sale for an estimated $3 million (C. Nov. 95).

> **Work on Paper:** No major mature works appeared.

MARKET ANALYSIS

Past

The market for Jackson Pollock shifted into high gear with the sale of the last painting produced by the artist, *Search*. This colorful oil on enamel canvas from 1955 went over estimate to sell for $4.84 million at Sotheby's in May 1988. The price proved to be no fluke as the November sales yielded another strong price of $5.7 million for *Frieze* (a superior painting but similar in size and period to *Search*).

The market for Pollock peaked with the sale of the superb "Drip" painting *Number 8, 1950* for a stunning $11.5 million at Sotheby's in May 1989. This was probably the best Pollock in memory to come up to auction. The same sale saw the cover lot Pollock *Number 19, 1949* sell for $3.9 million. Interestingly, the next painting in the series (*Number 20, 1949*) came up exactly a year later as the market started to fade. *Number 20* wasn't quite as good as *Number 19* but was close enough to serve as a market indicator for Pollock. *Number 20* sold for

$2.4 million, a drop of almost 40 percent.

Overall, the boom market results for Pollock were very strong, with all eight major canvases that sold going within or over estimate (three paintings passed). All four major works on paper sold over estimate.

Surprisingly, the market for Pollock's chief Abstract Expressionist market competitor, Willem de Kooning, appeared stronger. Surprising because there are far fewer important Pollocks than de Koonings. The reason that de Kooning's work produced greater prices and demand can be attributed to his work's greater accessibility. Pollock's best work is pure abstraction. It doesn't provide points of reference like de Kooning's women or landscapes. Simply put, Pollock demands more from his audience.

Present

In November 1995 at Christie's, the most important Jackson Pollock canvas to appear in the 1990s came up with a pre-sale estimate of $4–6 million. The painting, *Number 1, 1952*, was a multicolor "Drip" painting with an awkward format (24" x 106"). This last factor may have contributed to the fact that the bidding reached only $3.3 million before it passed (it was subsequently sold after the sale to a dealer). The other factor was that despite its beautiful appearance in the catalog, in person it was only a B+ painting.

You wonder why a dealer would tie up that kind of money (supposedly $3 million which would mean a carrying cost of $25,000 a month based on 10 percent interest) on a very good but not great painting. There are quite a number of reasons, the main one being that there are unlikely to be any "A" Pollocks coming onto the market anytime soon. Most are in museums. The purchaser bought the best of what was available at a price well below estimate. At some point a collector will appear who has to have a large classic "Drip" painting. The collector will likely pay up (a guess is at least $5 million) for the simple fact that there's nothing else to buy. The dealer who bought "Number 1, 1952" made a smart purchase.

That same month over at Sotheby's, a small canvas (23" x 18") from 1946 went below estimate ($600,000–$800,000) to sell for $525,000. A superior picture from the same year came up six months later at Christie's. The painting, titled *Something of the Past,* measured 56" x 38" and was expected to bring $2 million to $2.5 million. It sold for $2.4 million.

Unfortunately, there were no significant works on paper to come up for sale and thus none to discuss.

Future

The most prestigious Post-War work of art you can own is a Jackson Pollock "Drip" painting. To own a Willem de Kooning "Woman" is special. But it's still not a Pollock "Drip" painting. To own a great Mark Rothko with maroon rectangles is wonderful. But it's still not a Pollock "Drip" painting. To own an action-filled black and white Franz Kline is impressive. But it's still not a Pollock "Drip" painting.

The point is that Jackson Pollock is viewed as the top contemporary artist icon. Kline struggled, Rothko was tormented, and de Kooning embraced life. Pollock did all three. What else can you say about a man who, when asked if he painted nature, responded "I am nature."

Pollock's "Drip" paintings are strongest when they are at their biggest. Standing in front of *Lavender Mist* (at the National Gallery in Washington, D.C.) or any museum size Pollock Drip painting is perhaps the quintessential Abstract Expressionist experience. You lose yourself in the mass of swirling lines and walk away thinking that if Pollock had the guts to make pictures like this, then anything in art (and maybe life) is possible. As de Kooning once said, "Pollock broke the ice."

As far as the Pollock market is concerned, the picture is more muddled. It's a given that a collector of means should buy a Pollock Drip painting. I also don't see how you can overpay for one of these on canvas or paper. However, the rest of his art is another matter.

This may sound sacrilegious but the pre-Drip paintings (prior to 1947) are overpriced and overrated as works of art. For that matter, so are any non-Drip paintings. Aesthetically these are very ordinary looking abstract paintings. There's also nothing innovative about them. They're often clumsy compositions with colors that can best be described as muddy. Sure, with the pre-1947 works you can see where Pollock was heading before he embarked on his breakthrough Drip works. But so what? At that point you're chasing a ghost. You're buying a "promise" rather than a "deed."

Take the recent sale of the 1946 painting *Something of the Past* for $2.4 million (C. May 96). What did the buyer really get? A painting done by an artist who was still searching. The piece brought a lot of money because there are so few colorful large Pollock canvases on the market. But this is an awkward work of art that only has value because of the scarcity of the real thing (a "Drip" painting).

Maybe collectors will continue to pay big money to own a piece of a genuine art world legend. But ultimately they are cheating themselves out of having the authentic Pollock epiphany that can only be experienced when looking at a "Drip" painting.

ROBERT RAUSCHENBERG (b. 1925)

Prime Representation: Independent

Record Prices at Auction:

Combine Painting: $7,260,000. *Rebus*, oil and collaged paper/c, 96" x 131", 1955 (S. April 91).

Silkscreen Painting: $1,870,000. *Bait*, oil and silkscreen inks/c, 60" x 60", 1963 (C. May 91).

Transfer Drawing: $275,000. *Untitled*, solvent transfer and mixed media/p, 23" x 29", 1958 (S. Nov. 89).

Print: $165,000. *Booster*, lithograph and silkscreen, 72" x 35", edition of 38, 1967 (C. May 90).

Top Prices at Auction (Nov. 1994–May 1996):

Combine Painting: $150,000-$200,000 (passed). *Untitled*, oil and collaged paper on panel, 10" x 7 3/4", 1954 (S. Nov. 94).

Silkscreen Painting: $827,500. *Glider*, oil and silkscreen inks/c, 96" x 60", 1962 (C. Nov. 95).

Transfer Drawing: None appeared.

Print: $48,300. *Booster*, lithograph and silkscreen, 72" x 35", edition of 38, 1967 (C. Nov. 94).

MARKET ANALYSIS

Past

Robert Rauschenberg's boom market was dominated by the emergence of his "Combine" paintings as million-dollar blue-chip commodities.

The sale of *Backwash* (61 1/2" x 48", 1959), the cover lot of Sotheby's November 1987 evening sale, for $814,000 set the table for *Rebus* at the incredible Ganz Collection sale a year later.

The Ganz sale was Sotheby's marketing at its best. They produced a special

hardcover clothbound catalog. This is considered the ultimate in prestige for a "one owner" collection sale. Although the most valuable lots of the twelve-lot sale were the six Picasso paintings, the cover lot was Rauschenberg's "Combine" masterpiece, *Rebus*. Not only was *Rebus* on the cover but the catalog devoted four pages to it.

Rebus (96" x 131", 1955) had a pre-sale estimate of $2.5 to $3.5 million. The painting surprised all observers by bringing a robust $6,325,000. This immediately put Robert Rauschenberg in Jasper Johns's financial class. The lot that followed *Rebus* was another major Rauschenberg "Combine" titled *Winter Pool* (90" x 59 1/2" x 4", 1959). It carried an estimate of $1-$1.5 million and brought another strong price of $3,740,000.

An important footnote to the sale of *Rebus* was that it was acquired by a Swiss collector who a few years later went bankrupt. He was forced to liquidate his collection and *Rebus* came on the block again (S. April 91). This time it carried a $4-6 million estimate that appeared to be wishful thinking. The market was now in a deep recession and the number of buyers for a multi-million-dollar picture that had recently been at auction appeared small.

Much to the delight of Sotheby's, the bidding was intense, a testament to the quality and power of the painting. *Rebus* sold this time for $7,260,000, setting the record that still stands for a Rauschenberg.

The Rauschenberg boom market also witnessed the rise of his "Transfer" drawings and "Silkscreen" paintings to dramatic new price levels. His print market also saw one of his best prints, *Booster*, go over a hundred thousand dollars ($165,000).

While the rest of Rauschenberg's less important work went up along with the tide, in general, a relatively small number of works came up at auction. Considering the artist's vast production, this was surprising and difficult to explain.

Present

In an interesting reversal of last year's auction season, there wasn't a single Rauschenberg painting on polished metal that came up for sale. The 1994–1995 season saw three works come up; two sold for an average "giveaway" price of $30,400 (for paintings as big as 4' x 7'). It was shocking to see how much these paintings had slipped in price. Near the height of the market, a giant painting on aluminum called *Philosopher's Night Circus* had been estimated at $300,000–$400,000 (it passed). It was an extreme example but it illustrates the point of how valuable these works had once been.

This year's Rauschenberg action centered around the "giveaway" prices of

his works on paper. Currently, there are still plenty of works to choose from. However, some dealer will eventually start buying them up and prices will start to increase due to short supply. The 1995–1996 season saw a total of seven works on paper come up. The average selling price of those that sold was $19,700.

This season also saw the sale of two black and white "Silkscreen" paintings. Rauschenberg painted this series of 79 works between 1962 and 1964. The first to come up was a large work titled *Glider* (96" x 60",1962), at an estimate of $800,000–$1,000,000. The painting's subject matter centered around imagery of America's space program (screened images of a rocket and radar). *Glider* sold for $827,500 (C. Nov. 95).

The next night at Sotheby's saw the sale of one of the few small-scale works from the "Silkscreen" series, *Round Trip I* (30" x 40", 1963). This painting was composed of jumbled images of dancers, footballs, birds, and so on. *Round Trip I* had been off the market since 1963, which helped it go over estimate and sell for $211,500 (est. $80,000–$120,000).

Future

The question that never seems to be answered is why Robert Rauschenberg doesn't have a better market. The answer goes all the way back to his initial representation by Leo Castelli. There's probably a lot of truth to Rauschenberg's allegations that Castelli never treated Rauschenberg's work with the same respect as Jasper Johns's. This pattern continued from the 1960s to the early 1980s. Then Rauschenberg switched his allegiance to Knoedler Gallery. But even Knoedler wasn't able to raise his prices to a point commensurate with his place in art history.

The key to making a superstar like Rauschenberg into an artist with a superstar market is marketing the work properly. That means not only showing the work in the right context but editing it carefully (no small task given Rauschenberg's prolific ways). Castelli probably lacked the will to stand up to Rauschenberg and Knoedler never seemed like the right context. Currently, Rauschenberg is a free agent. But as this book goes to press, Pace Wildenstein is planning to do a series of two Rauschenberg shows.

While this doesn't necessarily mean that Pace will end up representing Rauschenberg, it's pretty obvious that they're trying each other out. If it goes well, it will be the best thing that could happen to Rauschenberg's market. Arne Glimcher certainly has the status and credibility to confront Rauschenberg with the truth; namely that he has to let Pace remake his image of being viewed as too prolific and not selective enough in what he releases. If Rauschenberg is smart, he'll listen to this advice and sign a contract with Pace.

The current opportunities for buying Rauschenberg are boundless. On the high end a collector would be wise to pursue a "Silkscreen" painting (Rauschenberg learned the technique from Warhol). Rauschenberg won the grand prize at the 1964 Venice Biennale with this group of paintings. This event single-handedly galvanized the American art scene. It symbolized the shift of power and influence from Europe to America.

Over the long term it would be hard to overpay for a color "Silkscreen" painting. The black and white "Silkscreen" paintings are also outstanding. These works, done between 1962-1964, are one of the great achievements of postwar art. They are arguably comparable in importance to Warhol's "Disasters."

In the late 1950s Rauschenberg invented a new technique for making drawings. He discovered that if you poured lighter fluid on a magazine page and then used an instrument to rub it onto a white sheet of paper, the image would transfer. The resultant imagery was ethereal. These drawings are historically important. The Museum of Modern Art owns a magnificent suite of 34 works that illustrate Dante's *Inferno*.

Several "Transfer Drawings" come up to auction each season. They currently can be expected to bring $25,000–$75,000. Any quality Rauschenberg drawing that can be bought for under $50,000 is a long-term bargain. It's definitely worth stretching to $75,000 for an exceptional example. At the height of the market, a great "Transfer Drawing" brought a record $275,000.

However, the real bargains are Rauschenberg's collaged works on paper from the 1970s and paintings on sheet metal from the 1980s.

The 1970s paper works vary greatly in size and quality, so you have to be discerning. The current price range is $7,500–$35,000, but there's little demand. This is probably due to the art market's prejudice against collage (based on the lack of the artist's touch). But this will eventually change. It's interesting to note that Warhol encountered early resistance in some quarters due also to lack of evidence of the artist's hand because of his silkscreen technique.

Perhaps a bigger bargain are Rauschenberg's 1980s paintings on various surfaces of metal (stainless steel, copper, etc.). The best of these works recall the glories of the early "Combines" (1950s paintings with Abstract Expressionist paint application and attached found objects) and "Silkscreens" with a twist: the shiny mirrored surface of sheet metal.

These pictures, called "Shiners" and "Urban Bourbons" by the artist, will someday be very collectible. They bring a ridiculously low $25,000–$75,000 at auction.

In summary, despite Robert Rauschenberg's failure to edit himself (he releases far too much junk), if you sift through the material and pick wisely, you'll do quite well financially. Rauschenberg's future investment potential remains explosive.

JAMES ROSENQUIST (b. 1933)

Prime Representation: Leo Castelli Gallery, New York

Record Prices at Auction:

Painting (1960s): $2,090,000. *F-111*. o/c with aluminum, 10' x 86', 1964-65
(S. Nov. 86, Robert Scull Estate).

Painting (1980s): $143,000. *Kabuki Blushes*, a/c, 39" x 41 3/4", 1984 (S. Nov. 89).

Print: $46,750. *F-111*, lithograph and silkscreen, 144" x 290" (on four sheets), edition of 75, 1974 (S. Nov. 89).

Top Prices at Auction (Nov. 1994–May 1996):

Painting (1960s): $55,200. *Exit*, o/c, 30" x 33", 1961 (C. Nov. 95).

Painting (1980s): $156,500. *The Kabuki Blushes*, o/c, 67 1/2" x 72", 1984
(C. Nov. 95).

Print: $12,650. *F-111*, lithograph, 144" x 290", edition of 75, 1974 (C. April 96).

MARKET ANALYSIS

Past

When you refer to James Rosenquist's past market, you need to take an extra step backward to the pre-boom year of 1986. In November of that year (at the estate sale of Robert Scull at Sotheby's), arguably the most famous Pop painting of all time, Rosenquist's *F-111*, sold for just over $2 million. It had been estimated to sell for $600,000–$800,000.

Not only was that an outrageous price at the time for a work of contemporary art, it was by far a record for a Pop painting. The sale cast a spotlight on Rosenquist. He was no longer in the shadow of Andy Warhol and Roy Lichtenstein. Rosenquist's market had grown up.

The *F-111*, painted in 1964–65, was the artist's statement on the growing U.S. involvement in Vietnam. The 86-foot-long painting's central image was a bomber, but also referred to the nuclear threat, consumerism, and technology. The *F-111* was a real *tour de force* in the truest sense of the expression. It was

fitting, then, that the biggest American collector of Pop Art, Robert Scull, bought Pop Art's biggest painting. He originally paid a discounted $45,000 for it (the asking price was $60,000).

As the art market moved into its glory years of 1988–89, Rosenquist was barely part of the celebration. The main reason was that so few of his major 1960s paintings came up. When they did, they always brought good prices (for Rosenquist).

The other reason that Rosenquist's market was left at the altar was lack of material. There have never been that many pictures to begin with. Rosenquist produced the fewest paintings of the major Pop stars. Many of his vintage works are in museums, permanently off the market. The rest are with collectors. Dealers seldom if ever have a 1960s Rosenquist for sale; auction houses only on occasion.

Present

The last *Art Market Guide* commented that the 1994–1995 season was disappointing because there were no major Rosenquists from the 1960s. The 1995–1996 season yielded one, but again the results were disappointing, as the painting didn't sell.

The painting, *Deep Pile* (58" x 72", 1966), depicted a close-up of a woman's red nailed fingers burying themselves in some plush colorful carpet. The painting had been estimated at $150,000–$200,000 and was passed at $110,000. While I wouldn't rank this painting in Rosenquist's top 10 percent from the 1960s, I would consider it to be in his top 20 percent. This would have been a perfect picture for a dealer to buy for inventory. There aren't any full-scale, good-quality Pop pictures that can be bought for approximately $150,000. Try buying a 5' x 6' Pop Lichtenstein, Warhol, or even Wesselmann for that kind of money. They don't exist.

The rest of the Rosenquist action centered around his pictures from the 1980s that depicted flowers overlaid with women's faces. There were two examples that appeared and Christie's had both of them. Its May evening sale had one of the best examples to ever come up to auction, *Females and Flowers* (66" x 78", 1984), which sold for a bargain $96,000 (est. $120,000–$150,000). *Females and Flowers* had previously sold at auction for $176,000 (S. April 91). The day sale also handed a collector another good deal, as the painting *Untitled* (60" x 60", 1990) sold for $55,200 (est. $50,000–$70,000).

Future

James Rosenquist, fractured imagery and all, is a significant artist. His accomplishments marry scale, technique, and imagery on a very high level. Many artists have an effective technique. Fewer have provocative imagery. Only the best combine both. Rosenquist goes a step further by being able to also work on a monumental scale.

Many of Rosenquist's best paintings are those that few people have seen; his 40 to 90 foot-long works. In fact, the bigger the painting the better Rosenquist gets. Some are commissions for public spaces, some are gallery installations (such as the famous *Star Thief* at the Castelli Gallery); all are mind boggling. These works date back to his well-known roots as a billboard painter.

Rosenquist has developed an original painting technique. If you examine his paintings up close, you'd be shocked at how loosely they're painted. Once again, as a billboard painter, Rosenquist learned how to paint with a certain economy–something about having to get the job done by 5 o'clock while trying to retain a certain basic accuracy.

Rosenquist's imagery incorporates fragments (visual sound bites) of contemporary life. His paintings are a mirror of our culture. His 1960s paintings predicted the channel-surfing mentality of our current times.

The Rosenquist market has consistently underperformed over time. His 1960s works have never sold for big bucks (with the exception of *F-111*). Most have sold for between $100,000–$400,000. That's chump change compared with early Andy Warhol and Roy Lichtenstein paintings. Rosenquist's prices pale even more when they are compared to the 1960s pictures of Jasper Johns and Robert Rauschenberg.

While it's true that Rosenquist doesn't deserve to rank with these four artists, he does rank just below. If you discard the price of *F-111*, you'll discover that the next highest price brought by a Rosenquist at auction was only $440,000 (*Mask*, C. Nov. 88, Tremaine Collection). His best Pop works should sell for an excess of $500,000 based on what his peers sell for.

A collector should be careful to avoid most works from the 1970s. Rosenquist went through a creative bankruptcy brought on by personal circumstances beyond his control. The canvases from this era are simply bad and the works on paper worse.

Rosenquist rebounded in the 1980s to paint some first-rate works. The imagery is layered and complex. Rosenquist superimposes slices of female faces on top of tropical flowers or outer space scenery. These pictures are better than they sound. Late Rosenquists bring between $50,000 and $150,000 at auction.

As Rosenquist's stature grows (as will all Pop artists as we approach the

millennium), more and more collectors will realize they should have a Rosenquist in their collection. At that point, the realization will set in that there aren't that many pre-1990 works available. Demand will exceed supply and prices will rise.

If you believe in an artist and your own convictions, then you have to buy that artist when he or she is out of favor. Not that Rosenquist is out of favor. He's simply not as sought after right now (nor are other 1960s luminaries such as Tom Wesselmann, Edward Ruscha, and Claes Oldenburg). This will change. The primary blue chip buying right now is in two areas: the most mainstream conservative artists (David Hockney, Roy Lichtenstein, Alexander Calder, and Sam Francis) and the artists that are the focus of international speculation (Andy Warhol and Jean-Michel Basquiat).

If you're looking to buy one of the above artists you're going to have a lot of competition (and pay a lot). But if you're willing to buy the art world equivalent of a long-term growth stock in a well run company, you should be looking at artists like Rosenquist.

An interesting bargain exists in the Rosenquist print market: the print version of his most important painting, *F-111*. This lithograph continues to come up to auction on a regular basis. It also continues to sell for a relatively low price (low considering it is one of the few great Pop prints). During the 1995-1996 season, two copies of the *F-111* came up with an average selling price of $10,925. In fact, all the great Pop prints are undervalued right now (including Jasper Johns's *Ale Cans*).

What are the great Pop prints? The following would make any curator's list:

Artist	Print	Most Recent Selling Price
Jasper Johns	*Ale Cans*	$101,500 (S. May 96)
Roy Lichtenstein	*Sweet Dreams Baby*	$10,350 (S. May 96)
Robert Rauschenberg	*Booster*	$48,300 (C. Nov. 94)
James Rosenquist	*F-111*	$9,200 (S. May 96)
Ed Ruscha	*Standard Station* (red & blue version)	$18,400 (C. April 96)
Andy Warhol	*Marilyn* (Pink face/turquoise)	$19,550 (C. Nov. 94)

SUSAN ROTHENBERG (b. 1945)

Prime Representation: Sperone Westwater, New York

Record Prices at Auction:

Painting: $550,000. *Hector Protector* (horse), a/c, 67" x 111 5/8", 1976 (S. Nov. 89).

Work on Paper: $99,000. *Untitled* (horse), a/p, 26 1/2" x 36", 1976 (S. May 90).

Print: $14,300. *Between the Eyes*, litho. and woodcut, 57" x 34", edition of 36, 1983-84 (S. Nov. 89).

Top Prices at Auction (Nov. 1994–May 1996):

Painting: $420,500. *Kelpie* (horse), a/c, 77 1/2" x 109", 1978 (C. Nov. 94, Gerald Elliott Estate).

Work on Paper: $12,650. *Aeiou*, acrylic and graphite/p, 41" x 30", 1977 (C. May 95).

Print: $4,887. *Boneman*, mezzotint, 30" x 20", edition of 42, 1986 (S. May 95).

MARKET ANALYSIS

Past

Susan Rothenberg's past market was wrapped up in the mystique of her "Horse" paintings. The "Horses" got a boost when, in 1987, the Gagosian Gallery did a high-profile show and catalog of these works. The show attracted a lot of attention and may have cemented Rothenberg's place in the big leagues (over $250,000 for a painting).

Rothenberg had been part of a group of artists loosely called "New Image" painters, who matured in the 1970s. Others included Neil Jenney and Robert Moskowitz. When the late 1980s hit, Rothenberg was already considered a veteran painter. Since her "Horses" had been shown since 1974, there was already over a decade of seasoning that allowed the market to make up its mind.

The main event in her market occurred at Sotheby's in November 1989.

A major "Horse," *Hector Protector*, went over estimate ($400,000–500,000) to bring a record-setting $550,000. Leading up to this sale was the previous record setter, *Three Trees*. It had sold for $209,000 in November 1987 at Sotheby's.

Only a few other works made it to auction in the 1980s. Overall, Rothenberg's market was seen as still developing in the 1980s and full of promise for the 1990s.

Present

Unfortunately, only a single work by Susan Rothenberg came up to auction this season. To make matters even more problematic, the piece couldn't have been worse. Sotheby's November 1995 sale contained a work by Rothenberg, *Untitled* (charcoal on paper, 24" x 18", 1983) that could barely be identified as hers. The imagery was a dark figure that appeared to have a tail. *Untitled* was estimated at $12,000–$15,000 and sold for only $5,462. That means the reserve was below $5,000. Enough said.

The fact that not a single canvas appeared indicates that collectors want to hang onto her work, rather than that collectors are afraid to sell out of fear of low prices. Based on the previous season's sale of a coveted "Horse" painting (*Kelpie* from the Gerald Elliott Estate for $420,000), chances are that had a similar painting come up this year, it would have done as well or better. This is because the art world has had another year to absorb and analyze her latest body of work (shown at Sperone Westwater in 1995). The general consensus, based on that show, is that Rothenberg continues to develop as an artist. The market's perception is that her work is more desirable than ever.

Future

Susan Rothenberg would have a terrific future at auction, if only more works were available.

Considering her age (51), Rothenberg has produced a small but tight body of work. That few works appear at auction is a tribute to the quality of her work. Collectors rarely sell.

Rothenberg made her reputation on the now-famous "Horse" paintings. Part realism, part abstraction, these works take on an edge from the artist's agitated brushstrokes. The few "Horse" canvases that have made it to auction have cleaned up. Since 1988, only three major examples have come on the block. The average selling price was $492,000.

The half-million figure for a "Horse" painting is probably the maximum price for one of these works in the future. The rare "Horse" on paper, which

would probably be estimated at $60,000–$80,000, offers the better opportunity for appreciation.

It's inevitable as time goes on and the artist produces more paintings that more will eventually come up for sale. I would be a buyer of any late canvas, the later the better. Rothenberg is currently doing the best work of her career (and that includes the "Horses").

Her move to New Mexico has improved her palette dramatically. Her imagery, derived from nature and incidents on her ranch, is spiritual, elusive, and very visual. The move also meant Rothenberg would be isolated from the New York art world's influences. There was also the possibility that she would fall under the influence of her famous artist husband, Bruce Nauman. To Rothenberg's credit, she avoided that trap.

In summary, the "Horses" will always have an audience and bring serious money. But it's the 1990s work that should be pursued if and when one comes up to auction. This is where the future serious money lies.

MARK ROTHKO (1903–1970)

Estate Representation: Pace Wildenstein, New York

Record Prices at Auction:

 Canvas: $3,630,000. *Black Area in Reds*, o/c, 69 1/2" x 92", 1958 (S. May 90).

 Paper on Canvas: $770,000. *Black Blue Painting*, o/p, 47 1/2" x 40", 1968 (S. May 96).

Top Prices at Auction (Nov. 1994–May 1996):

 Canvas: $1,542,500. *Maroon on Blue*, o/c, 92" x 70 1/2", 1957-1960 (S. May 96).

 Paper on Canvas: $354,000. *Untitled*, o/p, 29 3/4" x 22", 1959 (C. May 95).

MARKET ANALYSIS

Past

Every group of contemporary artists benefited greatly from the market surge at the end of the 1980s. Perhaps no group benefited more than the Abstract Expressionists. Mark Rothko was no exception. Major Rothko canvases (million-dollar paintings) came up no fewer than nine times. Where would the average selling price rank him among his peers?

Artist	Paintings Sold	Avg. Selling Price
Jackson Pollock	5	$5.17 M
Jackson Pollock (excluding sale of *Number 8, 1950* for $11.6 M)	4	$3.58 M
Willem de Kooning	9	$5.11 M
Willem de Kooning (excluding sale of *Interchange* for $20.7 M)	8	$3.16 M
Mark Rothko	9	$2.78 M
Franz Kline	8	$1.63 M

Note: Above results include only those paintings that sold.

Present

A grand total of three mature Mark Rothkos appeared at auction this past season (two canvases and one work on paper mounted to canvas). In November 1995, a five-foot-high "Multi-Form" canvas came up at Christie's with an estimate of $300,000 to $400,000. Looking at the reproduction in the catalog, you couldn't help but be impressed. However, upon seeing this predominantly amber painting in person, you couldn't believe how wrong your initial impression had been. The painting was badly damaged. Its surface was covered with cracks and fissures to the point where you could have retitled the painting "Grand Canyon" (its real title is *No. 16*).

The painting underscored the importance of only bidding on pictures that you have inspected in person. Catalog reproductions are often notoriously inaccurate and *No. 16* was an extreme but not atypical occurrence. This 1949 Rothko ended up selling for $310,500. Had it been in better condition it would have likely gone for at least $100,000 more.

The same evening sale at Christie's contained a mediocre yellow Rothko work on paper mounted on canvas. Surprisingly, it found a taker at $266,500 (est. $250,000–$350,000). You wonder if the lack of Rothkos on the market convinced the buyer to forego patience and just buy it out of desperation.

The last Rothko to appear this season was by far the best. Sotheby's Part I sale in May 1996 yielded a world-class example, *Maroon on Blue*. This classic Rothko disappointed a bit by bringing $1,542,500 (est. $1.5–2 million). Rothko's most moving paintings tend to be dark and moody. However, the market generally prefers bright, upbeat colors.

Future

As anyone who has taken an introductory art history class can tell you, Mark Rothko is an important artist. But where is his market going ?

Rothko has never had a bad market for his mature work. He was one of two Abstract Expressionists (the other is Willem de Kooning) to have made a lot of money in his lifetime. In fact, Rothko was doing so well toward the end of his life that he instructed his dealer, Marlborough Gallery, to quit sending him money (for tax reasons).

After his death and the infamous trial over the paintings remaining in his estate, Rothko was more renowned than ever. The trial (chronicled in the excellent book *The Rothko Legacy* by Lee Seldes) brought to light the romantic suffer-

ing Rothko went through to achieve his greatness. And make no mistake, he is a great painter. But more important from a market standpoint, he is also an icon of what we perceive a great painter should be.

We like our painters to be heroic. We like them to have come from humble backgrounds, to have suffered moments of doubt and pain that led to historic breakthroughs, and to be exploited by unscrupulous dealers. Rothko qualifies in all three categories.

The beauty of Mark Rothko is that his work actually does what it is supposed to: it offers the viewer a moment of spiritual reflection. Looking at a great Rothko under ideal viewing conditions (minimally lit with plenty of space around it) is one of the great art experiences you can have. It's a rare experience to actually be moved by a painting (there are a lot of works that we certainly enjoy but few that transport us). For this reason alone his work will always be in demand.

The other reason there will always be a strong Rothko market is scarcity. My estimate is that in any given season, only twelve to fifteen Rothko paintings come on the market. This total includes the international gallery scene as well as the international auctions. A typical auction season averages four to six Rothkos for sale. That's it. Even at Rothko's high price level there are still more buyers than sellers.

At the height of the market in the 1980s, major Rothko paintings averaged 2 to 3 million dollars. They now average half that. His best works on paper mounted on canvas used to average $300,000 to $450,000. They currently average approximately 80 percent of that.

While the canvases will start appreciating and approach their high water mark within ten years, the works on paper mounted to canvas are likely to exceed their previous acme in five years (a great example could bring $600,000 at that point). The best examples are currently undervalued. There are plenty of potential buyers in the current $250,000 to $375,000 auction range.

The bottom line is that you cannot boast about having a serious collection of modern art unless you own a quality Mark Rothko, and there are simply not enough to go around.

EDWARD RUSCHA (b. 1937)

Prime Representation: Leo Castelli Gallery, New York

Record Prices at Auction:

Painting: $297,000. *Honey I Twisted Through More*, o/c, 72" x 72", 1984 (S. Nov. 89).

Work on Paper (Silhouette): $187,000. *Hourglass*, dry pigment/p, 60" x 40", 1988 (S. Nov. 89).

Work on Paper (Ribbon Letter): $82,500. *Flood*, gunpowder/p, 14 1/2" x 22 1/2", 1967 (S. Nov. 89).

Print: $63,250. *Hollywood*, silkscreen, 12 1/2" x 41", edition of 100, 1968 (S. Nov. 89).

Top Prices at Auction (Nov. 1994–May 1996):

Painting: $51,750. *Untitled ("ART")*, a/c, 60" x 60", 1987 (C. May 96).

Work on Paper (Silhouette): $19,550. *Brown Navigation* (clipper ship), dry pigment/p, 60" x 40", 1986 (S. May 96).

Work on Paper (Ribbon Letter): $37,375. *City*, gunpowder/p, 12" x 29 1/2", 1967 (S. Nov. 95).

Print: $18,400. *Standard Station (red and blue version*, silkscreen, 25 1/2" x 40", edition of 50, 1966 (C. April 96).

MARKET ANALYSIS

Past

If there was a single market that epitomized the rampant speculation of the late 1980s, it was Edward Ruscha's. Ruscha is an unlikely artist to deserve this distinction. He wasn't a mainstream figure. He had a cult following among artists (for his "Artists' Books") and a loyal group of West Coast collectors. Despite being the only Californian represented by Leo Castelli, he seemed destined to remain a regional phenomenon.

Why his market began to heat up remains something of a mystery. One clue, of course, is that the Europeans and Japanese began speculating on his work. But it goes deeper than that. Art dealers informally and without concerted effort simultaneously decided Ruscha was undervalued. They realized the work was cheap, plentiful, and had an international exhibition track record: all the right ingredients to make a market.

In 1986, the going rate for an elongated gunpowder on paper drawing with ribbon letters was $2,500–$3,500. Three years later they had skyrocketed to $45,000-$65,000. It was this group of drawings that experienced the greatest rate of appreciation among Ruscha's oeuvre.

Prices for canvases also went wild. Paintings from the early 1980s, with phrases like *The Future*, which you previously couldn't give away for $25,000, reached $209,000 (S. May 89).

In another amazing example of appreciation, one should consider the record price set by a large "Silhouette" work on paper titled *Hourglass*. The work was originally created, exhibited, and sold by the Karsten Schubert Gallery (London) in 1988 for $8,500. It then flipped a few times and wound up back in Ruscha's hometown (Los Angeles) at a gallery for $55,000 in 1989. The drawing made it to auction later that year and sold for $187,000. All this within two years.

Even the artist's prints set off a feeding frenzy. His well known *Standard Stations* were trading at $3,500–$4,500 before 1988. They briefly soared to five times that. His best print, *Hollywood*, which was released in 1968 at $100, raced from a pre-boom $3,000 (C. East May 87) to over $63,000. It's true that prints by all artists appreciated dramatically, but few appreciated faster than Ruscha.

Present

Ed Ruscha's "Ribbon Letter" drawings were the story of the 1995–1996 auction season. After languishing in the $8,000 to $15,000 range since the early 1990s, the drawing *Kooks* broke the $15,000 barrier last season to sell for $20,700. That set the stage for *City*, the best Ruscha drawing to come up since the 1980s. *City* was estimated to sell for $15,000-$20,000. It surprised the audience by bringing $37,375 (S. Nov. 95).

This high price led to another big price six months later as yet another terrific drawing, *Sin* (complete with a few drops of liquid leaking from underneath the word) brought $28,750. The same sale also offered the drawing *Face It*. The selling price was lower, at $14,950, but it was apparent that the level of support for a "Ribbon Letter" drawing had risen to a minimum of $15,000.

An interesting postscript to the current season was the reappearance of two drawings, *Indust. Chem.* and *Hear Me Sonny?* Each of these large drawings

(40" x 60", 1986) came up at Christie's in May 1990, when the Ruscha market was in a speculative frenzy. The estimates then were $45,000–$65,000. Both drawings passed as the bidding never went above $42,000. This time around the estimates were a much more modest $15,000–$20,000. *Indust. Chem.* came up first and passed. The better of the two, *Hear Me Sonny?*, sold for a hammer price of $15,000 (netting the consignor around $13,500).

Future

Edward Ruscha's market is beginning to enjoy a comeback.

Ruscha's work has a lot of strengths. For one thing, he helped pioneer the use of language in art. Using words as images has influenced many young artists. Ruscha's use of unusual substances in creating his art is also innovative. You can count gunpowder, caviar, and axle grease among the materials he has used.

Ruscha's real strength as an artist is his elusiveness. You cannot pin his work down. What does the Ruscha phrase "Trashy Fish" really mean? What does the spoken word really look like? Another plus is that the work is highly original in appearance. Once you've seen a Ruscha you don't forget it. The work gets under your skin and stays with you.

Ruscha's market that matters is composed of three major areas: paintings from the 1960s, "Ribbon Letter" drawings, and "Silhouette" paintings.

The work of the 1960s, especially the rare large canvases such as *Twentieth Century Fox* and the *Standard Stations,* are Pop classics. One hasn't appeared at auction in the 1990s. The last major work to appear was *Boss* (72" x 67", 1961) at Sotheby's in May 1990. It was estimated at $400,000–$600,000 and passed due to a record estimate rather than a lack of bidders. If a comparable painting came up to auction today, it would probably be estimated at $150,000–$200,000 and would be an absolute long-term bargain for that price.

Another good long-term call are the "Ribbon Letter" drawings (words with each letter drawn to resemble a strip of ribbon), which demonstrate the remarkable dexterity of the artist. Now that they are back down to earth ($10,000–$20,000), they are once again worth pursuing.

The "Silhouette" paintings are a gambler's special; the art market has yet to pass judgment on these works. Ruscha took a tremendous risk around 1986, when he introduced representational imagery to his work. This painting strategy was as radical a departure as Philip Guston's move to a similar position in 1969. This is not to say Ruscha is as important an artist as Guston. On the other hand, it would be unfair to pass final judgment on Ruscha. He is only in his fifties and has a lot of painting ahead of him.

The silhouettes of such disparate images as a Joshua tree, an elephant, and a covered wagon seem to be holding up well as works of art. The best works are pure images without superimposed words. They infrequently appear at auction at estimates of $40,000–$75,000 for a canvas and $20,000–$25,000 for a work on paper. In terms of price they have not done well, but they're sleepers in terms of quality and therein lies the opportunity.

What about Ruscha's latest work? Basically, Ruscha hasn't been "heard from". He has been exhibiting (paintings of all but unreadable elongated words), but the work looks uninspired. Virtually nothing has been written about this work nor has there been any "buzz." What's up?

All artists go through periods of down time where they're searching for their next great idea. Sometimes it comes later rather than sooner. But the pressure to exhibit still remains. In the case of Ed Ruscha, an artist with an international following, the pressures are considerable. What should Ruscha do next? Probably keep experimenting, but hold the work off the market. There's no reason for an artist of his stature to exhibit until he's really got something that represents an authentic breakthrough.

At this stage in Ruscha's career, he's one of the two most important artists living in California (Wayne Thiebaud is the other). Others might ask what about John Baldessari or Charles Ray? Both are good artists but they're not in Ruscha's league (though Ray has the potential). Ruscha is due for another big move, similar to when he surprised the art world with his "Silhouettes". When and if it comes, it will stir up a fresh round of interest in his earlier work, and demand (along with prices) should rise.

ROBERT RYMAN (b. 1930)

Prime Representation: Pace Wildenstein, New York

Record Prices at Auction:

Painting: $2,310,000. *Summit*, o/c, 75 1/2" x 72", 1978 (C. Nov. 89, Manilow Collection).

Small Painting (under 12" x 12"): $148,500. *Untitled*, o/c, 11" x 11", 1965 (S. Oct. 88).

Print: $7,425. *Untitled (from On The Bowery)*, silkscreen, 25" x 25", edition of 100, 1969-71 (S. Feb. 90).

Top Prices at Auction (Nov. 1994–May 1996):

Painting: $387,500. *Report*, o/fiberglass, 80" x 72", 1983 (S. May 96).

Print: $1,265. *Untitled (from On The Bowery)*, silkscreen, 25" x 25", edition of 100, 1969-71 (S. Feb. 90).

MARKET ANALYSIS

Past

Robert Ryman's market slipped into high gear with the appearance of a first-rate 1961 canvas at Sotheby's evening sale in November 1988. The painting, *Untitled*, was expected to sell for $200,000 to $250,000. Instead it went for just over half a million ($550,000 to be exact). Robert Ryman had arrived as a major auction artist.

Up until the late 1980s, Ryman's was more of a "gallery" market. The audience for his paintings was small, but considered one of the most sophisticated around. If you owned a Ryman, it immediately established you as an intellectual collector. You needed a seasoned eye to be able to grasp the message of an artist whose palette consisted of only one color: white.

At the market's apex, in November 1989, Ryman burst through the million-dollar barrier with the sale of *Summit* (75" x 72", 1978) for over $2.3 million. Suddenly, Ryman had achieved the status (and then some) of fellow Minimalist Brice Marden. In fact, the price of "Summit" more than doubled the record price for a Marden painting ($1.1 million).

In May 1990, as the market was beginning its descent, an elegant 1966 Ryman canvas (62" x 62") brought a very impressive $1.76 million at Christie's. To put the price into perspective, the only other American artists to realize million-dollar prices that evening were Sam Francis, Mark Rothko, Franz Kline, Willem de Kooning, Clyfford Still, Roy Lichtenstein, and Brice Marden.

Present

A total of four Robert Ryman paintings came up during the 1995-1996 season, with three finding buyers (the fourth was sold after the sale). The most significant of the three was the lone evening sale picture, *Report* (80" x 72", 1983). Besides being attractive, the painting's chief selling point was that it had formerly been in the collection of the most important collector of the 1980s, Charles Saatchi. As anyone even mildly familiar with the contemporary art scene can tell you, Saatchi bought the best. *Report* carried a $350,000–$450,000 estimate and did not disappoint when it sold for $387,500.

Other than the satisfactory sale of *Report,* the most important observation that can be made about the current Ryman market is that his prices are quite reasonable now. So reasonable, that for only $28,000, you could have purchased a small painting on fiberglass (C. May 96). An 18" x 18" work from 1969 was bought for less than what a "dime a dozen" late Sam Francis works on paper would bring. Rymans from the 1960s are not common and quite desirable. Rymans from the 1960s for under $50,000 are genuine bargains.

Future

Robert Ryman's work continues to surprise. Just when you think he's wrung every possible combination of mark and pattern out of his all-white paintings, he challenges you with a new wrinkle. Since Ryman has kept his paintings fresh for over 35 years now, it's safe to assume that he'll continue to do so into the future. Since he's in every important international museum's collection, it's safe to assume that his work is of historical significance. Finally, since he's with Pace Wildenstein Gallery, it's safe to assume that he'll always have a serious market. But will it be a market that goes up or down?

One way of determining Robert Ryman's market is comparing it to Brice Marden's. It's a good analogy because both artists are considered the top Minimalist painters, both have had careers dating back to the 1960s, and both have been extremely successful financially. Marden gets the nod as far as historical importance. Marden's also probably a slightly better painter. But basically, they are both on the second highest tier of American painters. The only painters that are

more important are Jasper Johns, Robert Rauschenberg, Cy Twombly, Willem de Kooning, Frank Stella, and Roy Lichtenstein.

If you go with the premise that Marden is slightly better than Ryman, it should stand to reason that there would only be a slight discrepancy in their prices. However, if you look at the statistics of their auction results, you realize that the gulf in their prices is larger than it should be. Works by Marden are disproportionately higher (based on the quality of the work) than works by Ryman.

Let's look at the statistics. Unfortunately, there hasn't been a major Marden painting at auction in years. However, in November 1995, a major drawing came up at Sotheby's evening sale. This untitled charcoal drawing (20" x 22", 1966) was estimated at $60,000–$80,000 and sold for $129,000. This was a good early drawing but you wouldn't classify it necessarily as great. For comparison, you could have bought a pair of small paintings by Ryman for $128,200 from the 1995-96 sales.

A small Ryman called *Initial* (23" x 23", 1989) brought $96,000 (C. Nov. 95) and a small untitled painting (18" x 18", 1969) brought $32,200. Now while neither of these paintings could be classified as major, they were both attractive and undervalued. These two paintings combined are likely to be worth more than the Marden drawing in the future. The reason is that there are fewer Ryman paintings than Marden drawings, generally available. All things being equal, most collectors would opt for a good painting over a good drawing.

An estimate (since there hasn't been one at auction in years) is that a first-rate Marden canvas from the 1960s or the 1970s, that was at least 72" x 60", would sell at auction for $600,000 to $800,000. A comparable Ryman would likely be estimated at $400,000 to $600,000. Ryman will be a good buy until his numbers move up to $500,000 to $700,000. In other words, he's always likely to cost less than Marden, but the current 30–50 percent premium that you have to pay for a Marden is too great.

DAVID SALLE (b. 1952)

Prime Representation: Gagosian Gallery, New York

Record Prices at Auction:

Painting: $550,000. *Tennyson*, oil, acrylic/c with plaster object, 78" x 117" x 5 1/2", 1983 (C. Nov. 89).

Work on Paper: $28,600. *Untitled* (women), w/p, 22 1/4" x 30", 1979 (C. May 90).

Top Prices at Auction (Nov. 1994–May 1996):

Painting: $68,500. *An Illustrator Was There*, a/c, 84" x 60", 1980 (S. May 96).

Work on Paper: $17,250. *Untitled* (women), w/p, 25" x 31", 1984 (S. May 96).

MARKET ANALYSIS

Past

The David Salle boom years were an effective illusion. Most students of that era remember *Tennyson* selling for an outrageous $550,000 (supposedly to his dealer, Mary Boone). What they forget is that the next highest late 1980s price was only $143,000 for *Bones*. After that, the dropoff to the third highest price was to $77,000.

From that point most paintings offered went low or didn't sell at all. If you examine the numbers, you conclude that Salle had a rather weak "past" market. Between May 1988 and May 1990, if you eliminate *Tennyson* and *Bones*, ten large Salle canvases came up, with six selling. The average selling price was $56,800. They were estimated to sell for $64,000–$86,000.

Compared to Clemente, Fischl, Schnabel, Winters, Gober, and Koons, Salle had the worst track record of the art stars of the 1980s. The only artist whom Salle bested was Ross Bleckner. Yet, Salle emerged from the decade with his reputation as an important artist largely intact.

Present

David Salle's work continues to struggle at auction. What stands out from the 1995–1996 season is not the quality of work that appeared but how both houses dramatically lowered the estimates on these paintings.

For example, Christie's November sale in 1995 offered a Salle canvas (*Sailors Set on Shore*, 60" x 42", 1991) for only $20,000-$25,000. It sold for $34,500. While it may look good that it went over estimate, the painting sold for about half of its gallery price. A similar story took place at Sotheby's that same month. This time a painting, *Untitled* (78" x 48", 1989) was estimated a little higher, at $40,000–$50,000. It ended up selling for the same $34,500.

Finally, a canvas of a woman in an extremely lewd pose, called *Trouble in Routing* (60" x 42", 1983) came up with an estimate that at first glance seemed to be for a watercolor; $18,000–$22,000. It brought a "watercolor price" of $13,800 (C. May 96). It makes you wonder how the artist's dealer can justify Salle's retail prices for new paintings.

Future

David Salle's ambitious paintings were one of the hot commodities of the 1980s. But his performance at auction in the 1990s has made his work easy to dismiss as a sound investment.

Not that it's easy to dismiss Salle. He does have some talent but is probably better suited as an orchestrator of images (more of a movie director sensibility) than a creator of images. His paintings are problematic. They usually feature figures (often nude women) that are painted in an awkward manner. This is not intentional. Salle can't handle the figure. He's not close to having Eric Fischl's skills.

Another problem with his paintings is their often overblown scale. There's no reason for them to be so large other than to get attention. As mentioned earlier, Salle does have a fine visual sensibility for combining images. Yet here again you run into another problem. More often than not the images look good together but make no sense.

In spite of all these difficulties, some observers will still ask why Salle is considered a poor financial risk. The answer is that he has consistently performed poorly at auction, even during the boom years when virtually every artist did well.

As mentioned earlier, the record-setting *Tennyson* ($550,000) was an illusion. Most Salles used to sell for well under $75,000 or didn't sell at all. In recent years these numbers have spiraled downward. There is such a wide

disparity in the gallery asking price for a large painting ($125,000) versus what a similar painting currently is estimated for at auction ($50,000–$80,000), that it becomes a joke.

The key word is estimated. Over the last three years five large Salles have come up with the above estimates. Finally, in May 1996, one sold. Some collectors might say there's an opportunity to buy now at these low prices. However, it's hard to see what's on the horizon that could possibly lift his prices. Perhaps his film making career.

David Salle's foray into movies (he directed *Search and Destroy* in 1995) may not have been a big success but may have inadvertently helped his painting career. For one thing, it briefly refocused attention on the artist. More important, it may have given the artist a fresh perspective on making art. The cross-pollination that occurs between the arts may stimulate Salle to make stronger paintings.

At this point, the only way Salle's auction market will improve is if he makes stronger new paintings. The bottom line is that collectors need an excuse to reevaluate his older paintings. It's certainly not a function of price as they aren't likely to get any cheaper. If Salle's new work pulls its share of positive press, there's always a collecting element that will start buying his older paintings because they're getting a "deal." But first, the artist has to give these collectors/speculators a reason to get their courage up.

JULIAN SCHNABEL (b. 1951)

Prime Representation: Pace Wildenstein, New York

Record Prices at Auction:

Painting: $319,000. *Bob's World*, oil, plates, horns on wood, 97 1/2" x 146" x 12", 1980 (S. May 92).

$319,000. *Maria Callas No. 4*, oil on velvet, 108" x 122", 1982 (S. May 92).

Top Prices at Auction (Nov. 1994–May 1996):

Painting: $195,000. *Private School in California*, oil on velvet, 120" x 108", 1984 (C. Nov. 94, Gerald Elliott Estate).

MARKET ANALYSIS

Past

Julian Schnabel is one of the few well-known artists who didn't set his auction record during the market's top years. His record was set two years after the boom market came to an end.

This is not to say Schnabel didn't do well during the boom. He did. What was surprising was that despite the most hyped career in recent history, few collectors rushed to dump his work when the market fell apart. The 1980s' biggest buyer of Schnabel's work, Charles Saatchi, didn't sell off the two record-setting pieces until 1992.

Cynics will say that collectors didn't get rid of their Schnabels because they would have suffered heavy losses. That's probably true for a few speculators. Schnabel's boom market prices were very low compared to his peers. Basically, he didn't have that far to bounce back and thus was worth hanging onto.

Schnabel's celebrated stable mates during his Mary Boone years were Eric Fischl and David Salle. If you check your auction catalogs, you'll be amazed by how much these two artists' record prices exceeded Schnabel's. Eric Fischl's record was $715,000 (for *The Stuntman*) and David Salle's was $550,000 (for *Tennyson*). Schnabel wasn't even close at $319,000.

Present

It's hard to imagine an artist having a poorer 1995–1996 auction season than Julian Schnabel. Six Schnabels graced the pages of Sotheby's and Christie's auction catalogs, and only one of them found a home. What's even worse is the one that did sell brought only $46,000. This was for a large painting on velvet (108" x 84", 1983) titled *Portrait of John Poynt*. The estimate had been $50,000–$70,000 (S. Nov. 95).

Prior to this, a garish "Plate" painting had come up at Christie's in November 1995. This painting was titled *Portrait of Eva Ferraro and Her Two Sons*, measured 108" x 96", and was painted in 1983, a good year for Schnabel. The painting had been estimated at $100,000–$150,000. The painting bombed, failing to get a bid above $55,000. Coming on the heels of the successful sale of two major paintings at the Gerald Elliott sale, only a year earlier (one for $189,500 and the other for $195,000), it seemed like the bottom had dropped out of the Julian Schnabel market.

What happened? All the paintings that were offered in the 1995-1996 season were second and third rate (including the one that sold). The Schnabel market has become segregated. If you don't own the top 20 percent of his production, forget it. As even his most vocal supporters will admit, Schnabel has a low batting average. When he hits he hits, but most of those misses aren't worth the velvet they're painted on. With any artist (Schnabel even more so) it pays to wait for the best.

Future

When you separate all the hype from reality and edit the good work from the bad, you come to the conclusion that Julian Schnabel is worth buying.

This could go down as the biggest year of Julian Schnabel's career. A great new body of work? Nope. A retrospective at MOMA? Nope. What then? A feature-length movie on the life of the painter Jean-Michel Basquiat. Typical of Schnabel's large ego, the film is actually as much about Schnabel as it is about Basquiat. The world's top art critic, Robert Hughes, has described the movie as "The worst living American painter does a film about the worst dead one."

Schnabel has always had movies on his mind (he's confessed to seeing *The Godfather* 200 times). In fact, he was once quoted as saying; "What artist is famous compared to Burt Reynolds?" Well, Julian Schnabel may actually be more famous than Burt Reynolds once his movie, titled *Basquiat*, hits the screens. What's most intriguing is that *Basquiat* is the first movie made about an artist by another artist.

As many people know by now, both David Salle and Robert Longo directed movies in 1995. Both were good efforts for a first try, but taken on their own merits, they were disappointing films. Schnabel's film is a winner. Not as a film

for the ages, but as a surprisingly accurate portrayal of the glorious 1980s New York art world. Made for only $3.3 million, it should both turn a profit and enhance Schnabel's stature in the art world.

The likely outcome of Schnabel's film success is greater attention for his paintings. It's also quite likely that some nonbelievers, in positions of power in the art world (curators and critics), will reevaluate Schnabel's paintings. Most will remain unconvinced. But a few will change their tune and those few will eventually write something positive about the work or include him in an important show. It all adds up to growing support for his market.

However, Schnabel's market has had its share of controversy, fueled by the artist's personal adventures. Who can forget his autobiography, *CVJ*, considered the ultimate in chutzpah for the then-36-year-old artist. Or how about Schnabel's ridiculous drunken fist fight with Brice Marden (Schnabel had commented on Marden's work, was told something to the effect of not having paid enough dues to voice an opinion, and one thing led to another). This story pales next to Schnabel's famous remark that he considered Picasso and Jasper Johns (along with himself) to be the greatest artists of the century. The stories and braggadocio go on and on.

Bragging about your work (based on an egocentric view of the world) is one thing. Having the talent to back it up is another. Schnabel has the talent. When you look beyond all the nonsense, Schnabel delivers the goods. Although not a competent draughtsman nor an accomplished painter, the sheer force of his personality carries the work to a surprisingly high plateau.

Schnabel burst onto the scene and scored big with his radical plate paintings. Despite all the publicity, these paintings have never brought outrageous prices at auction. There's still a lot of potential for appreciation. This potential also exists for his other paintings, despite their attached objects, strange non-canvas surfaces, and immense size.

In fact, size is at least half the reason his auction prices have been held down. The future of Schnabel's market is dependent on apartment-size paintings (under 7 feet in all dimensions) becoming available. When they do come to market, they sell for between $50,000–$75,000. These paintings are undervalued.

Schnabel is still a young artist with a long career ahead of him. Lately, in the less pressure filled 1990s, his work has been steadily improving. The positive influence of Cy Twombly is evident (as seen at his 1996 Pace show). It's still going to be awhile until Schnabel is mentioned in the same breath as Cy Twombly and Brice Marden. He may never be. However, at this still early stage in his career, the potential exists. Buying his best works of reasonable scale has a better chance for financial reward than not.

JOEL SHAPIRO (b. 1941)

Prime Representation: Pace Wildenstein, New York

Record Prices at Auction:

Sculpture (Bronze): $404,000. *Untitled* (figure), bronze, 90" x 67" x 22", edition of four, 1989 (C. May 96).

Sculpture (Wood): $198,000. *Untitled* (figure), wood, 59" x 59 1/2" x 24", 1983 (C. Nov. 89, Manilow Collection).

Sculpture (Miniature): $242,000. *Untitled* (figure), bronze, 9 1/2" x 10", unique, 1980-82 (S. Nov. 89).

Drawing: $88,000. *Untitled* (figure), pastel on paper, 88 1/2" x 60", 1988 (S. May 90).

Top Prices at Auction (Nov. 1994–May 1996):

Sculpture: $404,000. *Untitled* (figure), bronze, 90 x 67" x 22", edition of four, 1989 (C. May 96).

Sculpture (Miniature): $74,000. *Untitled* (figure), bronze, 10" x 10" x 2 1/2", unique, 1979–80 (S. Nov. 95).

Drawing: $6,900. *Untitled* (one brown form, one blue form), colored chalk/p, 30" x 23", 1989 (C. Nov. 95).

MARKET ANALYSIS

Past

Joel Shapiro's boom market results were limited to the sale of only seven works. Two of those seven were throw-away sketches. Another two were mature but minor works. The remaining three were first-rate and yielded results that would serve as a solid foundation for the future.

In November 1989, a large-scale wooden figurative work came up to auction and sold within estimate for $198,000. Six months later, the first large-scale figurative drawing ever to appear also sold within estimate for a record-setting $88,000. The drawing was of museum quality and was composed of red, yellow,

and blue rectangles with lots of surrounding "signature" smudges. A better drawing at auction has not been seen since.

However, the result that stands out from the late 1980s was more astonishing. In November 1993, at Sotheby's, a very small (9 1/2" x 10") unique Shapiro bronze of a standing figure came up with a $40,000–$50,000 estimate. After a brisk bidding war, the work finally sold for $242,000. Once again, it was under twelve inches tall.

This price was even absurd by boom market standards. Was this the most outrageous result from that era? Perhaps not. The following is a list of ten comparable wild results (especially when you consider what some of the works are worth today). Most of the selected works are of a smaller scale. Here's the list, in alphabetical order:

Willem de Kooning: $825,000 (est. $180,000–$250,000). *Woman in Landscape #10*, oil/p mounted to canvas, 28 1/2" x 41", 1968 (C. Nov. 89).

Roy Lichtenstein: $231,000 (est. $50,000–$70,000). *Leda and the Swan*, colored pencil/p, 7 3/4" x 22 5/8", 1968 (S. Nov. 89).

Brice Marden: $572,000 (est. $35,000–$55,000). *Untitled*, oil and graphite/p, 18 3/4" x 39 5/8", 1984-88 (C. Nov. 89).

Brice Marden: $528,000 (est. $35,000–$55,000). *Untitled*, oil and graphite/p, 18 3/4" x 39 5/8", 1984-88 (C. Nov. 89).

Agnes Martin: $176,000 (est. $25,000–$35,000). *Island No. 1*, o/c, 12" x 12", 1960 (C. Nov. 89).

Donald Sultan: $143,000 (est. $60,000–$80,000). *Yellow Iris*, oil, tar, spackle on masonite, 12" x 12", 1981 (S. Nov. 89).

Donald Sultan: $115,500 (est. $50,000–$60,000). *Black Tulip*, charcoal/p, 50" x 36", 1983 (S. Nov. 89).

Cy Twombly: $561,000 (est. $100,000–$150,000). *Naxos*, gouache, crayon, and graphite on three sheets of paper, 1982 (S. Feb. 89).

Andy Warhol: $115,500 (est. $20,000–$25,000). *Mao*, 12" x 10", a/c, 1973 (S. Nov. 88).

Tom Wesselmann: $181,500 (est. $30,000–$40,000). *Little Great American Nude #25*, acrylic on board, 12 3/4" x 11 3/4", 1965 (S. Nov. 89).

Present

Joel Shapiro had a terrific season at auction. A large-scale figure set a record that eclipsed the previous record by over $100,000. Shapiro's large bronze figure, *Untitled* (90" x 67" x 22", ed. of 4, 1989), came up at Christie's May 1996 evening sale at an estimate of $200,000–$300,000. The piece sold for $404,000, breaking the old record of $288,500 (also for a large bronze figure).

On a sculpture that's priced under $500,000, this is close to the equivalent of the record- breaking performance of Bob Beamon in the long jump at the 1968 Olympic Games. For those unfamiliar with the story, the long jump is a track and field event that is only improved upon by an inch at a time. On a sunny afternoon in Mexico City, Beamon sailed over two feet beyond what any human had ever jumped before (29 feet-plus).

What's surprising is that *Untitled* was a good work but not the best to come up to auction. For one thing, this was a figure (with two arms, two legs, and a head) posed as if it were walking. Shapiro figures work best aesthetically when they are less literal, that is when a figure has an extra appendage or is posed in a slightly awkward manner. Also, *Untitled* was mounted to a flat sheet of bronze that served as a base. The best Shapiros are mounted so they are freestanding, whether to the floor or on a pedestal.

The other interesting Shapiro result was the sale of a rare miniature freestanding bronze figure (10" x 10" x 2 1/2", unique, 1979-80). This work, *Untitled*, was posed with the figure lifting a leg. Although this work was also a "literal" figure, it had a wonderful woodgrain texture that gave it an edge. It was also a pivotal early piece that was a precursor to Shapiro's later large-scale figures of the 1980s and 1990s. *Untitled* was estimated at $40,000–$60,000 and bought $74,000.

Future

Joel Shapiro is poised to have his biggest year ever, assuming consignors cooperate. His work is a "Buy" because he represents good value and should continue to go up in price. As the best figurative sculptor since Giacometti, Shapiro still has a long way to go in terms of price. In fact, Shapiro is America's only great

figurative sculptor (now that Duane Hanson has passed away and Willem de Kooning isn't working).

His early sculptures were tiny (under 12 inches) common forms taken from everyday life (such as houses, chairs, and tables), and usually made out of wood, cast iron, or bronze. Shapiro's breakthrough was the development of small geometric figures. When he pumped up the scale (3' to larger than life size), it took the work to a new level of recognition.

In some ways, the best value lies in his small-scale bronzes (under 24" tall and often in editions of 6), which go for under $75,000. Although they come up infrequently at auction, they are worth the wait. There are so few sculptors who make successful work on a small scale and can still be bought for under $100,000 (and in some of the following cases, under $35,000). These are artists who should be pursued as they represent an opportunity that's ripe for financial appreciation. The short list includes Shapiro, John Chamberlain, Joseph Cornell, Donald Judd, Louise Nevelson, and Carl Andre. A more speculative list would include Mel Kendrick, Bryan Hunt, and John Newman.

Shapiro's initial foray into larger work found him working in wood. Eventually he returned to his favorite medium, bronze. By switching to bronze, Shapiro was able to create large-scale works that could be placed outdoors. This opened a new market for him, allowing Shapiro to place his name in the hat for outdoor (and public) sculpture commissions.

For Shapiro fans, his most impressive sculpture can be seen in the lobby of the Sony building in New York (on 5th Ave. and 57th St.). This bronze figure measures close to twenty feet tall. Even though some would classify it as corporate art, it transcends this genre and is simply one of the most successful examples of large-scale sculpture around.

Shapiro's best work has generally done well at auction. Lesser works have not. Lately, his top works have gone within or above estimate. Full-size bronzes currently bring $150,00–$400,000. Small-scale bronzes go for $35,000–$75,000.

Like John Chamberlain, Shapiro has a limited but sophisticated audience. The *Art Market Guide* predicts that Chamberlain will increase in value. So will Joel Shapiro. The question is will Shapiro's sculpture increase in value faster than Chamberlain's?

The answer is yes. Chamberlain's work is more radical in the use of materials (crushed auto metal) and form (organic free-form). Shapiro's material (bronze) and form (geometric figurative), although radical in concept, are quite traditional in appearance. There was no precedent for Chamberlain. Shapiro's lineage goes all the way back to the father of modern sculpture, Constantin Brancusi.

Shapiro's beautiful smudged pastel drawings also offer room for financial growth. Drawings have been bringing $15,000–$25,000 over the last few years.

They should increase in value by 50 percent by the year 2000. The reason is quality as well as lack of competition. There simply isn't much good drawing being produced.

I've heard the argument that Shapiro's drawings have the appearance of being created just for the market place. That's nonsense. These works share a kinship with the dense drawings of Donald Sultan and Richard Serra. But unlike these artists, Shapiro's drawings have great variety in imagery. If Shapiro wanted to crank them out, they would take on the formulaic appearance of Sultan and Serra.

CINDY SHERMAN (b. 1954)

Prime Representation: Metro Pictures, New York

Record Prices at Auction:

Black and White Photograph: $47,150. *Untitled Film Still, #54*, 8" x 10", edition of 10, 1980 (S. May 96).

Color Photograph: $28,750. *Untitled (93)*, 24" x 48", edition of 10, 1981 (S. May 94).

Top Prices at Auction (Nov. 1994–May 1996):

Black and White Photograph: $47,150. *Untitled Film Still, #54*, 8" x 10" edition of 10, 1980 (S. May 96).

Color Photograph: $21,850. *Untitled #122A*, 40" x 30", edition of 18, 1983 (S. May 96).

MARKET ANALYSIS

Past

Cindy Sherman's market has a very recent past. Her work was not regularly seen at auction until the early 1990s.

The pivotal event in Sherman's developing market was the sale of *Untitled (Black Bra)* (C. Feb. 91) for $28,600. The estimate had been $6,000–$8,000. This photograph from 1977 was an unusually large black and white work measuring 28 3/4" x 37" (the same image was used for Film Still #6, 1978). Typical works from the "Film Stills" were 8" x 10". *Untitled (Black Bra)* was also a very small edition of two (versus 10 from the "Film Stills").

Untitled (Black Bra) depicted Sherman sprawled out on a bed, scantily clad in her underwear, holding a mirror (off to her side). The look on her heavily made up face was enigmatic. You couldn't tell whether she was apprehensive, ecstatic, or just plain spaced out. Regardless, bidders pushed it to a record price for a Sherman. More important, it served notice that Sherman's works had speculative potential.

The color photographs sold regularly but at inconsistent prices. You sensed that a different (more sophisticated) crowd bought the black and white work. For what it's worth, the "Film Stills" were originally priced at $100–$200 each in

the late 1970s. By the end of 1992, they were consistently bringing over $10,000 a piece.

Present

Cindy Sherman had a very strong auction season, paced by the ever increasing prices for her "Film Stills" series. It seems the art world can't get enough of these works. They continue to move up in price, even as they appear more frequently at auction.

In May 1996 at Sotheby's, *Untitled Film Still #54* (8" x 10", edition of 10, 1980) went way over its $25,000–$30,000 pre-sale estimate to sell for a record $47,150. This particular image portrayed the chameleon-like Sherman walking at night on a dark deserted street. She's dressed in a conservative but expensive outfit and is posed turning up her overcoat's collar. A compelling image, perhaps. But worth more than a Joseph Cornell "Penny Arcade" collage? Doubtful. Or how about a medium John Chamberlain sculpture from the prime year of 1964 that just sold for $46,000 (*Miss Remember Ford*, 26" x 40" x 23", C. May 96)? Ridiculous.

During the 1995-1996 season, a total of eight "Film Stills" came up (all sold), with an average selling price of $22,400. It's interesting to note that in November 1995, a print of the record setting *Untitled Film Still #54*, sold for $27,600.

Sherman's color photographs also had a good year. A total of ten full size-works came up, with nine selling. The average selling price was $16,200. The highest price was realized by *Untitled #122A*, which sold for $21,850. This photograph is one of Sherman's best known color images. It features Sherman wearing a black suit. Her blond hair covers her face with only one glaring eye exposed. Both fists are clenched and she looks "fit to be tied."

Future

Cindy Sherman has performed some sort of modern-day alchemy. She has convinced the art market that her photographs should be priced like paintings.

Sherman's career has been structured around transforming her own image, using an elaborate array of disguises, into innumerable personas. She is then photographed striking these poses.

Her earliest work, the black and white "Film Stills" (8" x 10", editions of 10), casts Sherman as a movie actress. At this point, she only altered herself by changing makeup, hairstyle, and her outfits. This series of photographs remains her best work.

From there Sherman moved into color photography and eventually began working on a much larger scale. She also began taking bigger risks with the imagery, creating elaborate disguises and environments in which to be photographed. The result was a group of disturbing images, some grotesque, some strangely erotic.

Her best large-scale color works cast her in a series of portraits that appear lifted from Old Masters' paintings. These were also decidedly quirky as Sherman often donned plastic body parts such as an enlarged nose.

The color photographs' edition sizes vary from 6 to 18 (although there are a few editions of 125). Current auction prices range from $10,000–$20,000. Prices for the black and white "Film Stills" generally range from $10,000–$25,000.

Sherman's work is certainly original and has held up visually. Still, it's overpriced. If you multiply a recent work that came up at auction such as *Untitled #122A* (40" x 30", color, S. May 96), which sold for $21,850 by its edition size of 18, you come up with $393,300. That's what the market is really saying a work by Sherman is worth. Since these photographs are treated as paintings, in theory each owner only owns one-tenth of this picture.

The Cindy Sherman market is a total contrivance of smart marketing by the auction houses. By placing her work in the contemporary art sales rather than the photography sales, they have determined how the art market thinks of her work (and what it spends on it).

If a decision had been made a long time ago to place Sherman's works in the photography sales, they would be selling for a fraction of what they do now. Her black and white "Film Stills" would undoubtedly be closer in price to Brett Weston ($2,000-$3,500 for basic work) than to their current Ansel Adams level ($5,000-$25,000 for basic work).

While collectors enjoy Sherman's work, eventually it will dawn on these people that her work is good, but very expensive for editioned contemporary photographs (which is what they really are). They will wake up and realize for "that kind of money" they should either buy paintings or vintage photography.

Despite the 1995–1996 season being her best ever at auction, Cindy Sherman remains a "Sell." It was certainly tempting to move her rating up a notch to at least a "Hold," especially with Pace Wildenstein's Beverly Hills branch showing her work (can Pace Wildenstein's New York gallery be far behind?). Yet the fundamentals haven't changed. Sherman is still overpriced based on the fact that her work is editioned. Thanks to the rising prices of her "Film Stills," she is now more overpriced than ever.

The big event in the Sherman market during the 1995-1996 season was the Museum of Modern Art's announcement that they had purchased a complete set of the "Film Stills." The collection of 69 works was acquired directly from Cindy

Sherman in a deal negotiated by her dealer Metro Pictures. The *New York Times* announced the purchase price as $1,000,000. That's right, a million dollars. For some reason the figure doesn't ring true. It sounds like a number inflated to impress the art world. If this figure is accurate, that means the average selling price per photograph was $14,500.

While the $14,500 a photograph sounds reasonable, logic dictates that MOMA would have gotten a considerable discount (just for the prestige of being MOMA and the cachet it would lend to the artist). The deal with MOMA was announced not long before the May 1996 sales. This definitely had a direct affect on the strong prices brought at auction. However, I would be surprised if Sherman's "Film Stills" went up again this season.

KIKI SMITH (b. 1954)

Prime Representation: Pace Wildenstein, New York

Record Prices at Auction:

Painting or Sculpture: $6,325. *Untitled* (painting of a hand), oil on panel, 13" x 20", 1981 (C. May 96).

Drawing: $8,050. *Untitled*, mixed media/p, 30" x 20", 1993 (S. Nov. 95).

Top Prices at Auction (Nov. 1995–May 1996):

Painting or Sculpture: $6,325. *Untitled* (painting of a hand), oil on panel, 13" x 20", 1981 (C. May 96).

Drawing: $8,050. *Untitled*, mixed media/p, 30" x 20", 1993 (S. Nov. 95).

MARKET ANALYSIS

Past and Present

Given her brief history at auction, Kiki Smith's past and present are one and the same. Smith made her auction debut in November 1995 at Christie's day sale. The very first work offered was an untitled rice paper collage. The work consisted of tiny wads of paper with graphite lines trailing each wad, which in turn met at a central wad at the bottom of the page. "Untitled" measured 30" x 20" and was executed in 1993. Estimated at $3,500–$4,500, the work generated a lot of interest and sold for $8,050.

Later in the same sale two more works appeared. Both were works on paper that measured 30" x 20" and were done in 1993. The first, called *Penis*, was a minimal graphite drawing on vellum paper of a hand squeezing a penis and white drops of sperm spurting out. The second, called *Bosom*, was an equally minimal graphite drawing of a hand squeezing a breast and white drops of milk spurting out. As anyone unfamiliar with Smith's work has figured out by now, the artist derives her imagery from the functions of the human body (and all the psychological symbolism that goes with it).

Both drawings were estimated at $3,500–$4,500, with *Penis* selling for $3,450 and *Bosom* fetching $3,737. Six months later at Christie's in May 1996, a fourth

173

work by Kiki Smith appeared at auction. This time collectors were treated to an unremarkable small painting of a hand with its veins exposed. This untitled work was estimated at $3,000 to $5,000 and sold for $6,325.

These four works were the sum total of Kiki Smiths to come on the auction block. In fairness to the artist, these four works were minor. While not atypical, they do not represent the full scope of the artist's output.

However, these works do represent the failure of the auction houses to exercise any form of long term-strategy in building a market for a new artist. The auction houses should have been astute enough to refuse all four works. Though they all sold, Sotheby's and Christie's should have waited until they had a more important work to offer by the artist. First impressions are lasting ones. Better to get a new artist's market off to a flying start with a great (and more expensive) work than to just auction whatever they are given.

I don't blame the Contemporary department heads for this strategy. Rather, I blame the auction house executives who are so concerned with the short term and "meeting their numbers" to keep shareholders happy, that they have no real vision on how to develop new markets. Both auction houses are great at promoting spectacular sales like the memorable "Jackie Onassis" sale. Dealing with celebrity sales is exciting and glamorous. However, although these sales are lucrative, they are one-shot deals. The real bread and butter is in developing markets that will be consistent money makers for years to come.

Kiki Smith is a young artist who is likely to be producing work for at least another thirty years. That's a lot of potential material that could find its way to auction. If the auction house leaders had just a little patience, they could have waited for a stronger Smith and positioned a new potentially lucrative "product."

Future

The rapid ascendancy of Kiki Smith's career represents the art world and art market at its worst.

Kiki Smith (the daughter of sculptor Tony Smith) gained early recognition when she began showing at the Fawbush Gallery in SoHo. Smith creates works that are concerned with the human body (usually female). Works include the portrayal of internal organs and bodily fluids. A typical Smith sculpture might be a life-size paper-maché female figure lying on the floor with a trail of intestines coming out of her body. This would be a valid statement except for one small thing. The work is so poorly made that a sophisticated viewer could never get beyond the physical object to concentrate on what the work is trying to say.

It's not that Smith doesn't have good ideas. She does. She just doesn't have much talent. As an artist, if your work centers around the realistic portrayal of

the human body, you had better have total mastery of how to create its imagery. But Smith knows neither how to draw or sculpt a figure. Some may argue that her work is not about realism. That's true. But the work is neither realistic (in the sense of a Duane Hanson) nor rough (in the sense of a de Kooning figurative sculpture). A Smith is just clumsy.

If Smith were not an auctionable artist and did not show with a high-profile gallery, she probably could get away with her mediocrity. But Kiki Smith shows with the world's top gallery, Pace Wildenstein.

When Pace signed up Smith a few years ago, it certainly raised a few eyebrows in the art world. Pace rarely falters when it comes to its evaluation of talent (the one lone exception is George Condo, whose representation was rumored to be politically motivated). Pace partner Arne Glimcher certainly has a good enough eye to know the difference between his immensely talented stable of artists and a minor talent like Smith. But Glimcher is not immune to art world pressures to be politically correct and show more female artists.

Up until a few years ago, Pace had only two women artists, Agnes Martin and Louise Nevelson (out of 30). However, Martin is a great artist and is in the same league as anyone Pace represents. Martin was chosen totally on merit. A strong case could also be made for Nevelson (now represented by Jeffrey Hoffeld but still affiliated with Pace). The climate of the art world has changed recently to include more women and minorities. The greater diversity these groups have brought to the scene has resulted in more interesting shows and a greater cross fertilization of ideas among artists.

By signing Smith, Pace can present itself as keeping up with the times by including more women artists. Pace also now represents Elizabeth Murray. The gallery has even gone so far as to list Claes Oldenburg's wife and collaborator, Coosje van Bruggen, as one of its artists. This is really pathetic as it dilutes Oldenburg's stature.

There will be plenty of collectors lining up to buy Smith's work at her next Pace show. But they will not be buying the work itself. They will be buying the Pace mystique for dealing with the best artists (and therefore best collectors). Whatever Pace's motivation for showing Smith, the fact remains that the work will probably do well in the short term at auction. Collectors will perceive this to be a ground floor opportunity. It's not.

FRANK STELLA (b. 1936)

Prime Representation: Independent

Record Prices at Auction:

Black Painting: $5,060,000. *Tomlinson Court Park* (second version), enamel/c, 84" x 109", 1959 (S. Nov. 89).

Metallic Painting: $1,320,000. *Quathlamba*, metallic paint/c, 77 1/2" x 178 3/4", 1964 (S. May 89).

Mitered Square/Concentric Square: $660,000. *Mitered Squares*, alkyd/c, 69 1/8" x 138 1/4", 1968 (C. Nov. 89, Manilow Collection).

Protractor: $605,000. *Damascus Gate Variation II*, fluorescent paint/c, 60" x 240", 1969 (C. Nov. 89, Mayer Collection).

Relief Painting: $660,000. *Jungli-Kowwa* (Indian Bird), mixed media/aluminum, 86" x 102" x 38", 1978 (S. Nov. 88).

Print: $154,000. *Talledega Three II*, etching, 66" x 51", edition of 30, 1982 (S. May 90).

Top Prices at Auction (Nov. 1994–May 1996):

Metallic Painting: $827,500. *Abajo ("Running V")*, metallic paint/c, 96" x 110, 1964 (C. May 96).

Mitered Square/Concentric Square: $200,500. *Pratfall*, a/c, 129 1/2" x 129 1/2", 1974 (C. May. 96).

Protractor: $150,000–$200,000 (passed). *Khurasan Gate III*, a/c, 60" x 180", 1968 (S. Nov. 94).

Relief Painting: $150,000–$200,000 (passed). *IL Palazzo Delle Scimmie* (Cone and Pillar), mixed media on metal/fiberglass, 124" x 99" x 27", 1984 (S. Nov. 95).

Print: $57,500. *Pergusa Three*, relief print, 66" x 52", edition of 30, 1982 (S. Nov. 95).

MARKET ANALYSIS

Past

Frank Stella's boom market days were dominated by a single event, the sale of a revered "Black Painting" for $5 million.

Most connoisseurs of the art world speak in awe when discussing the "Black Paintings." Their place in art history is assured. The intrigue was whether one would ever come up to auction. Almost all of the 23 paintings in the series are in museum collections. The decision of Southern Californian collector Robert Rowan to sell was greeted with heavy anticipation.

The painting, *Tomlinson Court Park*, came up in November 1989 at Sotheby's. This, of course, was the height of the market. The painting sold for $5,060,000 (estimate $3–3.5 million). Mr. Rowan's timing couldn't have been better.

Where does this price rank among the ten most expensive contemporary works ever sold? Here's the list:

1. $20,680,000 (estimate $4–6 million). Willem de Kooning, *Interchange*, o/c, 79" x 69", 1955 (S. Nov. 89).

2. $17,050,000 (estimate $4–6 million). Jasper Johns, *False Start*, o/c, 67 1/2" x 53", 1959 (S. Nov. 88).

3. $12,100,000 (estimate $5–6 million). Jasper Johns, *Two Flags*, o/c, 52 1/4" x 69 1/2", 1973 (S. Nov. 89).

4. $11,550,000 (estimate $8–10 million). Jackson Pollock, *Number 8, 1950*, oil, enamel, aluminum paint/c mounted on board, 56" x 39", 1950 (S. May 89).

5. $7,260,000 (estimate $4–6 million). Robert Rauschenberg, *Rebus*, oil and paper collage/c, 96" x 131", 1955 (S. April 91).

6. $7,040,000 (estimate N/A). Jasper Johns, *White Flag*, o/c, 52" x 78 3/4", 1955-58 (C. Nov. 88, Tremaine Collection).

7. $6,050,000 (estimate $5–6 million). Roy Lichtenstein, *Kiss II*, o/c, 57 1/8" x 67 3/4", 1962 (C. May 90).

8. $5,720,000 (estimate $4–6 million). Jackson Pollock, *Frieze*, oil, enamel, aluminum paint/c, 26 1/8" x 85 7/8", 1953-55 (C. Nov. 88, Tremaine Collection).

9. $5,500,000 (estimate $3–4 million). Roy Lichtenstein, *Torpedo . . . Los!*, o/c, 67 3/4" x 80 1/4", 1963 (C. Nov. 89, Mayer Collection).

10. $5,500,000 (estimate $5–6 million). Cy Twombly, *Untitled* ("Chalkboard" painting), o/c, 118" x 184 1/2", 1971 (S. May 90).

Surprise. Stella's *Tomlinson Court Park* would rank number 11, still an impressive achievement.

Present

Frank Stella's 1995–1996 market was a big improvement over the previous season, when more works passed than sold. This time fourteen works came up and ten sold (as compared to last season when only eight out of eighteen works found buyers). Still, all is not well with the Stella market.

But first, let's examine the triumphs. The biggest success was the sale of a major "Metallic" painting, *Abajo* (96" x 110", 1964). This painting was one of seven paintings that constitute the "Running V" series. It was estimated at $600,000–$800,000 and sold for $827,000 (C. May 96). This was the highest price achieved by a Stella in the 1990s.

Another positive result was the sale of a painting from the "Exotic Birds" series, *Dove of Tanna* (84" x 123" x 18", 1978). In a masterstroke of marketing, Sotheby's prevailed on the consignor to accept a ridiculously low estimate of $70,000-$90,000. Remember, this was for a large, quality painting by one of America's top artists. It soared to $178,500. For comparison, that same month at Sotheby's day sale, a small-scale work from the same series, *Newell's Hawaiian Shearwater* (20" x 28" x 5", 1976) was estimated at $60,000–$80,000. It passed.

The bargain of the season was the sale of a medium-size work from the "Shards" series, *Shards II* (40" x 45" x 6", 1982). This was a magnificent painting that showed what an original colorist Stella is. At first glance, the painting looks hopelessly chaotic. But as your eyes begin to decipher its "code," you're treated to a rush of sensual delight. *Shards II* sold for a disappointing $85,000 (C. Feb. 96). The estimate was $70,000–$90,000. This painting would easily command $125,000 in a gallery.

Future

Frank Stella is one of America's most important living artists. When it comes to sheer inventiveness, he has no peer.

Stella's career is unique in the annals of recent art history. Fresh out of Princeton, Stella embarked on his famous "Black Paintings" at the age of 23. These paintings and Stella's well-known quote, "What you see is what you see," were the birth of Minimalism.

Visually, the paintings are composed of hand-painted black stripes that barely touched, creating a pinstripe effect. Each of the 23 paintings has a different pattern. Their visual impact is mesmerizing.

The art world's reaction to the "Black Paintings" was immediate. Leo Castelli asked him to join his gallery (in 1959). The Museum of Modern Art bought one (a radical purchase at the time) and included several in the pivotal "Sixteen Americans" show in 1960. Naturally, Stella was the most controversial artist in the show.

Stella would never live down his fame nor up to the art world's expectations. No artist could. He went on to complete a number of highly successful series of paintings. Each body of work was more complex than the last. Eventually the paintings took on low-relief elements, became more three dimensional, and finally came off the wall to become sculpture.

Stella has faltered at times. Overall, though, his track record is outstanding. No visual artist challenges his audience more to keep up with him. For comparison, look at Jim Dine. Thirty-five years later he's still painting hearts and robes.

Stella is also one of the most intelligent and articulate artists around. A number of years ago, he delivered a series of art history lectures at Harvard (the *Norton* lectures) that remains a highwater mark in scholarship. These lectures were published in the book *Working Space*.

What of Stella's market? Currently it's weak. Two reasons come to mind. The first is obvious: He produces paintings that are physically imposing and nearly impossible to accommodate in most collectors' homes.

The second reason is political. Other than Picasso, Stella is the only artist to have two retrospectives at MOMA. You would think that would have led to increased demand for his work. It actually had the opposite effect. It was a case of overexposure.

The criticism of Stella's second retrospective in 1987 (which picked up chronologically where the first left off, in 1970) caused the art world to begin questioning the historical importance of all his post "Black Paintings" work. The practical effect was to drive collectors away. Ironically, business picked up for his prints.

The current market is ripe with opportunity, assuming you have the wall space and financial wherewithal. Stella paintings of good quality can be bought for less than $200,000 at auction. That won't buy you an average-quality Ellsworth Kelly. Small-scale Stellas are often sold for $50,000–$75,000. That's great value when you consider that the work is simultaneously decorative and historically significant.

Another solid example of why Stella is a bargain was illuminated by the sale of a small study from the great "Black Paintings." Lot number 32 of Christie's May 1996 evening sale was a small "Black Painting," *Untitled* (12" x 12", enamel on masonite, 1959). It was estimated at $150,000-$200,000 and barely hammered for $95,000. The total sale with the premium added was $107,000 (which means the consignor received only $85,500).

After the sale, I incredulously asked a few colleagues why the results were so disappointing. Most of them shrugged and said essentially who knows and who cares. So here was the problem in a nutshell. Stella's audience, for the most part, are collectors who value the work's decorative content (ala Helen Frankenthaler) but don't give the work enough historical credence. Supposedly, there were 24 small "Black Paintings" studies to compliment the 24 full-size "Black Paintings" canvases. So, as one dealer said, these small studies aren't that rare. Wrong. A total of 24 paintings from a series of pivotal historical importance (for an international market of collectors and museums) is nothing.

Frank Stella is dramatically undervalued. It's just a matter of time until art history and the art market are reevaluated yet again. It will likely be reevaluated enthusiastically in Stella's favor.

Sell

WAYNE THIEBAUD (b. 1920)

Prime Representation: Allan Stone Gallery, New York

Record Prices at Auction:

Painting: $605,000. *Heartcakes,* o/c, 36" x 47 3/4", 1975 (C. May 88).

Work on Paper: $143,000. *Bowtie Tree,* pastel on board, 15" x 10 1/4", 1968 (C. Nov. 89, Billy Wilder Collection).

Print: $29,700. *Big Suckers,* color aquatint, 17" x 21", edition of 50, 1970-71 (C. Feb. 90).

Top Prices at Auction (Nov. 1994–May 1996):

Painting: $244,500. *Nine Candy Apples,* o/c, 14" x 16", 1964 (C. May 96).

Work on Paper: $51,750. *Untitled* (a letter, phonebook, milk carton), pastel/paper, 22" x 30", 1972 (C. Nov. 94).

Print: $10,350. *Paint Cans,* lithograph, 30" x 23", edition of 100, 1990 (C. Nov. 95).

MARKET ANALYSIS

Past

Wayne Thiebaud's prices began their meteoric rise in 1984. A group of four small ink drawings appeared at Sotheby's in May of that year. The estimates were modest but consistent with the artist's then-current market ($800–$2,200). All the drawings sold with an average selling price of $6,000, close to three times the high estimate. In the same sale, a tiny watercolor estimated at $2,500–$3,000 soared to $23,100.

A pattern was established that would continue into the late 1980s; Thiebauds generally exceeded estimate. Prices rose to a record $605,000 for a first-rate painting of four cakes (cover lot, C. May 88). Rumor had it that the National Gallery acquired an important Thiebaud from the private sector for slightly over a million dollars.

Thiebaud never appeared to be "in play" (the subject of speculation). It was an orderly, well-orchestrated rise. Perhaps too orderly. Unlike virtually every

other major artist, one couldn't successfully speculate on Thiebaud's work. The main problem was there were too few of them.

To speculate on an artist, there preferably should be many works available in a wide range of prices. This allows as many participants as possible (the Warhol market was the ultimate example of this). Thiebaud clearly did not fit this definition. Yet something was driving his prices and it wasn't just scarcity.

Present

Wayne Thiebaud's current auction season was a big improvement over his 1994–1995 season. This can be directly linked to the appearance of several quality paintings from his most valuable period, the 1960s.

The painting most worthy of comment is *Nine Candy Apples* (14" x 16", 1964). This outstanding painting conveys everything about Thiebaud's artistry. The painting is composed of nine red candy apples in three rows of three. Each apple is painted with thick, tasty brushstrokes and has a corresponding creamy blue shadow. But what makes the painting really come alive is Thiebaud's unique ability to paint something as mundane as the sticks stuck into the apples, with four or five colors, and make it work aesthetically. It shouldn't but it does.

Nine Candy Apples had been to auction once before, in May 1990, right as the boom market was coming to a close. The painting brought $242,500 at Christie's. This time around it was estimated at $150,000–$200,000. *Nine Candy Apples* ended up selling for a surprising $244,500, exceeding its previous auction price. The painting had also been for sale within the last year in a San Francisco gallery for $250,000.

Another strong price was realized for the painting *Black Shoes* (20" x 28", 1963) at Sotheby's in November 1995. *Black Shoes* illustrated an isolated pair of men's black dress shoes whose laces were left undone. Estimated at only $70,000–$90,000, the painting surely delighted the consignor as it more than tripled its low estimate to sell for $244,500.

Future

Wayne Thiebaud is widely regarded as California's greatest living artist, a rank previously held by Richard Diebenkorn (Los Angeles resident David Hockney is considered international). This is precisely the dilemma; Thiebaud is considered significant in California but is not collected internationally.

In conversation with European dealers I asked the question, "Why isn't Thiebaud taken seriously in Europe?" The answer was that he never showed in Europe, except once in Italy in the 1960s. For comparison, fellow Californians

Edward Ruscha and Sam Francis were always highly regarded in Europe due to their frequent exhibitions there. On the other hand, Diebenkorn was for the most part thought of in the same context as Thiebaud.

If Thiebaud were given a retrospective at an important museum like the Whitney (and it then traveled to a European venue such as the Tate, Whitechapel, or the Stedelijk), it would do a lot to dispel the contrived feeling that seems to hover over his market. Thiebaud needs to be seen in a non-Californian context. He also needs to be seen in a few serious European collections in order to help justify his six-figure prices.

One's first thought is to blame Thiebaud's dealer, but that is too easy. Hindsight dictates the correct strategy would have been to develop markets for Thiebaud overseas. However, for an artist not represented by Leo Castelli to emerge in the 1960s and sell in the 1980s for hundreds of thousands of dollars is a remarkable achievement.

This brings up the question of how real those six-figure prices are. I suppose they are real if someone actually writes a check to Sotheby's and Christie's. But are collectors actually paying those big prices?

This is just a theory, but the artist is probably supported at auction by the bidding and buying of dealers. Since only a handful of important Thiebauds come up to auction each year, it wouldn't take much to protect the market by bidding and buying. This serves the dual purpose of protecting one's own holdings as well as future new works.

What's wrong with dealer support at auction? Doesn't it protect the artist and collector? Only in the short run. What happens if the dealer dies, loses interest, or goes broke? The market will then right itself.

Currently, Thiebaud's major works are priced close to medium-sized Philip Gustons. That's too close. Thiebaud is a fine artist but he's not in Guston's class. If Thiebaud's prices for a good work dip to $100,000–$150,000, I would feel good about buying him. At their current $150,000–$350,000 I would be a seller.

The shame of all this is that Thiebaud is an outstanding realist painter. His "food landscapes" of the 1960s and 1970s have worn well. His later San Francisco-inspired exaggerated "steep street landscapes" are totally original Thiebaud inventions. In fact, if there is a good buy in Thiebaud's work, it lies with these paintings. They just might be better works of art than his food paintings and in the future could be more valuable.

CY TWOMBLY (b. 1929)

Prime Representation: Independent

Record Prices at Auction:

 Painting ("Chalkboard"): $5,500,000. *Untitled*, oil and crayon/c, 118" x 184 1/2", 1971 (S. May 90).

 Painting: $4,840,000. *Untitled* ("Roma"), oil, crayons, pencil/c, 78 1/2" x 94 1/2", 1961 (C. Nov. 90).

 Work on Paper: $577,500. *Formian Dreams and Actuality*, oil, oilstick/p, 39 1/4" x 27 1/2", 1983 (S. Nov. 89).

 Print: $63,250. *Note 1*, etching, 8" x 11", edition of 14, 1967 (S. Feb. 90).

Top Prices at Auction (Nov. 1994–May 1996):

 Painting: $574,500. *Untitled* ("Roma"), house paint, oil crayon, pencil/c, 38" x 50", 1961 (C. Nov. 95).

 Work on Paper: $222,500. *Lycian*, oil and crayon/p, 39 " x 27 ", 1982 (S. May 96).

 Print: $18,400. *Note II*, etching, 26" x 21", edition of 14, 1967 (S. May 96).

MARKET ANALYSIS

Past

Although Edward Ruscha and Donald Sultan had the highest boom market percentage growth, it was Cy Twombly (along with Andy Warhol and Jasper Johns) who had the greatest dollar value increase.

Twombly went from a pre-boom record $308,000 for a "Chalkboard" painting (C. May 87, Gilman Paper Company Collection) to the multimillion dollar level, culminating with the sale of another "Chalkboard" for $5.5 million (S. May 90).

For the uninitiated, a "Chalkboard" is a painting with a deep gray background that resembles a blackboard. Its surface is covered with continuous scrawled circular marks that appear drawn with chalk.

The catalyst that launched the big-time Twombly market was (what else?) the Andy Warhol Collection sale (S. May 88). Twombly was one of Warhol's favorites, as evidenced by the six works that appeared. All six sold for way over estimate.

The key sale from the Warhol Collection was yet another "Chalkboard" painting that was estimated at $300,000–$400,000 (consistent with what the "Gilman" work had brought a year earlier). It zoomed to almost a million, finally selling for $990,000. It was the most expensive contemporary work sold at the special sale, outdistancing canvases by Johns and Lichtenstein that had both been estimated higher. The rush for Twombly was on.

By November 1989, Twombly had easily broken the million-dollar level. But the real action was yet to come. As the contemporary boom market was coming to a close, Twombly's market was kicking into high gear.

In May 1990 at Sotheby's, a grand total of five major Twombly canvases came on the block. *All had million-dollar estimates.* Only two sold (one for $5.5 million, the other for $3.8 million).

The height of absurdity (for Twombly mania) was reached at rival Christie's during the same month. An untitled collaged work on two sheets of paper (52 1/2" x 59 1/2" and 32" x 24 1/2", 1976) came up with a numbing $600,000–$800,000 estimate (it passed). What was astounding was the mediocre quality of the drawing. The pressure on Christie's staff must have been considerable.

Twombly's auction success continued through the recession of the early 1990s. There was still heavy demand for great paintings, although prices returned to the $1 million to $2 million level.

The untalked-about critical factor in Twombly's rise to auction superstardom was the unprecedented dealer support (European) his work received at auction. While dealers have tried at various times to make a market for an artist at auction, never had this strategy succeeded so spectacularly.

Present

Continuing a trend that started last season, Twombly's late work continues to bring strong prices. Sotheby's May 1996 evening sale featured a colorful painting on paper, *Lycian* (39" x 27", 1982). Estimated at $200,000 to $300,000, *Lycian* sold for $222,500. Observers may scoff and question how this represents a strong price since it sold toward the low end of its estimate. But that's not the point. The point is that a late work on paper brought in excess of $200,000.

When you think about how few artists can command this sort of price for a work on paper, the magnitude of the achievement sets in. In fact, the only living contemporary painters whose works on paper bring over $200,000 are Cy Twombly, Jasper Johns, and Willem de Kooning. That's pretty exclusive

company for Twombly.

Other results from the 1995–1996 season saw most of the action focus on works on paper from the 1960s and 1970s. Only a couple of canvases came up and they were pretty minor. The works on paper that sold went from bringing a low of $25,300, for an ordinary drawing with a hint of color and scattered marks (10" x 14", 1960), to $107,000 for a "Chalkboard" style drawing (white chalk marks on gray gouache, 27" x 34", 1970).

Future

Cy Twombly, for all practical purposes, has become more of a European artist than American. Twombly began spending time in Italy in 1957 and eventually emigrated there in the 1960s (while still a Leo Castelli artist). Only in recent years has he begun spending time again in America. As a result, Twombly falls into a difficult category. Do you evaluate his market as American or European?

The answer is neither. Twombly is the most international of all living artists. So is his market. You are just as likely to see a Twombly painting in a London auction sale as a New York sale. What's noteworthy is that his work would likely bring a similar price if sold in either continent. The only analogous situation is David Hockney (a British expatriate living in America).

Having equal strength in both major international auction markets is certainly a plus for Twombly. What works against his general market is the current glut of works available, both in the private sector and at auction (though this situation is rapidly improving). Twombly, though not prolific in the way Andy Warhol and Sam Francis were (and the way Robert Rauschenberg is) still wasn't shy when it came to releasing work.

This wouldn't be a problem if Twombly weren't so expensive. The quality of his work is high enough for the market to absorb all of it. Despite his prices coming down from the stratosphere, the large canvases are still too expensive for all but the wealthiest collectors. Twombly is currently in the Mark Rothko price range for a major canvas (one million dollars-plus) and the Jasper Johns range for a great work on paper ($150,000–$250,000, exclusive of Johns's early work).

However, the majority of Twombly's works on paper are starting to sell for under a $100,000. When drawings such as the "Roman Notes" get closer to $75,000, they will be irresistible. Major paintings continue to be hard to come by at auction. Apparently the market is finally starting to absorb all those paintings that became available in the early 1990s (as a result of some 1980s speculators needing to sell).

Even though Twombly is rated as a "Hold," he's very close to being rated as

a "Buy." If I were in the market, I would "keep my powder dry" until the work came down another 10 percent. There is no guarantee, of course, that this will happen. However, the work has gotten more reasonable in recent years.

There are two reasons why Twombly's "stock" is more likely than not to rise in coming years. The first is his 1994 retrospective that was seen in both New York (MOMA) and Los Angeles (MOCA), among other venues. The second is the publication of a catalog raisonné (a book listing and illustrating the complete works of an artist; may also be specific, such as just paintings or prints).

Despite the usual complaining that accompanies virtually any retrospective (in Twombly's case, not enough mid-career work, poor installation at MOMA, etc.), Twombly's show was triumphant. Even though it took place three years ago, it stays with you. It undoubtedly exposed the work's brilliance to new potential collectors. Those that had already bought the work most likely felt their decision confirmed by the strength of the show. This should keep additional work off the market.

The Twombly catalog raisonné, with additional volumes to come, gives dealers an important promotional tool. Again, it also reinforces the decision of those collectors who already own Twomblys. Everyone loves to see their pictures documented. In a collecting field as jittery as the art world, the aura of history and permanence that a catalog raisonné offers should not be underestimated.

It's surprising how few major artists have catalog raisonnés of their unique works (then again, maybe not considering the Herculean task of putting one together). The following is a list of existing *catalogs raisonnés* for contemporary artists:

> Alexander Calder (in production)
> John Chamberlain
> Joseph Cornell (in production)
> Richard Diebenkorn (in production)
> Richard Estes
> David Hockney (only early work)
> Donald Judd (only early work)
> Roy Lichtenstein (in production)
> Morris Louis
> Isamu Noguchi
> Jackson Pollock
> Mel Ramos (early work)
> Mark Rothko (in production)
> Ed Ruscha (in production)
> David Smith

Frank Stella (more volumes to be added)
Cy Twombly (more volumes to be added)
Andy Warhol (in production)

ANDY WARHOL (1928–1987)

Estate Representation: Vincent Fremont, New York

Record Prices at Auction:

"Marilyn": $4,070,000. *Shot Red Marilyn*, a/c and silkscreen inks, 40" x 40", 1964 (C. May 89).

"Multiple Marilyn": $3,960,000. *Marilyn Monroe (Twenty Times)*, a/c and silkscreen inks, 76 3/4" x 44 3/4", 1962 (S. Nov. 88).

"Liz": $2,255,000. *Liz* (single image on two silver panels), a/c and silkscreen inks, 40" x 80", 1963 (C. Nov. 89).

"Elvis": $2,200,000. *Triple Elvis*, a/c and silkscreen inks, 82" x 48", 1964 (S. Nov. 89).

"Electric Chair" (small): $220,000. *Electric Chair* (blue), a/c and silkscreen inks, 22" x 28", 1964 (S. Nov. 89).

"Jackie": $88,000. Blue Jackie, a/c and silkscreen inks, 20" x 16", 1964 (C. Feb. 90).

Note: *Red Jackie*: $825,000, a/c and silkscreen inks, 40" x 40", 1963 (S. May 89, Karl Ströher Collection).

"Self-Portrait": $286,000. *Self-Portrait* (blue, photo booth image), a/c and silkscreen inks, 20" x 16", 1964 (C. Nov. 89).

"Brillo Box": $77,000. *Brillo Box*, oil on wood, 17" x 17" x 14", 1964 (C. May 89).

"Flowers" (5 inch): $22,000. *Flowers* (white), a/c and silkscreen inks, 5" x 5", 1964 (S. Nov. 89).

"Flowers" (8 inch): $55,000. *Flowers* (hot pink), a/c and silkscreen inks, 8" x 8", 1964 (S. May 89).

"Flowers" (14 inch): $115,500. *Flowers* (two white, two yellow on green), a/c and silkscreen inks, 14" x 14", 1964 (S. Nov. 89).

"Flowers" (24 inch): $242,000. *Flowers* (two yellow, one pink, one red on green), a/c and silkscreen inks, 24" x 24", 1964 (C. Nov. 89).

"Flowers" (48 inch): $687,500. *Four-Foot Flowers* (three red, one lavender on green), a/c and silkscreen inks, 48" x 48", 1964 (S. Nov. 89, Edwin Janss, Jr., Collection).

"Mao" (small): $115,500. *Mao*, a/c and silkscreen inks, 12" x 10", 1973 (S. Nov. 88).

"Mao" (medium): $192,500. *Mao*, a/c and silkscreen inks, 26" x 22", 1973 (S. May 89).

"Mao" (large): $484,000. *Mao*, a/c and silkscreen inks, 50" x 42", 1973 (S. May 89).

"Marilyn Reversal" (single panel): $110,000. *One Pink/Black Marilyn*, a/c and silkscreen inks, 18" x 14", 1979-1986 (S. May 90).

"Marilyn Reversal" (four panel): $467,500. *Four Multicolored Marilyns*, a/c and silkscreen inks, 36" x 28", 1979-1986 (S. Oct. 89).

"Marilyn Reversal" (nine panel): $632,500. *Nine Multicolored Marilyns*, a/c and silkscreen inks, 54 1/2" x 41 3/4", 1979-1986 (S. May 89).

"Dollar Sign" (small): $46,750. *Dollar Sign*, a/c and silkscreen inks, 10" x 8", 1981 (S. Feb. 90).

"Dollar Sign" (medium): $49,500. *Dollar Sign*, a/c and silkscreen inks, 20" x 16", 1982 (S. May 89).

Prints:

"Marilyns" (portfolio of 10): $522,500. *Marilyns,* screenprints, 36" x 36", edition of 250, 1967 (S. May 89).

"Marilyn" (individual): $88,000. *Marilyn* (F/S 31, hot pink and yellow), screenprint, 36" x 36", edition of 250, 1967 (S. May 89).

Top Prices at Auction (Nov. 1994–May 1996):

"Mariyln": $3,632,500. *Shot Red Marilyn*, a/c and silkscreen inks, 40" x 40", 1964 (C. Nov. 94).

"Elvis": $497,500. *Double Elvis*, a/c and silkscreen inks, 82 1/2" x 42 1/2", 1963 (C. May 95).

"Jackie": $74,000. *Jackie* (blue), a/c and silkscreen inks, 20" x 16", 1964 (S. May 96).

"Self-Portrait": $112,500. *Self-Portrait* (fingers over his mouth), a/c and silkscreen inks, 22 1/2" x 22 1/2", 1966 (S. Nov. 94).

"Flowers" (5 inch): $13,800. *Flowers* (yellow), a/c and silkscreen inks, 5" x 5", 1964 (C. May 96).

"Flowers" (22 inch): $85,000. *Flowers* (two yellow, one red, one blue), a/c and silkscreen inks, 22" x 22", 1964 (S. Nov. 95).

"Mao" (small): $43,700. *Mao*, a/c and silkscreen inks, 12" x 10", 1973 (C. May 96).

"Mao" (medium): $123,500. *Mao*, a/c and silkscreen inks, 26" x 22", 1973 (S. Nov. 95).

"Marilyn Reversal" (single panel): $101,500. *One Multicolored Marilyn*, a/c and silkscreen inks, 20" x 16", 1979-86 (S. May 96).

"Marilyn Reversal" (four panel): $79,500. *Four Marilyns* (black), a/c and silkscreen inks, 36" x 28", 1979-86 (S. Nov. 94).

"Dollar Sign" (small): None appeared

"Dollar Sign" (medium): None appeared

Prints:

"Mariyln" (portfolio of 10): $200,500. *Marilyns*, screenprints, 36" x 36", edition of 250, 1967 (S. Feb. 95).

"Marilyn" (individual): $19,550. *Marilyn* (F/S 23, pink and turquoise) screenprint, 36" x 36", edition of 250, 1967 (C. Nov. 94).

MARKET ANALYSIS

Past

The death of Andy Warhol in February 1987 was a major factor in the development of the international boom market for works of art. It dovetailed into a booming world economy and a partial switch of assets from stocks to collectibles after the October 1987 stock market crash.

When Warhol died, his reputation was already on the upswing. Smart collectors were coming to the conclusion that his best work was grossly undervalued. After Warhol passed away, collectors realized that the gods of Pop Art were mortal. They were getting older and wouldn't be producing art forever.

In a way, Warhol had been his own worst enemy. His post-1967 work (with the exception of the "Maos") had been pretty lightweight. This blinded most of the

art market to his accomplishments. There were occasional flashes of brilliance (the "Self-Portraits" from 1986), but for the most part, the art world began to regard him as a talisman rather than the massive talent he had once been.

Three months before Warhol's death, a major painting, *200 One Dollar Bills*, from the estate of Pop collector Robert Scull (S. Nov. 86) brought what was then a record price: $385,000. By May 1987, three months after Warhol's death, the Swiss dealer and collector Thomas Ammann paid $660,000 for *White Car Crash 19 Times* (C. May 87). The Warhol boom was on.

It's hard to believe now, but the price for a good 24" x 24" "Flowers" painting was only $15,000 just prior to Warhol's death. His great 1967 "Self-Portraits" were also under $20,000. "Jackies" were a hard sell at $8,500. Small "Maos" were $4,500.

As the art market moved into 1989, prices for great Warhols seemed to rise exponentially. The bidding wars that broke out regularly at auction culminated with the $4,070,000 brought by the infamous *Shot Red Marilyn* (C. May 89). The estimate had been $1.5 million to $2 million.

For those not familiar, the origin of the title was based on an event that occurred at "The Factory" (Warhol's silver-foil-covered studio) in 1964. A crazy "groupie" walked in, spotted several "Marilyns" leaning against a wall, pulled a gun from her purse, and fired at the movie star's forehead. The paintings were subsequently repaired and became known as the "Shot Red Marilyns."

The number of anecdotes surrounding the vast number of Warhols to come up to auction are too numerous to mention here. Suffice it to say that the art market's boom years would have been a lot duller (and a lot less lucrative) if there had been no Andy Warhol.

Present

The most important event in the 1995-1996 season's Warhol market did not take place in New York but in London. In June 1996, the largest "Mao" painting (82" x 56") ever to come up at auction appeared at Sotheby's. The pre-sale estimate was a tease at 100,000–150,000 British pounds (approx. $150,000–$225,000). The estimate proved to be wrong. Experts predicted a price of around $350,000–$500,000. They were wrong too. The painting sold for 672,500 pounds, approximately $1 million ($1,034,770 to be exact).

Why the extraordinary price? First and foremost, this was a very special painting. In 1972, Andy Warhol did a handful of large-scale "Maos" (a giant one that measures 176 1/2" x 136 1/2" can be seen at the Metropolitan Museum of Art). Warhol was pleased with the results and ended up doing an actual series of "Mao" paintings in 1973 (three sizes : 12" x 10", 26" x 22" and 50" x 42"), as

well as prints and wallpaper. Critics such as Robert Hughes have been quoted as saying that the "Maos" were Warhol's last flicker of genius.

The impact of the "Million-Dollar Mao" on the Warhol market was instantaneous. During the summer of 1996, dealers were quoting as much as $55,000 for the smallest size "Mao" and $200,000 for the next size up. The last price is amazing when you consider that the record price for a medium-size "Mao" is only $192,500 (achieved at the height of the market in 1989). But even before the sale of the "Million-Dollar Mao," a small one had come up a month earlier at Christie's and had more than doubled its estimate to sell for $43,700.

The *New York Times* attributed the million-dollar price for the "Mao" to three American dealers bidding against each other (on behalf of clients), as well as the outstanding quality of the painting. That's totally correct. What the *Times* neglected to mention was that demand for Warhol in general was on the way up prior to the London auction.

The quality of material that came up during the 1995–1996 season in New York was the weakest it's been in years. One of the more interesting results were the surging prices for "Jackie" paintings. The stage was set by the strong price achieved by *Nine Blue Jackies*, at Sotheby's in November 1995. This painting, best described as three rows of three paintings mounted on top of one another, was estimated at $375,000 to $425,000. It brought $398,500.

Six months later, two individual "Jackies" came up and each brought a good price. The first, a blue profile of Jackie in mourning, came up at Sotheby's May 1996 evening sale. The estimate was $40,000–$60,000. It sold for $74,000. The next day at Sotheby's day sale, a blue Jackie in mourning (wearing a veil), came up with the same $40,000–$60,000 estimate. It brought $63,000.

Part of the resurgence in prices for individual "Jackies" can be attributed to the success of the Jackie Onassis sale (a few months earlier at Sotheby's). The other reason is probably the realization by collectors that the "Jackies" are the only "Disaster" paintings available for under $100,000. Regardless of the reason, one thing is clear, the days of being able to buy a "Jackie" painting for under $50,000 are over.

Future

Andy Warhol is the greatest artist of the second half of the twentieth century. (Picasso undoubtedly was the greatest artist of the first half.) Although artists such as Pollock, de Kooning, and Johns have produced profound bodies of work, none has come close to Warhol in terms of influence on our culture. Simply put, Warhol's influence transcended the art world.

In the 1960s Warhol had his finger on the pulse of society. His "Race Riots"

from 1964 (images of African-American protesters being attacked by police dogs) reflected the racial anger of the times. His "Disasters" (graphic images of car crashes, suicides, etc.) resembled opening a newspaper on a daily basis and reading with detachment about all the global violence. They were done in mind-numbing repetitive images, often a dozen or more on one canvas.

The "Consumer Goods" works (such as "Brillo Boxes" and "Campbell's Soup Cans") certainly made the trip down the supermarket aisle a lot more visual. The "Celebrities" (Elvis Presley, Marilyn Monroe, and Elizabeth Taylor) spoke of our society's fascination with fame, glamour, and everyone's craving to connect with it in some way.

Warhol's commissioned "Portraits" were the best portraiture of its kind during this century. For $25,000 (plus $5,000 each if you wanted additional canvases), anyone could have his or her portrait painted by Warhol. First you would have lunch at his studio and then sit for a Polaroid photo session (he would then select the most flattering Polaroid to paint). Eventually you would receive a 40" x 40" painting of yourself that made you as glamorous as any of the "Celebrities."

This having been said, how does Warhol's future market look? You could write a book on the subject. Instead, for the *Art Market Guide's* purposes, the focus will be on paintings under $150,000 and their predicted value five years from now.

The paintings Warhol produced between 1962 and 1967 remain his most important achievement, particularly the great "Disasters" and "Celebrities." The most undervalued works from this period are the "Electric Chairs" and "Self-Portraits."

The small "Electric Chairs," technically considered "Disasters," are rarer than most collectors assume. There are only about 75 in existence. These paintings have strong content and are extremely visual. If one came on the market it would probably be estimated at $100,000-$125,000. The prediction here is that they'll be $200,000 five years from now.

Between 1964-1967, Warhol produced three distinctive groups of "Self-Portraits." Although they don't have any official designations, good descriptions would be "Photo Booth"; "Mum Voyeur" (with fingers in front of his mouth); and "Youthful" (looking straight ahead with his nose slightly turned up).

Warhol got the idea of creating his own likeness from Ivan Karp, the dealer whom many credit with discovering Warhol. Karp suggested that audiences wanted to see Warhol and that he was his own best subject matter. Current auction estimates would range from $100,000–$150,000 for any of the three styles. It's quite possible that a good one will bring at least $250,000 five years from now. In fact, a "Youthful" painting brought an unexpected $211,000 in London

during May 1995.

Warhol's "Flowers" (1964) were his most banal image from the 1960s and his most optimistic works from that period. The "Flowers" varied in size from 5" x 5" to 80" x 160". The 24" x 24" "Flowers" are the classic example of the genre. Current auction estimate for one would be $80,000–$100,000 (although a multicolored one hasn't come up in four seasons and a great one would likely go for $125,000). Look for a multi-color example to bring $200,000 in five years.

A 5" x 5" "Flowers" is the least expensive serious Warhol a collector can buy (they're also the most common size). Their current auction estimate would be $10,000-$12,000. They should "max out" at $20,000. The 8" x 8" "Flowers" would be currently estimated at $15,000–$18,000, with a potential ceiling of $30,000. The 14" x 14" "Flowers" currently fall in the $30,000-$35,000 range. The better ones could eventually reach $65,000. The key to buying "Flowers" is of course color. The more "Pop," the more valuable. The black and white examples will barely appreciate.

"Jackies" (Jacqueline Kennedy Onassis), once again from 1964, were created in at least seven different poses and four colors (blue, white, brown, and gold). The ones with a partial view of President Kennedy in the background have the most potential to appreciate. However in the current market, one pose has not proven to be more valuable than another (nor has a particular color)." Jackies" have been coming up to auction on a regular basis and selling for $55,000-$75,000. Despite not being scarce, they're good paintings and could go to $100,000 within five years.

In 1973 Warhol made a bit of an artistic comeback to produce his last body of historically significant work: the "Mao" paintings. At the time, the United States was just beginning to have a dialogue with China. Warhol created a Mao portrait that appeared both malevolent and benign at the same time. From this dichotomy, Warhol found an image with great visual/political tension.

The small 12" x 10" paintings are the best of the series because of their iconic stature. Their current estimated range is $35,000–$45,000. Look for them to go to $75,000 in less than five years.

Of the late Warhols, the "Marilyn Reversals" seem to have the most resonance. Although they're slightly commercial in appearance, the demand is strong for multi-color examples. The four-panel versions make the strongest visual statement. Current range for multi-color, four-panel works is $125,000–$175,000. They should be worth $250,000 in five years. Single panel works are currently $50,000–$100,000. The multi-color examples could go to $150,000 in five years.

The "Dollar Signs" of 1981 are Warhol at his commercial best. They are divided into two main categories: 10" x 8" and 20" x 16". The 10" x 8" works are currently estimated at $10,000–$15,000, while the 20" x 16" paintings are

$15,000–$20,000. Look for these to bring $25,000 and $35,000, respectively, in five years.

In 1986, Warhol created his last group of "Self-Portraits." This ghostly view of Warhol (with his silvery wig standing up) seemed to predict his imminent death. These works are real "sleepers" when it comes to investing in Warhol.

The smallest size, 12" x 12", has only appeared at auction once ($44,000, S. May 89). Current estimate would be $30,000–$40,000, with a future value of possibly $75,000. The best size to buy (both aesthetically and financially) are the 22" x 22" examples. They are the most readily available privately and are rarely seen at auction. The current estimate for one would probably be $65,000–$85,000. Future value could go as high as $150,000, five years from now.

While Andy Warhol is a definite "Buy," there are some issues that the art market (auction houses and art dealers) needs to address. The biggest concern is "consumer confidence," that is to say the wealth of misinformation that continues to circulate about Andy Warhol's paintings.

At the heart of the issue is authentication. Right after Warhol's death in 1987, the most frequently asked question was: "Is it real?" To answer that question, the Andy Warhol estate set up an authentication committee. The problem was that the committee was overwhelmed with requests by well-intentioned collectors. This led to the committee designating specific times that they would meet to authenticate work. If you needed an immediate answer, you were out of luck and had to be patient.

Another concern voiced about authentication is that few of the committee members were around the "Factory" (Warhol's studio in the 1960s) when the work was made. However, that doesn't mean a committee member couldn't become an expert on the work. There are certainly Picasso experts (as well as experts on virtually every deceased artist) who didn't know the artist personally and weren't there when the art was made.

Dealers are frequently asked about a painting's provenance. When asked, dealers often respond, "See if the painting is in the Crone book." What they are referring to is the only published Andy Warhol catalog raisonné, *Andy Warhol*, by Rainer Crone, published by Praeger in 1970 (at an original cost of $12.50, it now runs $800–$1,200). The Crone book has lots of valuable information, especially when it comes to major paintings from the 1960s. Its major shortcoming is the vast number of omissions. Not only did Warhol give away paintings as gifts, but apparently records weren't kept on all the small paintings he produced. For instance, the Crone book has no listing for how many five inch and eight inch "Flowers" paintings were done.

A much more comprehensive catalog raisonné is being compiled by Thomas Ammann Fine Art in Zurich in collaboration with the Andy Warhol Foundation.

The catalog was begun during the last few years of Warhol's life, at Warhol's suggestion to Thomas Ammann. When it's released, it should answer a lot of questions, such as how many small "Mao" paintings were done? In fact, other than Picasso, never has there been an artist more in need of a catalog raisonné than Andy Warhol.

Another frequently asked question about individual Andy Warhol paintings is whether the work is signed or stamped. Most of Warhol's work was signed. But not all of it. One thing that's known is that Warhol was inconsistent when it came to signing his work. Some works were signed immediately upon completion, others weren't signed until they were sold or left the studio for an exhibition. This would account for the many unsigned paintings that remained in his studio after his death. Those remaining paintings that weren't signed were stamped by the Warhol estate and are fine to acquire.

As time goes on and as more information comes to light, the Andy Warhol market will become even stronger than it is now.

TOM WESSELMANN (b. 1931)

Prime Representation: Sidney Janis Gallery, New York

Record Prices at Auction:

Painting: $528,000. *Seascape #20*, o/c (shaped canvas), 72" x 60", 1967 (C. Nov. 89).

Great American Nude: $495,000. *Great American Nude #43*, mixed media on panel, 48" x 47 3/8" x 8", 1963 (C. Nov. 94).

Still Life: $275,000. *Little Still Life #7*, mixed media on panel, 16 1/2" x 22", 1963 (C. May 89).

Cut-Out: $111,400. *Blonde Vivienne (3-D)*, oil on cutout aluminum, 78" x 78" x 10", 1988 (C. Feb. 96).

Print: $19,800. *Still Life with Petunias, Lilies and Fruit*, screenprint, 48" x 62", edition of 100, 1988 (C. Feb. 90).

Top Prices at Auction (Nov. 1994–May 1996):

Great American Nude: None appeared

Still Life: $48,875. *Great American Still Life No. 9*, mixed media on panel, 16" x 17" , 1962 (S. May 96).

Cut-Out: $111,400. *Blonde Vivienne (3-D)*, oil on cutout aluminum, 78" x 78" x 10", 1988 (C. Feb. 96).

Print: $5,175. *Monica Sitting with Mondrian*, screenprint, 40" x 29", edition of 100, 1989 (S. May 96).

MARKET ANALYSIS

Past

Around 1987, a well-known European dealer decided that the Tom Wesselmann market was greatly undervalued. He was quoted as saying, "The gap between Lichtenstein's prices and Wesselmann's is too great." Apparently, he was right.

Several American dealers threw in their lot with him. The mini-cartel then began buying Wesselmann and boosting his prices at auction.

The breakthrough moment was the sale of *Bathtub Collage #5* (S. Oct. 87). Estimated at $25,000–$35,000, it sold for $93,500 to one of the dealers. The painting was small (30" x 35", 1964), but outstanding, and it deserved to go high. However, when it tripled estimate, it certainly raised some eyebrows. By bidding up and buying this lot, the dealers boosted the value of their Wesselmann inventory while calling attention to the artist.

This tactic worked well and Wesselmann became sought after. Even though many of his works traded back and forth among dealers, some did reach collectors. A somewhat efficient market had been established.

During the late 1980s, Wesselmann performed extremely well at auction. Wesselmann had never been that popular, so the prices the vintage pieces brought, particularly the "small gems," were impressive.

The "Great American Nudes" series enjoyed the lion's share of attention. Large, important works began selling for over $400,000. They previously had been tough to sell for half that. Small (16" x 14" and smaller) early canvases had been $5,000–$8,500 in 1986. They began to routinely bring $45,000 and sometimes as much as $80,000.

Amazingly, prices were based on "heads or tails." If your painting only had feet or legs you didn't do as well as when you had the top half of the figure, with bonus points if she was blonde. Like all individual artists' markets, Wesselmann's had its peculiar rules too.

Present

An unusually large number of Wesselmann "Cutouts" came up in the 1995-1996 season. The highlight of the group was the record-setting cover lot of the February 1996 sale at Christie's. The record was deserved, as *Blonde Vivienne* was by far the finest "Cutout" ever to come up to auction. The piece was a direct descendant of Wesselmann's acclaimed "Great American Nudes" series. What was especially appealing about *Blonde Vivienne* was its three-dimensional quality (most works from the series are flat). The work was estimated at $70,000–$90,000 and sold for $111,400, breaking the old record of $110,000 by the slimmest of margins.

Six other "Cut-Outs" came up for sale, with five finding buyers. Of the five, three were figures set in various environments (as opposed to isolated individual figures). The most common setting was a bedroom. These three works averaged $45,800 each.

Since Wesselmann's importance is based on his works from the sixties, it

was hard to evaluate where his market was going since none of these pictures came up. Perhaps that's a sign that collector's are holding onto those early works. That would certainly make sense. Chances are in the future we'll only see one (two at the most) great early Pop paintings at auction, per season.

Future

Wesselmann's early works remain a "Buy" and his late works remain a "Sell"; hence last year's *Art Market Guide* gave him an overall "Hold" rating. At this point it's becoming obvious that the 1960s works are the only way to think of Wesselmann. It's thus better to treat 90 percent of the "Cutouts" as if they were done by another artist. With that in mind, Tom Wesselmann's rating is being upgraded to a "Buy" recommendation. Now if only some decent early work would come on the market.

If you go back to the early 1960s, you'll find Wesselmann was a Pop artist in good standing. His long running "Great American Nude" series cast him as one of the only artists of the group interested in traditional subject matter: the figure. His other main series, consumer product "Still Lifes," reinforced this image of working with the traditional.

Wesselmann's historical importance places him above Mel Ramos and Robert Indiana and just below James Rosenquist. However, Wesselmann's auction record places him on par with Rosenquist, perhaps even a shade better. Just like Rosenquist, he has had trouble breaking the $500,000 barrier (although Wesselmann did it once).

Wesselmann has also had to overcome a more limited market because of his use of semi-erotic imagery. Most of his works are stereotypical humor rather than titillation, although he occasionally crosses the border into the more blatantly explicit. Regardless, it was (and still is) a very real issue with female collectors, curators, and critics.

Wesselmann's vintage works have worn pretty well so far. Great 1960s works are scarce but, surprisingly, don't go wild at auction. They should. The art world will eventually think of these pieces as important historical works.

History is generally made by individuals rather than movements. Markets are made by individuals, too, but enhanced by movements. The mystique of Abstract Expressionism and Pop Art certainly has done its share to push prices up for their movements' top practitioners. It's the "movement mystique" that will eventually carry early Wesselmanns into the big money. A collector will be told, "You're buying a great Pop painting" rather than, "You're buying a great Wesselmann."

Despite his "Buy" rating, the only thing that could rain on Wesselmann's

parade is his post-1985 output. I am referring to his "Cutouts." It has been over 10 years since Wesselmann switched from canvas to cut-out metal. These colorful works look like linear sketches, cut out of aluminum, that allow the white of the wall to fill in the negative space.

Seeing the "Cutouts" dominate the current Wesselmann market makes you hope that collectors are growing tired of living with the work. But that's probably wishful thinking. The most likely reason all these works are coming up for sale is that there's now been over ten years of production. It's the natural order of things that more of these late works are finding their way to auction.

Wesselmann has remained loyal to nudes and still lifes, so the subject matter hasn't changed. What has changed is the work's integrity. In a word, it has become commercial. Like an overage ballplayer who hangs on too long, it would have been better if Wesselmann had retired.

When a good "Cutout" comes up at auction, it surprisingly doesn't do too badly ($45,000–$75,000 is generally the expected range). There are probably a lot of collectors who prefer these to the early works. Another five years of "Cutouts" and it's possible they might catch on in an even bigger way. One hopes the artist will come to his senses by then and return to canvas.

Introduction to Galleries

The two main components of the art market are the auction houses and the galleries. Private dealers and art fairs also play a part. The 1995–1996 *Art Market Guide* was concerned exclusively with the auctions. To create a more balanced picture, this current version of the *Art Market Guide* is listing 50 galleries that have distinguished themselves in some way.

In selecting 50 galleries to write about, the following criteria were used. First and foremost the gallery had to be influential in the contemporary American art market. The gallery also had to either mount exceptional shows, produce great catalogs, represent the top artists of their era, or the top artists of a school, or any combination thereof.

For the sake of clarity, galleries are categorized by those that more or less specialize in art from roughly a twenty-year time span (or originally made their reputation doing so). It should be noted that of the galleries handling work from the 1980s–1990s, many more qualify than are included here. Space limitations do not permit commentary on the numerous fine galleries specializing in that period.

Artists selected as the "Best Buy" are chosen as much for their market potential as for the quality of their work. In some cases, artists are selected who once had big reputations (but have since fallen from grace) and are now ripe for a comeback. Artists chosen are all currently good values and may turn out some day to have been great values. Finally, "Price Range" refers strictly to gallery prices for typically sized works by that artist.

C&M Arts, New York

Overview

Almost overnight, C&M Arts (dealer James Corcoran and major collector Robert Mnuchin) established itself as the top gallery in New York for Abstract Expressionist works of art. In fact, it's such a rarefied field that C&M is the only gallery to specialize in this material. The only thing more impressive than their inventory is their exhibition program (which could get even better with the addition of former Gagosian Gallery exhibitions director Robert Pincus Witten). Past shows at C&M have included two exhibitions by Willem de Kooning, including "The Women," and an even better show of abstract canvases from the underrated 1970s. The gallery also publishes handsome catalogs to document each of its shows. Though intimidating, the gallery's townhouse exhibition space gives the viewer the privilege of viewing major works in an elegant residential setting.

Best Buy: Joseph Cornell
Price Range: $60,000 to $250,000 (boxes)

Since taking over the Joseph Cornell estate from Pace Wildenstein, C&M has prevailed on the estate's trustees to lower the prices. This has led to an improving market for Cornell's work, especially the collages. You can still buy a classic "Penny Arcade" collage for only $35,000. The primary market for the boxes has actually been helped by the auctions, as Cornell has done well lately. One of these days Linda Roscoe Hartigan will finish the Cornell catalog raisonné (it's been over 15 years in production), which will stimulate more interest in his market. Deborah Solomon's long-awaited Cornell biography will be out soon and Charles Simic's wonderful book, *Dime Store Alchemy*, continues to attract new potential collectors.

Sidney Janis Gallery, New York

Overview

Sidney Janis was an art dealing legend who showed Arshile Gorky, Franz Kline, Mark Rothko, Willem de Kooning, and Jackson Pollock. Janis had an uncanny intuition for what came next as evidenced by the groundbreaking "New Realist" show in 1961 (the first group show of Pop Art). This led to Jim Dine, Claes Oldenburg, George Segal, and Tom Wesselmann joining the gallery. It also led to Philip Guston, Robert Motherwell, and Mark Rothko leaving the gallery in protest. The current version of the gallery is run by the son and grandson of Sidney Janis. The Janis Gallery has continuously mounted historically significant group shows (with works by artists such as Mondrian) but retains its relevance by showing younger artists such as Rona Pondick, Sandro Chia, and Peter Halley. They have also been fortunate in having Tom Wesselmann stay with the gallery for over 30 years.

Best Buy: George Segal

Price Range: $150,000 to $200,000 (new single "full" figures)

George Segal, an original Pop Artist, is not someone who immediately comes to mind when you think of the 1960s. Yet when you look through books on the era or stumble onto a piece in a museum, you remember how impressive his work was. Those ghostly white bandaged figures still hold up (especially those placed in great environments such as a figure stretching to place red plastic letters on an actual white movie marquee). His recent work also holds up well. By introducing color, Segal has managed to create a new range of moods and emotions. The work may have lost some of its grit from its Pop Art days, but it has gained a new foothold as traditional figurative sculpture.

Allan Stone Gallery, New York

Overview

Known for developing the careers of Richard Estes and Wayne Thiebaud, Allan Stone was also known for being the first person to spend a million dollars on a de Kooning at auction. Stone has been a long time champion of the Abstract Expressionists, having shown and handled works by Barnett Newman, Arshile Gorky, and so on. He also represented Joseph Cornell for a brief period. Stone's old gallery on 86th street not only showed art but was a treasure house of artifacts, such as shrunken heads. But the gallery collection was nothing compared to his personal collection. A visit to Stone's home is one of the great experiences in the Western world (or at least the art world). A few years ago, Stone moved further uptown into a beautifully renovated firehouse and began to do shows that emphasized young emerging talent (while sticking to his roots by doing a major de Kooning show in 1993).

Best Buy: Lorraine Shemesh

Price Range: $12,000 to $55,000 (paintings)

Lorraine Shemesh is a realist painter who paints figures in swimming pools, with a twist. She manipulates the figure in such an extreme way, that from the viewer's perspective, you feel as if you're in the pool with the swimmer. Many artists such as David Hockney have explored pool imagery. When viewing a Hockney, you enjoy the picture's sensual qualities but as an observer. In a Lorraine Shemesh picture you feel like asking for a towel because you're about to get wet. Her work is that realistic and has a memorable "in your face" quality. Shemesh's paintings work best on a large scale. She's an unusual example of an artist where bigger is better.

1960s 1970s

John Berggruen Gallery, San Francisco

Overview

John Berggruen is probably the best source in America for Bay Area Figurative art as well as the "Ocean Park" works on paper by Richard Diebenkorn. Berggruen is also a major player in the Wayne Thiebaud market. As you might assume, Berggruen's "back room" resale material is impressive (Stella, Rothenberg, Di Suvero, etc.). However, Berggruen's greatest significance as a dealer is that for 25 years he has anchored the San Francisco art scene. Remove his two monthly exhibitions and the city would slip below Chicago in its national art scene ranking. That's how much this gallery means to this city. John and Gretchen Berggruen are also known to have an outstanding personal collection.

Best Buy: David Park

Price Range: $125,000 to $400,000 (paintings)

David Park's Bay Area Figurative imagery looks stronger and stronger over time. Park is the most abstract of the group and for that reason was the slowest to receive recognition in the marketplace. His estate's old dealer, Maxwell Galleries, used to sell most of Park's paintings for under $10,000 in the late 1970s. For years Park was a lot less expensive than the more known Diebenkorn and Elmer Bischoff. That all changed when a small, colorful (and fresh to the market) mature painting brought a record $178,500 at Sotheby's in May, 1996. This may seem like a lot of money, but it's not when you consider that a Diebenkorn canvas of comparable scale and quality would bring almost double the price. In the future, Park will likely command such prices, making him a real bargain now.

1960s
1970s

Peder Bonnier Gallery, New York

Overview

Peder Bonnier made the unusual conversion from gallerist to private dealer and back to gallerist again. Usually it works the opposite way as dealers often have spaces and then go private. Bonnier got his start in the early 1970s as a partner in Gallerie Aronwitsch in Stockholm. He developed an early and continuing interest in Donald Judd. In fact, his current gallery continues to show Judd along with Cy Twombly and Robert Rauschenberg. But the gallery's real strength is in the secondary market. With his European as well as American connections, Bonnier is considered an excellent source for works by the above artists as well as Andy Warhol and Frank Stella. In fact, Peder Bonnier is one of the few Warhol experts around. Currently, Bonnier has two knowledgeable partners, Frits de Knegt and Jim Jacobs.

Best Buy: Not applicable because the gallery does not represent a stable of artists.

1960s
1970s

Brett Mitchell Collection, Cleveland

Overview

Running a serious gallery in Cleveland (despite the city's great Cleveland Museum of Art) has got to be one of the art world's most difficult assignments. Yet Mitchell Shaheen somehow has found a way to make it work. He does it by having secondary market inventory that's as good (and often better) than what you find in New York. Shaheen is an excellent source for unique works by Alexander Calder, Claes Oldenburg, Joel Shapiro, Alfred Jensen, and others. The other half of the "equation" is his son Brett, who runs a second gallery across the street called the Scarabb Gallery. This gallery specializes in the better prints of Roy Lichtenstein, Robert Motherwell, Elizabeth Murray, and Frank Stella.

Brett Shaheen also works on bringing emerging talent to the gallery. He recently mounted a successful show for Californian Dennis Hollingsworth. Brett Shaheen has the potential to become an art world rarity, the child of a successful dealer who surpasses the parent.

Best Buy: Not applicable because the gallery does not represent a stable of artists.

Leo Castelli Gallery, New York

Overview

Historically, Leo Castelli is in a class by himself. There are no accolades that haven't already been offered. At one time in the 1960s Castelli's roster included Jasper Johns, Robert Rauschenberg, Roy Lichtenstein, Cy Twombly, Claes Oldenburg, John Chamberlain, Frank Stella, Andy Warhol, and James Rosenquist. Nothing short of mind-boggling. Perhaps overlooked is Castelli's role in the 1980s. He has not been given enough credit for his willingness to change with the times. By showing Julian Schnabel, James Brown, and others, Castelli risked diluting all his vast achievements. Needless to say his reputation is just fine. If he ever retires, it's likely that Jasper Johns and Roy Lichtenstein will never have another main dealer again (they'll probably become free agents). It would just never be the same for them after their 30-year-plus affiliation with Castelli.

Best Buy: James Rosenquist

Price Range: $85,000 to $175,000 (new paintings)

James Rosenquist is still one of the most provocative painters around. Though I can't say I was overly impressed with his recent "Doll Heads" or his current "Guns," I like the way they're painted and they do make you think. It's likely that history will judge Rosenquist kindly, which makes his current work, good value. Other than David Hockney and Wayne Thiebaud, there aren't too many other blue chip artists who successfully deal with real life imagery. Of the three, Rosenquist's work has the biggest edge to it (and it's also the least expensive). Rosenquist's "Flower" paintings from the 1980s (with overlays of female faces)

remain a good deal on the secondary market. His classic 1960s Pop works remain in demand and difficult to find.

Paula Cooper Gallery, New York

Overview

Paula Cooper was the first gallery to open in SoHo in 1968 and has remained in the vanguard ever since. Over the years, the gallery has suffered some major defections, including Joel Shapiro, Donald Judd, Elizabeth Murray, and Robert Mangold. Most galleries wouldn't survive losses of this magnitude. However, Cooper has managed to weather the storm. The gallery still has a strong stable of artists that includes Carl Andre, Jennifer Bartlett, Robert Gober, Jackie Winsor, and relative newcomer Rudolf Stingel. Recently installed in its new Chelsea location, expect Cooper to come up with some outstanding new artists.

Best Buy: Julian Lethbridge

Price Range: $5,000 to $25,000 (paintings)

Julian Lethbridge is one of the finest young abstract painters around. His work's surfaces owe a debt to the buttery strokes of Jasper Johns. The chief rap against the artist was his failure to expand his all-white palette. This criticism was laid to rest when Lethbridge surprised his audience at his last show by filling his trademark "cell-like" structures with rich pastel color. This new move obviously opens up new possibilities for future growth. Right now the market for abstract painting is weak (work with body parts or work that makes political statements is hot). So it's probably a good time to be buying young abstractionists such as Lethbridge, David Row, Richmond Burton, David Reed, Jonathan Lasker, Mary Heilmann, Jaqueline Humphries, and Caio Fonseca.

Andre Emmerich Gallery, New York

Overview

Only a few short years ago this was a gallery that was in danger of losing its relevance. Apparently Mr. Emmerich was aware of this and decided to give the gallery a facelift. He hired Donald McKinney as his new director, who in turn brought in a fresh group of artists. The gallery still boasts having the estates of Sam Francis, Morris Louis, and Hans Hofmann. They still represent the second most salable living artist in David Hockney (Roy Lichtenstein is the first). Now, however, the gallery has some impressive younger artists, including Andrew Masullo and Stephen Ellis. It's also noteworthy that they now handle the lucrative estate of Keith Haring. Finally, the rest of New York's galleries will be watching with much curiosity how Emmerich's new partnership with the auction house Sotheby's unfolds.

Best Buy: David Row

Price Range: $6,000 to $25,000 (paintings)

David Row has quietly become one of the most important abstract painters in America. In terms of importance he ranks below Brice Marden, Robert Ryman, Agnes Martin, and Ellsworth Kelly. I would also rate him about even with Philip Taaffe, Sean Scully, and Robert Mangold. That's quite a burden for someone of only 46, but Row is up to the challenge. He brings to the surface of his paintings the touch and intellect of Jasper Johns. His small studies on paper have a lot of moxie and are unusually good value as well. Row's palette is quirky. In the past his color has ranged from that of a juicy pomegranate to the sublime pink of Willem de Kooning's *Queen of Hearts*. I can't wait to see his next move.

Richard Gray Gallery, Chicago

Overview

In May 1995, Richard Gray and Pace both did major Picasso painting shows. Richard Gray's was better. That's saying something. Richard Gray is to Chicago what John Berggruen is to San Francisco, Ron Greenberg is to St. Louis, and Margo Leavin is to Los Angeles: the foundations of their cities' gallery scenes. The Gray Gallery has recently staged important shows of David Hockney, Barry Flanagan, and Jim Dine, among others. They're also willing to take risks by showing lesser known artists such as the abstract painter Suzanne Caporael. Richard Gray is also a major international source for top-level artists such as Mark Rothko, Franz Kline, and Roy Lichtenstein.

Best Buy: David Klamen

Price Range: $15,000 to $20,000 (paintings)

The exhibiting of realist David Klamen reflects the emergence of Paul Gray's (Richard's son) greater role in the gallery's direction. Klamen paints large-scale interiors that often appear to have a deep perspective. The paintings seem to comment on architecture and the history of painting. No other artist comes to mind for a comparison, which is in the work's favor. Like many realists, his production is limited by the meticulous nature of the imagery. Klamen seems destined for a big career in New York.

**1960s
1970s**

Greenberg Van Doren Gallery, St. Louis

Overview

For years, Ronald Greenberg has been the top source in the Midwest for collectors seeking works by some of the bigger names in contemporary art. Previously, the gallery did major exhibitions for Sam Francis, Ellsworth Kelly, and Frank Stella. A few years ago long-time gallery director Sissy Thomas retired and Greenberg took John Van Doren as a partner. Recently, the gallery has begun to focus less on exhibitions and more on handling works by the above names as well as Roy Lichtenstein and Andy Warhol. Greenberg Van Doren Gallery is also an active participant in art fairs (which is becoming more crucial for galleries that are not part of the New York/Los Angeles axis). The fact that a gallery can still function on a high level in the middle of the Midwest is a tribute to Ron Greenberg and his staying power.

Best Buy: Not applicable because the gallery does not represent a stable of artists.

**1960s
1970s**

O.K. Harris Works of Art, New York

Overview

The 1997 *Art Market Guide* would be incomplete without paying due respect to O.K. Harris owner Ivan C. Karp (who turned 70 in 1996). Karp, a former director of Leo Castelli for ten years, was either solely responsible or collaborated (often with Richard Bellamy) to discover and promote the following artists: Andy Warhol, Roy Lichtenstein, James Rosenquist, John Chamberlain, Tom Wesselmann, Claes Oldenburg, Richard Artschwager, Cy Twombly, and Donald Judd. No other single dealer (including Leo Castelli) is credited with that many important discoveries. Karp's current O.K. Harris Works of Art has developed the artists Duane Hanson, Deborah Butterfield, Ralph Goings, Richard McClean, and Robert Bechtle. Other

artists of merit shown by the gallery include Randy Dudley, Daniel Douke, John Baeder, and Davis Cone.

Best Buy: Peter Saari *

Price Range: $12,500 to $22,000 (paintings)

At first glance a Peter Saari painting appears to be a large fragment of a fresco plundered from ancient Pompeii. As you explore the painting further you discover that the work becomes quite contemporary when placed in the context of a gallery. Saari's love affair with Pompeii is as much about the beauty of a painted surface as it mellows over the centuries as it is about the imagery itself. At its best, Saari's work gets the viewer involved in absorbing the mystery and beauty of weathered surfaces that we walk past on a daily basis. There's always the danger that work which deals with the slickness of material illusion might grow tired. Saari avoids that trap by keeping the paintings just raw enough.

* Please note: The author has previously represented this artist

 Knoedler & Company, New York

Overview

Knoedler was at one time one of the five most important galleries in New York. Then a few years ago it suffered a mass defection of artists (Diebenkorn, Scully, Hodgkin, Stella, etc.). It also lost several respected directors: Lawrence Rubin, who opened a gallery in Switzerland, and Jeffrey Hoffeld, who went private and also represents the estate of Louise Nevelson. However, Knoedler remains formidable as it still represents Helen Frankenthaler, Robert Motherwell's estate, and Donald Sultan. The gallery has also been around for an astounding 150 years. Recently, Knoedler has attempted to update its stable by taking on some younger artists such as Caio Fonseca and John Duff as well as some established ones like Michael Heizer.

Best Buy: Caio Fonseca

Price Range: $10,000 to $20,000 (paintings)

Caio Fonseca emerged several years ago at the Charles Cowles Gallery. Cowles did a terrific job promoting him and in a few short years Fonseca was well known in the art world. In a move reminiscent of Julian Schnabel leaving Mary Boone for Pace and Peter Halley leaving Sonnabend for Gagosian, Fonseca recently left Cowles for Knoedler and presumably greener pastures. Will it pay off? Probably in the short run. You hate to see an artist leave a dealer who has done a first rate job for him. However, at least at his first show, Fonseca will be seen by a fresh group of collectors and critics as having "arrived" (due to Knoedler's big reputation). On the other hand, Knoedler's reputation did nothing for the career of Donald Sultan after he moved there from Blum Helman (who, like Cowles, did a first rate job developing the artist).

 Margo Leavin Gallery, Los Angeles

1960s
1970s

Overview

Margo Leavin made a shrewd move early in her career when she aligned herself with Leo Castelli. This led to her exhibiting Claes Oldenburg, John Chamberlain, and Jasper Johns. In fact, her Johns show remains the only gallery show by that artist ever to take place on the West Coast. Leavin's 1992 show and catalog of drawings by "Johns, Marden, and Winters" remain another West Coast milestone. Currently, the gallery has been emphasizing its younger stable including Stephen Prina, Roy Dowell, and Mark Lere. Not long ago the gallery celebrated its 25th anniversary, an occasion marked by the publication of a valuable catalog documenting the gallery's history. Let's hope that other important dealers will follow Leavin's lead and preserve their pasts.

Best Buy: Alexis Smith

Price Range: $15,000 to $40,000 (assemblages)

Collage has always been an underrated medium and Alexis Smith certainly has been one of its prime practitioners. Not long ago, Smith had two well received museum shows at MOCA Los Angeles and the Whitney Museum. Her work reflects a keen eye for found objects and a sophisticated sense of humor. To Smith's credit her work is not readily identifiable as Californian. At some point this artist will get a high-profile New York dealer, more attention, higher prices, and perhaps some respect for "collage" as a serious art form.

Marlborough Gallery, New York

Overview

In the old Frank Lloyd days, Marlborough Gallery permanently etched itself into the art world's consciousness by its tragic involvement in the scandal over Mark Rothko's estate. Fortunately, the gallery recovered and has gone on to flourish under the direction of Pierre Levai. Marlborough has some of the most marketable artists around including Larry Rivers, Alex Katz, and Red Grooms (its European roster is just as salable). Marlborough's real strength is its worldwide connections with galleries and museums, giving the gallery a truly international market. A few years ago, the gallery made a smart move by luring away the top Photorealist painter, Richard Estes, from the Allan Stone Gallery (with the promise of European exposure and catalogs), thus giving Marlborough another cash cow.

Best Buy: Larry Rivers

Price Range: $60,000 to $100,000 (new paintings)

This is not a recommendation of Larry Rivers's recent work nor is it an endorsement of anything he has produced since the 1960s. However, the early work has held up well and should be considered both for its historical importance as well as its visual content. As much as Johns and Rauschenberg, Rivers bridged the gap between Abstract Expressionism and Pop Art. His popular culture imagery (such as "Dutch Masters" cigar box paintings) and use of language (such as his "Maps" and "Charts") helped pave the way for a lot of artists. Sadly, despite his wonderful paint handling and talent as a draughtsman, Rivers's recent work has become a parody of itself. Stick with the older work.

Barbara Mathes Gallery, New York

Overview

Always known for her outstanding secondary market material, Barbara Mathes has become known for her well-presented exhibitions since moving a few years ago to the Fuller Building. Her 1993 show of Willem de Kooning works on paper rivaled the one held at Allan Stone's gallery during the same time (and his show was outstanding). Mathes carved out another niche by gaining access to the paintings of Neil Jenney, an artist whose works are extremely difficult for dealers to obtain (since he represents himself). Besides contemporary art, Mathes has been a long time advocate of the American Modernist Oscar Bluemner. The Mathes Gallery is also known for the intimate works of Hannelore Baron.

Best Buy: Peter Alexander

Price Range: $15,000 to $30,000 (paintings)

It's ironic that Peter Alexander's work never looked as good in his native Los Angeles as it did in his show at Barbara Mathes. Alexander (the brother of dealer Brooke Alexander) frequently paints nighttime imagery, most recently of Las Vegas. The garishness of his color accurately captures the neon intensity that is Las Vegas. Alexander's other body of work worth considering is his Los Angeles "city lights" imagery. These paintings place the viewer in the vantage point of a passenger on a jet just coming in for a landing (all you see is a very visual geometric abstract pattern of glowing lights). My guess is that thanks to the positive reactions to this show, Peter Alexander will in the future be seen more frequently in New York.

Louis Meisel Gallery, New York

Overview

Louis Meisel has accomplished something no other gallery owner has been able to do; he controls an entire art movement. I am referring to Photorealism. Meisel not only owns extensive inventory (he has the world's largest collection of Richard Estes paintings), but he also tirelessly promotes the work through shows and loans. However, his most important achievement has been writing the most authoritative book on Photorealism, aptly called *Photorealism* (2 volumes, published by Abrams). Meisel's new venture is "Pinup" art (paintings of thinly clad female beauties who were featured years ago on calendars and other ephemera). Look for him to bring the same energy to the field and publish the dominant book on the subject.

Best Buy: Charles Bell

Price Range: $100,000 to $400,000 (paintings)

The biggest names in Photorealism are Chuck Close, Richard Estes, and Ralph Goings. Charles Bell ranks right behind them. If pressed, I might even rank Bell ahead of Goings. Bell's best known images are large-scale close-ups of gumball machines (often complete with prizes). Other imagery includes tin toys and marbles with swirling colors. Bell's technique is flawless. A handsome monograph on his work was published a few years ago with text by the late Henry Geldzahler. If Bell ever receives a museum show, his market will move up rapidly (in the meantime, it will do fine due to the limited number of paintings available).

1960s
1970s

Pace Wildenstein, New York and Beverly Hills

Overview

I'm sure that when Arne Glimcher opened the original Pace Gallery in Boston in 1960, he never dreamed that someday it would become the most important gallery in the world. Then again, given his famous self-confidence, maybe he did. Pace is certainly the most ambitious gallery around. It's Picasso "Sketchbooks" exhibition in 1986 remains the acme of gallery exhibitions. Pace's catalogs, which incredibly are published for almost every single show, are often of museum quality. Its roster of major artists and estates is frightening in its comprehensiveness. Its biggest challenge is keeping so many superstar artists happy. There's only so much space and attention to go around (see the departure of Brice Marden for details). On a positive note, the additions of directors Anthony Grant (New York) and Marc Selwyn (Beverly Hills) have considerably helped soften the corporate ambiance of both galleries.

Best Buy: John Chamberlain

Price Range: $18,000 to $135,000 (new sculptures)

John Chamberlain's 1996 show at Pace was not only beautiful but affordable. In fact, his smallest works, called "Baby Tycoons", were priced at $18,000. They remain the only bargains for collectors seeking to own sculpture by a major artist. Other than Joel Shapiro, Chamberlain is the only major sculptor whose small works have the same visual impact as his large works. There have been complaints over the years that Chamberlain has done little to change as an artist. Why should he? He succeeds because none of his pieces look the same. Look closely and you'll discover the varieties of shape and color are as endless as the variance of a snowflake.

Sonnabend Gallery, New York

Overview

Ileana Sonnabend is held in high esteem by her colleagues, many of whom would argue that she has a better eye than her ex-husband and partner Leo Castelli. Sonnabend's greatest historical contribution was opening a gallery in Paris in the 1960s to give Europe its first exposure to American greats like Johns, Rauschenberg, Lichtenstein, Oldenburg, and Warhol (the tiny catalogs she did for these shows are now collectors' items). Her current New York gallery's significance is based on the best Euro/American mix of exhibitions around. The most interesting artists of this group include Wim Delvoye, Mel Bochner, Jannis Kounellis, and Carroll Dunham.

Best Buy: Terry Winters

Price Range: $55,000 to $125,000 (paintings)

Of all the art stars from the 1980s, Terry Winters is now the least talked about. He's still one of the most talented pure painters around. In a way, his market never recovered from all the bad press his 1992 retrospective received. It was a bad rap. These days his imagery has been simplified from his "biology textbook" work of the 1980s. Winters's new work appears more intelligent while retaining his sure sense of color and terrific paint handling. Changing his imagery was a good move. The next move Winters should consider making is changing his gallery representation. Though I admire loyalty in an artist, this is a case where a change of scenery might be best for his career. Winters is also an outstanding printmaker. In fact, he's the best printmaker of his famous 1980s peer group (see the portfolio published by U.L.A.E. titled *Folio*).

Ace Gallery, New York and Los Angeles

Overview

Ace Gallery has been controversial and a gallery of extremes. However, one thing is certain, owner Douglas Christmas selected one of the best names for a gallery. He also built the largest commercial exhibition spaces in both Los Angeles and New York. What about the history of the galleries themselves? Christmas began his dealing career in Vancouver. However, Ace came into its own in Venice, California, where it did major exhibitions of work by Andy Warhol and Robert Rauschenberg. The gallery then moved to an old department store building in L.A. and did outstanding shows for such disparate talents as John Millei, Richard Mock, and James Hayward. Ace opened its cavernous New York space with a show of "truck size" sculptures by Michael Heizer that resembled prehistoric implements. It was a show that New Yorkers were unlikely to forget for sometime. This show (and a follow-up by Sol LeWitt) put Ace on the map.

Best Buy: Roger Herman

Price Range: $7,500 to $40,000 (paintings)

Roger Herman received his art training in Germany and settled in California in the 1970s. His expressionist imagery predicted the success of Anselm Kiefer and George Baselitz in America. Herman's strength is an informed painting sensibility derived from a European background and an American residency. The best of Herman's imagery is his long running series of "Apartment Buildings." These thickly painted works deftly play the geometric forms of the buildings off the abstract patterns created by their shadows. Herman's mainstream recognition in New York is long overdue. In 1996, Herman was given a big show at Ace (New York), which should go a long way toward achieving that goal. With his good looks, charisma, and talent, Roger Herman will someday be an art star.

Angles Gallery, Santa Monica

Overview

Owner David McAuliffe has quietly put together one of the best galleries in Los Angeles, if not the country. I have never seen a gallery with a more consistent vision. Every show is impeccably installed. Each work is placed in such a way as to create a dialogue between the works that gives the show an energy greater than its individual works (obviously, all galleries strive for this but most can't pull it off). Angles represents artists that are best described as having a Minimalist aesthetic with a high degree of refinement. Standouts in this group include Jeff Colson (a better artist than his more celebrated brother Greg), the shimmering paintings of David Simpson, and Leinhard von Monkiewitsch (the richest blacks I've ever seen in a painting).

Best Buy: Jeff Colson

Price Range: $5,500 to $7,500 (sculptures); $2,000 to $14,000 (paintings)

Jeff Colson is a "double threat" artist; it's hard to say which are stronger, his paintings or his sculpture. Colson makes three-dimensional ovoid forms out of raw unvarnished wood that are meant to rest on the floor. He infuses these forms with subtle color by coring out small sections and then plugging them with the section he had just removed (only with paint added to the plug). The effect is similar to a sheet of plywood with plugged knots. In fact, the work calls to mind Sherrie Levine's gold-painted knots in sheets of plywood. Colson's work also relates to the hand-crafted quality of Martin Puryear's work. If Colson can vary his forms a bit more, he looks like a shoe-in for a big career since there's so little good sculpture around.

Dru Arstark Gallery, New York

Overview

One of the good things to come out of the early 1990s art market plunge was that rents for second-story gallery space in SoHo became affordable. This gave a number of young dealers the chance to open their first space. Dru Arstark was one of those dealers. Arstark got her start dealing Hudson River landscapes at the Kenneth Lux Gallery. In 1994, she opened a small adventurous space that is dedicated to developing a stable of new artists. She is doing it without the benefit of secondary market dealing (out of the so-called back room). However, with the current small margins in selling resale material, her strategy might be the right approach. Arstark also has the right attitude. She never walks around without color announcements from her latest show and is quick to hand you one with a gracious request that you come see the gallery. It works.

Best Buy: Spelman Evans Downer

Price Range: $1,000 to $10,000 (drawings and paintings)

Spelman Evans Downer makes art that seems to draw inspiration from aerial landscape photographs. His paintings resemble street maps that are drawn free hand and then filled in with color to the point of abstraction. The result says more about unconventional landscape painting than about factual information. Downer's work is also informed by the "Earthworks" artists (Robert Smithson, Walter De Maria, Michael Heizer, and James Turrell).These artists altered the land as a form of sculpture that couldn't be experienced within the four walls of a gallery or museum. But their two-dimensional works served more as diagrams rather than works of art in their own right. Downer could put together an interesting career by doing the opposite; making two-dimensional works that are significant.

Adam Baumgold Fine Art, New York

Overview

In a few short years Adam "Ace" Baumgold has been able to put together a tidy stable of artists that are likely to have important careers. These artists include Tony Fitzpatrick, Jessica Gandolf, Sally Webster, Andras Borocz, and Arlyne Bayer. Adam Baumgold is also a good source for works from the secondary market, especially Saul Steinberg. Another interesting aspect of the gallery is its penchant for group shows. I've never seen a gallery give so many unknown but promising artists much needed exposure. This is what a good gallery should be about; a sense of risk taking and adventure.

Best Buy: Nick Blosser *

Price Range: $1,800 to $2,500 (paintings)

Nick Blosser comes out of the American Modernist tradition of Arthur Dove and Marsden Hartley. Yet his small-scale landscape paintings feel quite contemporary. Perhaps the much esteemed Albert York (who shows at Davis & Langdale Company) would be a better comparison. Blosser sees nature in all its magnificent detail, whether the air-blown seed from a milkweed pod or the luminescence of a butterfly wing. He then uses naturally occurring and imagined color to abstract the image and lift it to a higher plateau of meaning. Blosser also makes and paints his own frames, which serve to both isolate the image and extend it. His current prices are a true bargain considering what happened to those of Albert York (currently $20,000 to $30,000).

* Please note: The author has previously represented this artist

Tanya Bonakdar Gallery, New York

Overview

Tanya Bonakdar got her start as a dealer working for Anthony d'Offay in her native England. From there she came to New York to work as the gallery director at the Cohen Gallery on Madison Avenue. At the Cohen Gallery, Bonakdar established herself as a risk-taker by showing a challenging range of British and American artists, most of whom were unfamiliar to New York audiences. However, what put her on the map was giving the then unknown Damien Hirst his first show in New York. A few years ago, Bonakdar opened her own space in SoHo. There she has continued to launch careers, including those of the photographer Uta Barth and the sculptor Charles Long. The gallery's success stems not only from the quality of the shows but from how passionately Bonakdar discusses her artists' work.

Best Buy:　　Damien Hirst

Price Range:　$7,000 to $40,000 (paintings)

Even though Hirst is British (and this book is about American art) it's irresistible to talk about him. Oddly enough, even though his reputation is based on the sensational (actual bisected cows and pigs immersed in formaldehyde-filled, glass-walled tanks), it is his paintings that have the most long-term potential. Much has been written about the "anything to get attention" posture of Hirst's sculpture. Little has been said about his "Pharmaceutical Paintings." These works are best described as rows of multicolored pastel dots that resemble pills on a white background. The paintings are as interesting conceptually as they are visually. As for Hirst's latest foray into abstract painting, the circular "Spin Paintings" it's too early to tell (better to give it a couple years). If forced to choose, I would vote in favor of their going up in value.

Mary Boone Gallery, New York

Overview

More than any gallery in the 1980s, Mary Boone's came to symbolize the era. Her marketing acumen along with a very talented group of artists made her space the first stop in SoHo. The list of artists that Boone showed now feel like old masters: Jean-Michel Basquiat, Eric Fischl, and Julian Schnabel. Some *are* old masters, like Brice Marden. Along with her artists, Mary Boone has become an old master herself, in the dealer hierarchy. At the end of the 1980s, the gallery went through a phase that found it doing carefully focused historical shows such as Roy Lichtenstein's "Mirrors" (the silver-leaf lined book for the show remains the most sumptuous gallery catalog ever produced). Boone also did shows of Clyfford Still and Agnes Martin paintings. In 1996, the gallery made a major move to reinvent itself by moving uptown to Fifth Avenue. It was a smart move.

Best Buy: Ellen Gallagher

Price Range: $10,000 to $20,000 (paintings)

Ellen Gallagher's first show at Mary Boone was the "debut" show of the season (receiving a crucial positive review in the *New York Times*). Her minimal abstract canvases make references to such disparate sources as Agnes Martin and children's drawings. Initially, there was talk that Mary Boone's representation of Gallagher was a slick move politically (the artist is African-American and a woman). But Gallagher was a true standout in the last Whitney Biennial and her elevation to the highest tier of gallery representation is legitimate. Like a rookie "phenom" in baseball, Gallagher carries a "can't miss label." Unless her second show suffers from the "sophomore jinx" (which is unlikely), her future market looks bright.

Campbell - Thiebaud Gallery, San Francisco

Overview

When it comes to gallery ambiance, the Campbell-Thiebaud Gallery has it down. The gallery inhabits an old 1908 building in the North Beach section of town (far from the downtown gallery district). But it's worth the walk. Veteran Bay Area dealer Charles Campbell and partner Paul Thiebaud focus on work that is about traditional painting (this does not mean the work isn't innovative). The gallery shows works by Christopher Brown (San Francisco's most sought after painter), James Weeks, Gordon Cook, and Wayne Thiebaud. It also takes risks such as bringing the work of British artist Frank Auerbach to town. The high-light of the year is the gallery's annual "25 Treasures" show, complete with catalog. The partners select 25 visual objects that have ranged from a choice Richard Diebenkorn drawing to a vintage BMW automobile to a great 19th-century religious Retablo painting on tin.

Best Buy: Manuel Neri

Price Range: $45,000 to $125,000 (plaster, bronze, and marble sculptures)

Manuel Neri, though not unknown, certainly deserves to be better known. Neri makes almost life-size figurative sculpture (and fine drawings as well). His works are the sculptural link to the Bay Area Figurative painters. Neri's plaster works, painted with dry pigments, are his best works. Surprisingly, they are also his least expensive. These rough-hewn works have a poignant human quality that is hard to describe. The artist also works in marble and bronze. As mentioned elsewhere in the *Guide*, the paintings of Neri's peers (Diebenkorn, Wonner, Park, Oliviera, and Bischoff) continue to rise in price at auction. It's inevitable that Manuel Neri's work will someday enjoy a wider audience and do the same.

Laura Carpenter Fine Art, Santa Fe

Overview

Laura Carpenter certainly has one of the most beautiful spaces around, which is enhanced even more by its romantic Santa Fe setting. She formerly owned the New York gallery Carpenter + Hochman (Irena Hochman). Her current gallery is the only source for blue chip work in the Southwest, including that of Bruce Nauman, John Chamberlain, and Agnes Martin. The gallery is also a strong advocate of the work of Louise Bourgeois. The fact that this is the only gallery in the *Art Market Guide* from the Southwest demonstrates both the courage of Carpenter and the difficulty facing any dealer who chooses to open a space far away from the mainstream.

Best Buy: Wes Mills

Price Range: $1,500 to $2,500 (drawings)

Wes Mills is a young artist who is developing quite a reputation for his small-scale drawings. Mills builds up nervous irregular lines into a rich patch of graphite, often haphazardly placed on the page. His work seems informed by the drawings of Brice Marden and Richard Tuttle. As the art world knows, it's very difficult for an artist to build a career just on the strength of his or her drawings. Judged by the surprising number of dealers handling Mills's work at the 1996 Chicago Art Fair, the artists seems well on his way to successfully bypassing that rule.

Cirrus Gallery, Los Angeles

Overview

In 1996, owner Jean Milant was honored by the Los Angeles County Museum of Art with a 25-year retrospective of prints produced by the gallery's press, Cirrus Editions (the show also marked the publication of a handsome catalog raisonné). It was an important moment of recognition for a gallery that gets too little attention. Cirrus has consistently worked to promote Los Angeles by giving the area's top artists a chance to develop their ideas by making prints. The range of work as well as the artists who have worked at Cirrus is impressive. These artists include: Ed Ruscha, Ken Price, Bruce Nauman, Vija Celmins, and John Baldessari. Located downtown (away from the other galleries but close to the Los Angeles MOCA), the quality of the shows at Cirrus more than make up for the schlep.

Best Buy: Cirrus Prints

Price Range: $750 to $7,500 (prints by emerging and established artists)

Since the 1960s, America has seen the growth of a number of distinctive print publishers. A number of shops have done good work, developed innovative techniques, and sold an amazing number of prints. But at a cost. These shops sacrificed the individuality of the artists (in the name of commerce) to a point where all the prints seemed to look alike. The sign of a mediocre publisher is when you look at a print and the first thing that comes to mind is the name of the publisher (not the name of the artist). Currently, the only major publishers where the identity of the individual artists dominate are Universal Limited Editions, Crown Point Press, Alexander Heinrici, and Cirrus Editions. A particular standout, recently published by Cirrus, is an "Untitled" Renaissance-like landscape by Joan Nelson, available for $1,800.

1980s
1990s

Janet Fleisher Gallery, Philadelphia

Overview

Under the stewardship of John Ollman, the Janet Fleisher Gallery has been the pacesetter in the Outsider art market. But Ollman's real achievement has been to bring the works of Bill Traylor, William Edmondson, Martin Ramirez, and Joseph Yoakum into the contemporary art world's consciousness (the dealer Phyllis Kind should also be given credit). Ollman's done this through his natural enthusiasm for the material and his ability to share this enthusiasm with eager-to-learn collectors (all great dealers are also great teachers). The Fleisher Gallery has also received recognition for the discovery and promotion of the Philadelphia Wireman (the unknown ingenious creator of tiny tightly bound wire sculptures that encapsulate urban flotsam and jetsam such as pennies, bottle caps, and bits of mirror). This work remains the greatest Outsider art discovery of the last twenty years.

Best Buy: Tony Fitzpatrick

Price Range: $500 to $5,000 (prints and drawings)

Tony Fitzpatrick is rapidly becoming an art world phenomenon. This former professional boxer surprisingly has one of the gentlest touches when it comes to handling a drypoint needle (used to make his wondrous prints). Fitzpatrick makes handsome cartoonish drawings that call to mind the drawings of H.C. Westermann. But the real stunners are his prints. These small-scale works contain numerous sophisticated doodles of subjects ranging from ants to alligators to figures to crossword puzzles; in other words, anything and everything that pops into Fitzpatrick's fertile mind. The images actually resemble little tattoos right down to the off-shades of red, yellow, and blue. This is a career on the verge of moving to the next level.

Gagosian Gallery, New York and Beverly Hills

Overview

Larry Gagosian emerged as the new dominant force in the 1980s by being gutsy and making all the right moves. He forged alliances with wealthy collectors that gave him access to both working capital and great secondary market inventory. Equally important, he aligned himself with Leo Castelli, which gave him credibility with the museums (which, in turn, proved valuable in helping the gallery secure loans for shows). Overlooked in all the talk about the gallery's business dealings is the fact that Gagosian, at least in the late 1980s, did the best shows around, (even better than Pace's). These "better than museum quality" exhibitions and accompanying catalogs included "Jasper Johns: The Maps," Cy Twombly "Bolsena Paintings," Sam Francis "Blue Balls," and others. Who cares about Gagosian's personal reputation? The real winner was the public who got to see so many great shows.

Best Buy: Philip Taaffe

Price Range: $25,000 to $150,000 (paintings)

Last year's *Art Market Guide* commented that Robert Gober was the most important sculptor to emerge from the 1980s. Well, the most important painter is a little less obvious. However, any serious list would have to include Philip Taaffe. His paintings feature abstract pattern motifs that are often derived from the art and architecture of exotic foreign cultures. His "lino-cut collage" over paint technique is exquisite. Taaffe was never viewed as trendy in the 1980s, which is why he remains a good buy in the 1990s. Taaffe's paintings are already expensive and likely to stay that way. They also rarely appear at auction and do well when they come up (the last major work appeared at Christie's in May 1996 and brought $101,500 against an estimate of $60,000 to $80,000).

Jay Gorney Modern Art, New York

Overview

Jay Gorney cut his gallery teeth back in 1985 with a space in New York's East Village. An early spotter of talent, Gorney developed the artists Meyer Vaisman, Tim Rollins & K.O.S., and Haim Steinbach. Gorney was astute enough to realize that to gain serious exposure for his artists, he needed to form alliances. He did this by co-representing Steinbach with Sonnabend Gallery and getting Vaisman a show at Leo Castelli. This was a 1980s strategy that several other dealers pursued. Mary Boone played it to perfection by co-representing Schnabel and Salle with Castelli. Whenever the better galleries team up to show a first-rate artist, everyone involved benefits from the work's exposure in a fresh context. Gorney's current space in SoHo shows a diverse group of talent, including Lari Pittman (one of the few Californians to break through in New York), David Deutsch, Sarah Charlesworth, and the quirky Carl Ostendarp.

Best Buy: Jessica Stockholder

Price Range: $5,000 to $20,000 (sculptures)

Fresh off a well-received show at the prestigious Dia Foundation, Jessica Stockholder has emerged as one of the brightest young sculptors around. Stockholder creates sculpture out of non-traditional sculptural materials such as old furniture, yarn, colorful fabrics, and plugged-in light bulbs. The work succeeds because it is grounded in the formal concerns of sculpture; structure and composition. Stockholder's work is compelling because of the beautiful way she binds together her improbable materials into an unlikely coherent statement. As difficult as it is to sell sculpture, collectors appear to be taking their cue from the Whitney Museum, the Corcoran, and the Art Institute of Chicago (all of whom acquired works within the last year).

Fred Hoffman Fine Art, Santa Monica

Overview

Fred Hoffman is now on his third art dealing venture (he was also the owner of New City Editions, who published Basquiat prints) and seems to have finally found a situation that works. He only does four shows a year, but each show has been strong and accompanied by a serious catalog. Hoffman recently showed George Segal and Tom Wesselmann, two artists rarely seen on the West Coast. Seeing these two artists outside of New York energized the work and helped the viewer consider them in a fresh way. Hoffman also has a commitment to the artists of Los Angeles as evidenced by his exhibiting the works of Charles Arnoldi and Eric Orr.

Best Buy: Charles Arnoldi

Price Range: $10,000 to $45,000 (paintings)

Charles Arnoldi has always been sought after by collectors for his signature "Tree Branch" paintings, yet ignored for his recent abstract canvases. Earlier, I would have agreed with the validity of that consensus. His recent show at Hoffman changed my thinking. Arnoldi's new paintings are actually far superior to his wooden "Tree Branch" or "Chainsaw" works. These bold new paintings manage to create a lot of visual tension by playing Matisse "Cutout" forms off impossibly beautiful colors. I doubt whether even as great a painter as Brice Marden could make Arnoldi's diverse palette work. Arnoldi's career has been held back by living in California. If he lived in New York, he'd rank right up there with the best abstract painters and have a substantial career. Someday it will happen.

Rhona Hoffman Gallery, Chicago

Overview

Long-time Chicago dealer Rhona Hoffman has consistently demonstrated a good eye for both contemporary masters and picking what's next. During the 1996 Chicago Art Fair, she mounted a provocative show at her gallery of new British artists that had this viewer walking away wanting to see more. Some of the artists the Hoffman Gallery showed early on were Jenny Holzer, Barbara Kruger, and Cindy Sherman. Hoffman was formerly a partner in the Young/Hoffman Gallery (former partner Donald Young now operates a gallery in Seattle). Equally important, Rhona Hoffman provides a counterpoint to the Richard Gray Gallery for Chicago collectors wishing to acquire works by well-known artists.

Best Buy: Carrie Mae Weems

Price Range: $3,500 to $7,000 ("photographs")

Carrie Mae Weems is one of a growing number of artists who have chosen to explore the cultural history of their race (others chose their religion or gender) and turn it into their art. The problem most of these artists face is how to make the work visual enough so the viewer sticks around long enough to absorb the message. Weems's work appears to have struck a balance between text and photography that's convincing intellectually and visually. Weems has chosen to focus on forms of historical prejudice that are part of the African-American experience. It may sound corny, but everyone has experienced discrimination of some sort, so Weems's work strikes a universal chord. If she can now move on and successfully explore non-racial aspects of the human condition, she'll have a noteworthy career.

Paul Kasmin Gallery, New York

Overview

Paul Kasmin is a rarity in the art world: he's the child of a well-known art dealer who is just as talented as his parent. Despite the obvious advantage a son or daughter has by growing up in an art-dealing family, the opposite of what you'd expect usually happens: the kid is usually incompetent. If you look around New York, you'd quietly laugh and quickly agree with this point of view. Paul's dad is the British dealer John Kasmin, known for discovering and promoting David Hockney. Paul has good instincts of his own. His gallery has worked with a strong group of diverse artists that includes Nancy Rubins, Peter Schuyff (an underrated abstract painter whose work has matured since the old East Village days), and Suzanne McClelland. Interestingly enough, Paul Kasmin is part of another father and son relationship; he shows the work of Alessandro Twombly (the son of Cy Twombly).

Best Buy: Donald Baechler

Price Range: $20,000 to $40,000 (paintings)

Donald Baechler's intentionally crudely painted images of beach balls, flowers and other subjects received a fair amount of attention in the 1980s. His paintings were often associated by critics with the Tony Shafrazi group of artists (such as James Brown). In the 1990s, it's obvious that Baechler's work stands on its own and defies earlier comparisons. Baechler's best works are his multi-media works on paper. A 48-inch-tall drawing runs about $12,500. These works incorporate collaged elements along with the artist's trademark "bad" painting imagery (especially effective are the "rough" flowers). These drawings have the compositional discipline of a Kurt Schwitters collage along with the rich marks of a Cy Twombly painting.

Barbara Krakow Gallery, Boston

Overview

Barbara Krakow began dealing art privately in the late 1960s, went through a number of gallery partnerships (including one involving Portia Harcus), and evolved into a sole proprietorship. The one constant through the years was her ability to spot new talent early (she did one of the first shows for Sean Scully). Through the years, the gallery has stood out for handling works on paper by some of the top Minimalist painters, such as Agnes Martin and Brice Marden. The gallery still works heavily with Sol LeWitt. Krakow has also worked to develop local Boston talent such as Chuck Holtzman. Currently, the Krakow Gallery exhibits artists on a show by show basis rather than representing them as part of a stable. This has allowed them the time to focus on projects such as putting together a *catalog raisonné* of multiples by Kiki Smith.

Best Buy: Not applicable because the gallery does not represent a stable of artists.

Luhring Augustine Gallery, New York

Overview

Visitors to Luhring Augustine walk into a gallery that challenges the uninitiated and pleases the informed. Partners Lawrence Luhring and Roland Augustine charted a course to show work that wasn't the easiest but that was certainly worthwhile for those willing to spend time with the it. Recently the gallery put together a Gerhard Richter show that was of museum caliber. Luhring Augustine has also done impressive shows for two photography-oriented artists: Sophie Calle and Larry Clark (of the controversial movie *Kids*). While a number of American galleries regularly include European artists in their programs, Luhring Augustine also includes contemporary Japanese artists,

making the gallery one of the most international around.

Best Buy: Christopher Wool

Price Range: $20,000 to $45,000 (paintings)

In the 1980s the late curator John Caldwell referred to Christopher Wool as the most important young artist in America. Quite a statement. Wool carved out a niche for himself by painting black letters on large sheets of aluminum that were covered with white enamel paint (the stenciled letters looked like they were printed from a woodblock, giving the work a punchy hand-made quality). These letters spelled out simple words or phrases that were often provocative or disturbing (such as "Cat's in Bag, Bag's in River"). The work caught on and sold at increasingly higher prices. Wool moved on to make works with overlapping printed images of floral patterns and other motifs. These days, you rarely hear or read about Wool anymore, yet he's currently doing his best work. Sounds like a good time to be buying him.

Curt Marcus Gallery, New York

Overview

Curt Marcus established himself as an aggressive gallery director at Grace Borgenicht Gallery by putting together a stable of surprising new talent. At some point, Marcus must have realized that since he had the relationships with the artists, he should probably go off on his own and represent the artists himself. It was a smart move. Though some of his choices have faded from view, others such as Mark Innerst and Mark Tansey have become much sought after by collectors. In the case of Tansey, the artist has already had a traveling museum show and commands six-figure prices at auction. I can't think of too many young dealers who can make the same claim for an artist he or she developed.

Best Buy: Mark Innerst

Price Range: $12,000 to $32,000 (paintings)

Mark Innerst's small jewel-like paintings first came into prominence in the late 1980s. Collectors have been buying him from day one. It's easy to see why. Innerst's best paintings are of urban New York scenes: the geometric canyon-like appearance of the city's tall buildings as you look up and then down any street. The artist abstracts these scenes just enough to transport the viewer's imagination. Innerst's most recent work incorporates figures enjoying Central Park. However, these paintings have an edge. In some of the pictures, the viewer enjoys the same breath of fresh air as the figures in the painting before being jolted back to urban reality by the park's surrounding buildings. With paintings like these, Innerst's career should continue to flourish.

Matthew Marks Gallery, New York

Overview

Matthew Marks has made a big impact in a short time. Marks's baptism by fire was helping to organize the great Picasso "Sketchbooks" exhibition when he worked for the Anthony d'Offay Gallery in London (the same show that traveled to Pace). Marks's key move in establishing his American presence was making a deal with Brice Marden to exclusively represent his drawings. This of course did not thrill Marden's previous dealer of both his paintings and drawings, Mary Boone. Apparently Marden liked it so much at Marks (his books done for Marden's shows didn't hurt), that he eventually gave Marks the paintings too. Marks used this coup as a springboard to sign up Ellsworth Kelly and have direct access to Willem de Kooning's work. Not bad.

Best Buy: Richmond Burton

Price Range: $7,500 to $35,000 (paintings)

Richmond Burton is a very talented young abstract painter who showed much promise in the 1980s and has come into maturity in the 1990s. He immediately caught the art world's eye by doing a series of paintings that borrowed so blatantly from Frank Stella's "Black Paintings" (and were so well done) that you had to label Burton as worth watching. Despite occasional growing pains, the artist has not disappointed. His most recent work is as colorful as a kaleido-

scope and as complex too. In fact, what's most refreshing about Burton is his fearless use of color. Also, his initial forays into printmaking have resulted in an admirable body of work.

Jason McCoy Inc., New York

Overview

Jason McCoy has an extraordinary background. He is the nephew of Jackson Pollock and also had a close relationship with Lee Krasner. As a result, his gallery is a good source for Abstract Expressionist works. But it's really the gallery's stable of artists such as Helen Miranda Wilson, Philip Smith, and Michael Tetherow (and the catalogs he does for them) that makes McCoy's establishment stand out. At America's top art fair, "The Art Show," McCoy is known for distinguishing himself by mounting shows of previously unseen work (most recently of Pollock) rather than the usual accumulation of resale material. Jason McCoy is also a big Andy Warhol fan. A while back, he mounted a show of Warhol "Self-Portraits" that reminded the public that Warhol was his own best subject matter.

Best Buy: Gregory Amenoff

Price Range: $8,500 to $18,000 (paintings)

Gregory Amenoff is a major talent whose career suffered when he left the Robert Miller Gallery for Hirschl & Adler. Back in the Robert Miller days, the Stephen Wirtz Gallery made a commitment to Amenoff's work and has stuck with it, despite the artist's fall from glory. Based on Amenoff's last show in San Francisco, the Wirtz's loyalty might be rewarded. So will Jason McCoy's recent decision to represent him. Amenoff is a superb colorist and inventor of organic forms. His work is heavily influenced by Outsider art (he's also a big collector of this genre) but is also quite sophisticated. Amenoff's strength as a painter is creating tension between his naive influences and his obvious mastery of painting organic forms. Someday, the art world will grant him a second chance and those who held onto his work will be glad they did.

McKee Gallery, New York

Overview

Many years ago while working for Marlborough, David McKee did a very smart thing. He developed a relationship with Philip Guston. Years later, when he opened his own gallery, McKee had positioned himself to represent the artist's estate. The McKee Gallery also at one time handled the Franz Kline estate (which has since been dispersed). The gallery's other big triumph was developing Sean Scully into an international blue chip artist. In typical art world irony, Scully ended up leaving McKee and ultimately wound up at Mary Boone (McKee's new next door neighbor). Fortunately, McKee had developed other first-rate artists, including Martin Puryear, Jake Berthot, and William Tucker. Sculptor Martin Puryear, in particular, has been in heavy demand as evidenced by his recent record-setting price at auction of $178,500 (Christie's, May 1996).

Best Buy: Vija Celmins

Price Range: $125,000 (new paintings) (drawings: $25,000 to $45,000)

Vija Celmins has never been part of the art world's collective consciousness. But whenever you see one of her works you wonder why she isn't. Celmins paints canvases depicting close-up cross sections of ocean waves or the countless stars in our galaxy. These works are painted in a tight realist style, often in toned grays or blacks. The paintings are so beautifully painted and the subject matter is so meditative that viewing a Celmins painting is a highly spiritual experience (a much over used expression in the art world but fitting here). As outstanding as her paintings are, the drawings are the best deal ($35,000 on average). They feature the same imagery, but the artist's "presence" is more evident than in the more detached and cooler paintings.

Robert Miller Gallery, New York

Overview

From its gorgeous bleached wood floors to beautifully installed shows to tasteful catalogs, no one has more style than the Robert Miller Gallery. Under the direction of John Cheim, the gallery has assembled an unusually eclectic (Robert Maplethorpe, Alice Neel, etc.), politically correct (photography/painting, male/female, young/old, gay/straight), and salable (Joan Mitchell, Joan Nelson, etc.) group of artists. The gallery has been both innovative-it was the first to show Ed Ruscha's silhouette paintings-and willing to take big risks by attempting to resurrect the careers of Philip Pearlstein and Milton Resnick. The Robert Miller Gallery has also worked with overlooked estates such as Lee Krasner and sought after estates such as Jean-Michel Basquiat's (until recently). In short, this is a gallery that's carefully managed to put together a very enjoyable program and a very desirable group of artists. As this book went to press, John Cheim had left the gallery and will likely open his own space.

Best Buy: William Eggelston

Price Range: $4,000 (for a photograph, edition of 5)

William Eggelston remains one of the best buys in the photography market. His color die-transfer prints portray a very personal vision of the Deep South. Eggelston works from his home in Tennessee, but also travels extensively. His quirky eye has captured in print everything from the garish splendor of Graceland to the sad vanishing world of Dixie. But whether photographing an image of one of Elvis's costumes or that of an old tattered Confederate flag, Eggelston manages to infuse his works with a haunting humanity. There have been three books published that provide a good introduction to his work: *The Democratic Forest*, *Ancient and Modern*, and the hard-to-find MOMA publication, *William Eggelston's Guide*.

Morris Healy Gallery, New York

Overview

Young dealers Paul Morris and Tom Healy have put together a fine gallery that is also one of the pioneering spaces in Chelsea. Morris gained valuable gallery experience from having worked for Hirschl & Adler and Anthony d'Offay. Healy has worked previously in New York as an independent curator. The two dealers are carefully developing a group of artists that have precise viewpoints (rather than the usual homogenous look among artists that you see at many galleries). These artists include Peter Dayton (who makes pictures of "Pop" flowers out of color laser prints and covers them with clear resin), Robert Adams (who constructs pictures out of actual match heads) and the Finnish photographer Esko Mannikko (who takes beguiling photos of his countrymen in oddly colored interiors). I predict this gallery will be sending one or two artists to the next Whitney Biennial.

Best Buy: George Stoll

Price Range: $1,200 to $8,000 (sculptures)

If you can imagine beautifully colored wax forms that resemble plastic tumblers stacked on top of one another, than you have a pretty accurate idea of what George Stoll's work looks like. Make no mistake, the description may sound frivolous but these small-scale works are compelling. Stoll is a great colorist, something extremely rare among sculptors. Stoll's choice of medium, wax, is a very rich, sensuous material whose properties have only been explored by a few artists (Bruce Nauman's "Heads" come to mind). The key for Stoll is to now build on this initial success by exploring new forms. That shouldn't be a problem.

Ricco/Maresca Gallery, New York

Overview

If John Ollman should be recognized for giving the Outsider art market greater credibility, then the Ricco/Maresca Gallery should be given credit for giving the movement a higher profile. Partners Roger Ricco and Frank Maresca have distinguished themselves by authoring the lavishly illustrated books: *Bill Traylor*, *American Primitive: Discoveries in Folk Sculpture*, and the much needed *American Self Taught* (a reference book on the top Outsider artists). The gallery shows the artists Bill Traylor, William Hawkins, Thornton Dial, and others. However, perhaps the most memorable moment at the gallery was a show of found objects. Due to form or obscure function these objects transcended being mere curiosities and entered the realm of the uncanny (such as a heavily patinated row of metal hands used many years ago as a mold for making gloves). This show demonstrated the partners' sure sense of aesthetic judgment as well as the rare ability to see beyond the obvious.

Best Buy: Eugene Von Bruenchenhein

Price Range: $1,800 to $4,000 (photographs and paintings)

Eugene Von Bruenchenhein was an amateur (but serious) artist who liked to take erotic photographs of his wife posing semi-nude in strange positions. The hand-tinted photographs are the most sought after. The artist also made tiny chairs (under a foot high) composed of chicken bones. Von Bruenchenhein's best works are his small, colorful paintings with weird graffiti (such as a little dragon) scratched through the paint. While these bodies of work may sound trivial, they have integrity. Von Bruenchenhein is of interest because of the sheer pleasure you sense the artist got from making the work. Most of the good work you see is about issues of content, innovation, and so on. Von Bruenchenhein didn't care about the issues that consume most serious artists. For him, art just had to bring pleasure.

Bennett Roberts Fine Art, Los Angeles

Overview

Borrowing a concept from Los Angeles dealer Thomas Solomon, Bennett Roberts opened a "garage" gallery (literally) in a residential district. Previously, Roberts was a partner in the Richard/Bennett Gallery (with Richard Heller, now the owner of the Richard Heller Gallery in Santa Monica). Roberts's new gallery focuses strictly on developing new talent and appears to have picked a few winners: the painters Michelle Fierro (who also shows at Jack Tilton in N.Y.) and Lucas Reiner. Roberts himself is a tireless promoter of his artists. Speaking with him for half an hour, you walk away thinking he has the most important artists in the universe. That's a good dealer.

Best Buy: Dennis Hollingsworth

Price Range: $2,500 to $10,000 (paintings)

Dennis Hollingsworth is a Los Angeles painter who works with paint and poured resin on canvas. The work calls to mind the early resin work of Ed Moses as well as the "Veil" paintings of Morris Louis. The results are canvases that are quirky, memorable, yet more New York looking than Los Angeles (yes, there is a distinction). The artist also makes drawings that exhibit the same level of effort that goes into his paintings. Hollingsworth presents a real dilemma to Roberts. At some point, a serious New York dealer is going to come courting and it's going to be awfully hard for Bennett Roberts to hold on to him. Then again, Roberts is the sort of dealer who inspires loyalty.

Arthur Roger Gallery, New Orleans

Overview

Arthur Roger has put together a program that strikes just the right balance between showing local artists and artists of national repute. Roger mixes shows of New Orleans's own Ida Kohlmeyer with the likes of New Yorker Peter Halley. The result is a gallery that anchors the New Orleans art scene. In the 1980s, Roger opened a second space in the heart of SoHo. Despite putting together a good series of shows, running two spaces and flying back and forth between two cities proved too costly. Roger closed his New York space and decided to concentrate all his energy on New Orleans. The gallery emerged as part of a relatively new hybrid: a gallery that retains its regional flavor while showing enough established artists to have a national identity. Other galleries in this category include Fay Gold of Atlanta, Susanne Hilberry of Birmingham (Michigan), and Robert McClain of Houston.

Best Buy: David Bates

Price Range: $6,500 to $35,000 (paintings)

Looking at the exotic flora and fauna that inhabit a David Bates painting, one might think that the artist is an under-educated good old boy from the Deep South. The truth is the artist is a very sophisticated individual who finds inspiration in the creatures, vegetation, and people who inhabit the bayou. Bates's distinctive "quasi-primitive" style provides just enough charm to draw the viewer into his pictures. But behind the charm is a painter of substance. The swamp images combine mystery and a haunting nostalgia that's still present but rapidly vanishing from the southern United States. Bates's paint handling is intentionally crude, which further reinforces the appeal of his paintings. Lately the artist has been creating good but expensive painted bronze sculpture. For now, his paintings are the better value.

Tony Shafrazi Gallery, New York

Overview

Tony Shafrazi has been a controversial dealer since day one. Originally an artist, Shafrazi became infamous in 1974 for spraying graffiti on Picasso's *Guernica* at the Museum of Modern Art (for those who are curious he sprayed "Kill all lies"). In the aftermath Shafrazi said he did it to make an artistic statement. Give me a break. Ironically, he became an art dealer and a good one at that. Say what you want about him personally, but in the 1980s his gallery showed some of the hottest artists around: Keith Haring, Kenny Scharf, Jean-Michel Basquiat, Donald Baechler, and James Brown. While he has become less of a factor in the 1990s, he still does good shows (especially in the area of photography, such as a recent show of the actor Dennis Hopper's work).

Best Buy: Kenny Scharf

Price Range: $18,000 to $45,000 (paintings)

While Kenny Scharf is not a great painter, he's still a lot better than most of what you see when you walk around SoHo. His work has come a long way from his 1980s "Jetsons" cartoonish imagery. Some of his recent paintings of alligators and Everglades landscapes may sound dubious if you haven't seen them. If you have, you'd likely agree that this series was imaginative, highly enjoyable to look at, and well painted. Scharf's greatest strength is his sense of humor, a quality underrated and under-explored in today's art world (Richard Prince is one of the only other artists who uses humor in his work). While I won't go out on a limb and say that twenty years from now Scharf will go up in price, I do think his work would be fun to live with.

Holly Solomon Gallery, New York

Overview

Holly Solomon began life in the art world as a serious collector of Pop Art. In November 1994 at Christie's, the famous Roy Lichtenstein painting *I . . . I'm Sorry* (a portrait of Holly commissioned by Horace Solomon in 1965-66) brought almost 2.5 million dollars. The painting served as a reminder of how long Solomon has been successfully involved in the art world. In 1975 Solomon opened a gallery in SoHo and quickly became known for her stable of artists, which included Robert Kushner, William Wegman, Nicholas Africano, and Judy Pfaff. She has continued to move forward by taking on new artists like Suzan Etkin, Y.Z. Kami, and Rob Wynne while continuing to promote her mainstays like Nam June Paik.

Best Buy: Nam June Paik

Price Range: $35,000 to $85,000 (typical sculpture, installations are more expensive)

Holly Solomon (along with Cincinnati dealer Carl Solway) was early in seeing the potential of the video art pioneered by Nam June Paik. Her instincts proved correct, as video art has become mainstream to the point of Bill Viola representing the United States at a recent Venice Biennale. Recently, Paik did a video installation at the Solomon Gallery of a giant blue neon map (perhaps thirty feet long) of the United States with television sets inserted into each "state." The visual impact was memorable. Video art will obviously never be as collected as commonly as painting and sculpture. But there will always be a market for less traditional art forms providing the artist is the first to develop that particular form of expression (the light sculptor Dan Flavin, the first artist to use electric current in his work, is a good example).

Sperone Westwater, New York

Overview

Partners Angela Westwater and Gianenzo Sperone have developed a program with a strong international following. In fact, they also have another space in Rome called Galleria D'Arte Moderna. When you walk into the New York space, director David Leiber has managed to create a feeling that this is a serious place to look at some serious artists. By mixing well known European artists with equally established American counterparts, the viewer walks away feeling knowledgeable about Europe as well as America. The gallery's big success story is the development of Susan Rothenberg into one of the country's top painters. Sperone Westwater also shows works by Francesco Clemente (though represented by Gagosian), Greg Colson, Ray Smith, and On Kawara.

Best Buy: Jonathan Lasker

Price Range: $15,000 to $70,000 (paintings)

Jonathan Lasker, who got his start at the Massimo Audiello Gallery, is one of the higher profile abstract painters around. Lasker's imagery can be described as a few irregularly shaped rectangles with a few corresponding squiggly lines. His colors intentionally clash but somehow manage to work. The paintings appear to be hard to live with. But if you spend some time with them, you come to realize that Lasker is intentionally thumbing his nose at the viewer. He provokes you by using unappealing color and unattractive forms to get you to think about the nature of abstract painting. The work sticks with you like gum on the bottom of your shoe; it's hard to discard.

Daniel Weinberg Gallery, San Francisco

Overview

Daniel Weinberg's gallery came full circle when it moved a few years ago from Los Angeles back to San Francisco. As far as exhibitions go, Weinberg's are the best in San Francisco. He also serves as an important link between New York and the West Coast. If it weren't for Weinberg, San Franciscans would never see the likes of Eric Fischl, Sol LeWitt, Robert Ryman, and John Chamberlain. Daniel Weinberg was also the first gallery on the West Coast to show Robert Gober. Finally, the gallery has been a long-time supporter of the under-exposed artists Ralph Humphrey and John McLaughlin. Viewing the high caliber shows that Weinberg mounts reminds you of how the public often takes for granted the huge efforts that galleries outside of New York make in order to bring major work to their communities. As this book went to press, the gallery had announced that it was going private.

Best Buy: Steve Wolfe

Price Range: $5,000 to $40,000 (paintings and sculpture)

Daniel Weinberg's strength as a dealer is his willingness to get on a plane to New York, look over the scene, and consistently bring back some of the best talent. However, the exception to this rule is Steve Wolfe. He is the one artist that the Weinberg Gallery discovered and developed on its own, and he's a winner. Wolfe creates meticulously crafted realist paintings of books as well as three-dimensional boxes of books. The key to these works is the titles of the books in each composition (anything from classics to nature guides to novels). They create a stimulating intellectual dialogue within each painting when the artist places unlikely titles next to one another. Steve Wolfe also shows with Luhring Augustine Gallery in New York.

Stephen Wirtz Gallery, San Francisco

Overview

It seems like whenever you walk into a Bay Area collector's home, more often than not there's a piece from the Stephen Wirtz Gallery. However, the gallery name is a misnomer. Stephen's wife Connie deserves a large share of the credit for selecting the gallery's artists. The Wirtzes are known for their heavy commitment to their artists and continually network them into a surprising number of shows. Over the years the gallery has shown a diverse group of internationally known artists, including Man Ray, Arnaldo Pomodoro, and Antoni Tapies. Its current roster features Raymond Saunders, Marc Katano, and Michael Kenna. But the gallery's real strength may be photography. Stephen Wirtz possesses one of the finest collections of "anonymous" 19th and 20th century photography around. If he ever decides to release it to the public, you'll see the birth of a major new category in art collecting.

Best Buy: Deborah Oropallo

Price Range: $6,500 to $30,000 (paintings)

The Bay Area artist, Deborah Oropallo, is a painter of enigmatic images. She makes paintings that aren't what they at first glance appear to be. In the past, Oropallo's lush realist imagery has ranged from life preservers to violins, often with painted narrative text. The work seemed laden with meaning and the heaviness of "message." With her most recent body of work, large paintings of train tracks, Oropallo finally seems ready to go beyond issues of personal imagery and explore issues of art history. In the new paintings, she silkscreens a few scattered black train tracks on an eggshell white ground. These works whisper of Agnes Martin. The spare abstract quality of the new work shows that Deborah Oropallo is ready to be less literal and leave more to the viewer's imagination. This strategy should pay off in the form of getting an important New York dealer.

About the Author

Richard Polsky was born in New York and graduated from Miami University (Oxford, Ohio) with a degree in fine art. He has been a professional art dealer since 1978. His background includes working as a gallery director and owning a gallery (Acme Art, San Francisco). Acme Art did exhibitions of Joseph Cornell boxes, Andy Warhol paintings, Bill Traylor drawings, and also showed works by emerging artists. Currently, Richard Polsky is a private dealer of contemporary art in San Francisco.

Questions or Comments:
The author can be reached at 415-885-1809 (phone), 415-885-1962 (fax)

Photo: Penni Gladstone